SHADES—OF PAINTING AT THE LIMIT

SHADES—OF PAINTING AT THE LIMIT

JOHN SALLIS

INDIANA UNIVERSITY PRESS
BLOOMINGTON & INDIANAPOLIS

This book is a publication of

Indiana University Press
601 North Morton Street
Bloomington, Indiana 47404-3797 USA

www.indiana.edu/~iupress

Telephone orders 800-842-6796
Fax orders 812-855-7931
Orders by e-mail iuporder@indiana.edu

Publication of this book is made possible in part with the
assistance of a Challenge Grant from the National Endowment
for the Humanities, a federal agency that supports research,
education, and public programming in the humanities.

Sallis, John, date
 Shades—of painting at the limit / John Sallis.
 p. cm. — (Studies in Continental thought)
 Includes bibliographical references and index.
 ISBN 0-253-33424-1 (cloth : alk. paper). — ISBN 0-253-21222-7
(pbk. : alk. paper)
 1. Painting—Philosophy. 2. Painters—Psychology. 3. Creation
(Literary, artistic, etc.). I. Title. II. Series.
ND1140.S26 1998
750' . 1—dc21 98-18462

1 2 3 4 5 03 02 01 00 99 98

To my brother, **Jim**

CONTENTS

List of Plates

List of Figures

Acknowledgments

This book draws upon a series of papers that appeared in *Tema Celeste*; to Demetrio Paparoni, editor of this contemporary art review, I am grateful for permission to use material from these papers. I want also to thank Sperone Westwater Gallery (New York) for permission to use material that appeared in the exhibition catalogue *Amici*.

I am grateful also to Magdalena Dabrowski, Curator at The Museum of Modern Art (New York), whose generous assistance was invaluable in acquiring the materials and permissions needed for certain reproductions. Above all, I want to express my deep gratitude to my editor and friend Janet Rabinowitch; this book has benefited enormously from her expert editorial advice and from her tireless and uncompromising effort in its behalf.

Thanks also to my wife Jerry for her photographs of the Paladino mask (plates 19 and 20). I am grateful also to my daughter Lauren Lewis and to Nancy Fedrow and Robert Metcalf for help during the preparation and production of this book.

Boalsburg
February 1998

SHADES—OF PAINTING AT THE LIMIT

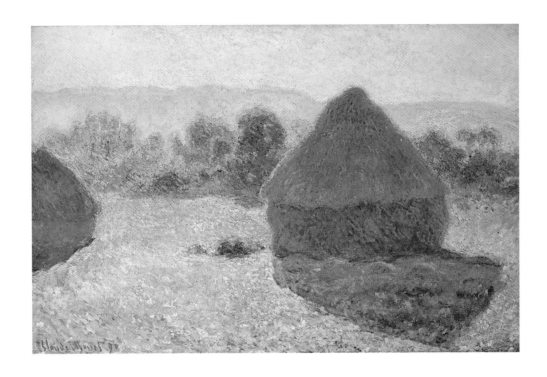

Plate 1. **Claude Monet**

Wheatstacks in the Sunlight, Midday (W 1271), 1890.
65.6 x 100.6 cm.
National Gallery of Australia, Canberra.

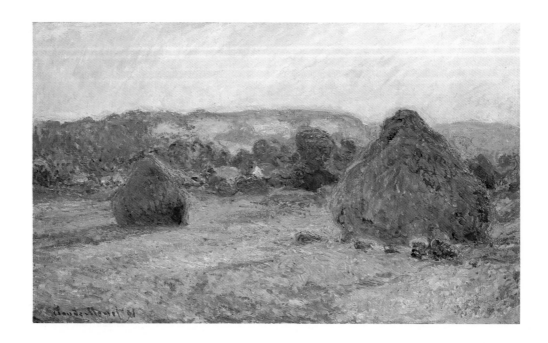

Plate 2. **Claude Monet**

Wheatstacks, End of Summer, Evening Effect (W 1269), 1891.
60 x 100 cm.
The Art Institute of Chicago (Arthur M. Wood in memory of
Pauline Palmer Wood, 1985.1103). Photograph © 1996, The
Art Institute of Chicago, All Rights Reserved.

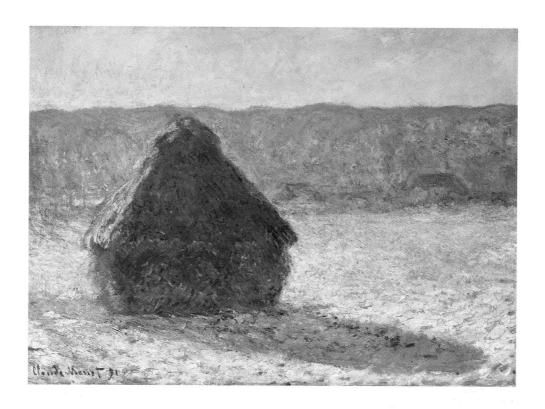

Plate 3. **Claude Monet**

Wheatstack, Snow Effect, Morning (W 1280), 1891.
65 x 92 cm.
Museum of Fine Arts, Boston (gift of Misses Aimée and
Rosamond Lamb in memory of Mr. and Mrs. Horatio A.
Lamb. Courtesy Museum of Fine Arts, Boston).

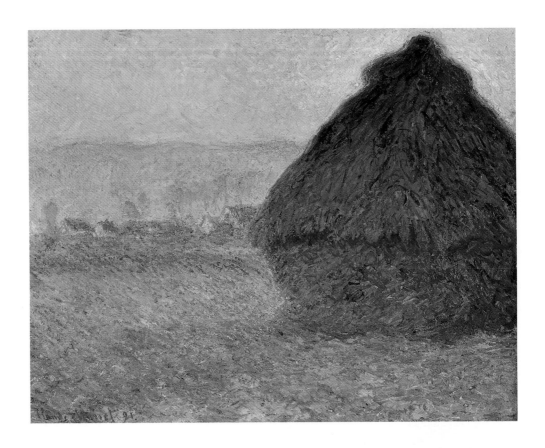

Plate 4. **Claude Monet**

Wheatstack, Sunset (W 1289), 1891.
73 x 92 cm.
Museum of Fine Arts, Boston (Juliana
Cheney Edwards Collection. Courtesy
Museum of Fine Arts, Boston).

Plate 5. **Claude Monet**

Wheatstacks, Sunset, Snow Effect (W 1278), 1891.
65 x 100 cm.
The Art Institute of Chicago (Mr. and Mrs. Potter Palmer
Collection, 1922.431). Photograph © 1996, The Art
Institute of Chicago, All Rights Reserved.

Plate 6. **Claude Monet**

Wheatstack, Snow Effect, Overcast Day (W 1281), 1891.
65 x 92 cm.
The Art Institute of Chicago (Mr. and Mrs. Martin A.
Ryerson Collection, 1933.1155). Photograph © 1997, The
Art Institute of Chicago, All Rights Reserved.

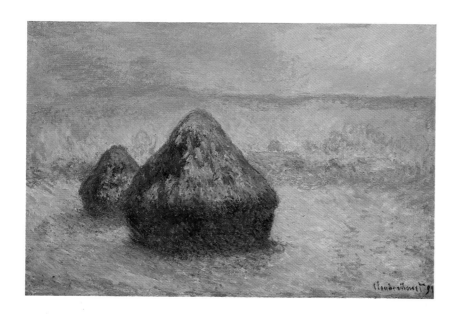

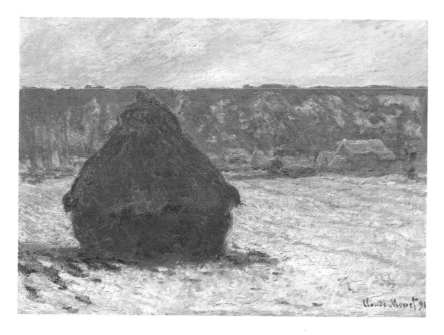

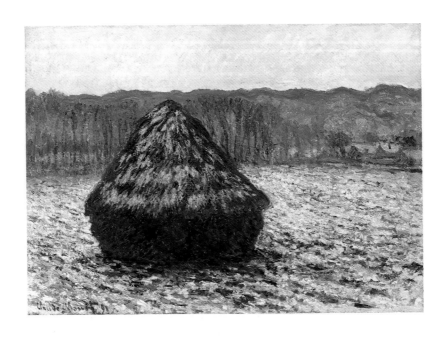

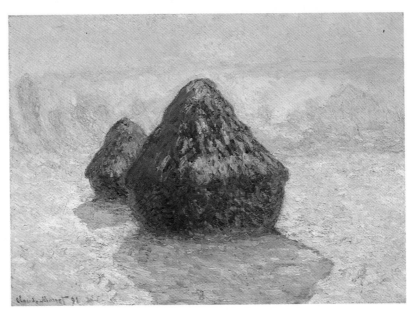

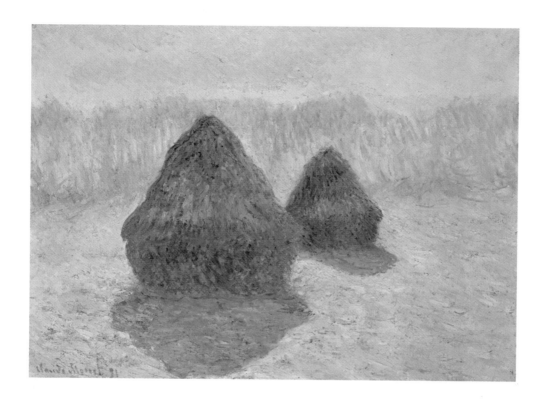

Plate 7. **Claude Monet**

Wheatstack (W 1283), 1891.
65 x 92 cm.
The Art Institute of Chicago (Restricted gift of the
Searle Family Trust; Major Acquisitions Centennial
Endowment; through prior acquisitions of the Mr.
and Mrs. Martin A. Ryerson and Potter Palmer
Collections; through prior bequest of Jerome
Friedman, 1983.29). Photograph © 1997, The Art
Institute of Chicago, All Rights Reserved.

Plate 8. **Claude Monet**

Wheatstacks, Effect of Hoar-Frost (W 1277), 1891.
65 x 92 cm.
The National Gallery of Scotland.

Plate 9. **Claude Monet**

Wheatstacks, Winter Effect (W 1279), 1891.
65 x 92 cm.
The Metropolitan Museum of Art (H. O.
Havemeyer Collection, Bequest of Mrs. H. O.
Havemeyer, 1929, 29.100.109). Photograph
© 1996, The Metropolitan Museum of Art.

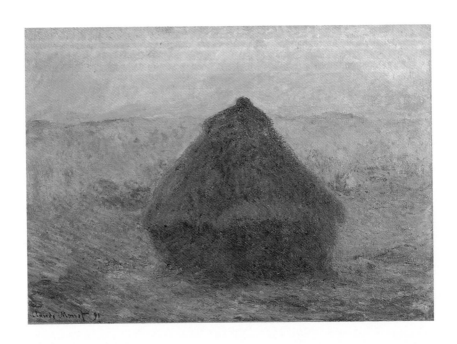

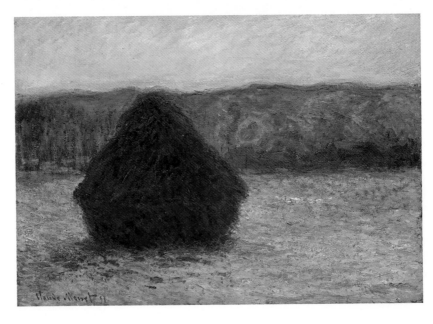

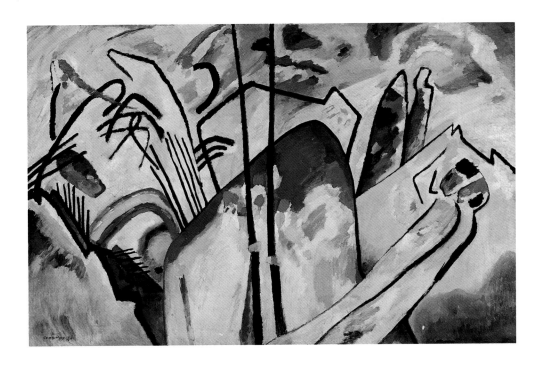

Plate 12. **Wassily Kandinsky**

Composition IV, 1911.
159.5 x 250.5 cm.
Kunstsammlung Nordrhein-Westfalen. By
permission of Kunstsammlung Nordrhein-
Westfalen; Walter Klein, Düsseldorf; and
Artists Rights Society.

Plate 10. **Claude Monet**

Wheatstack (W 1285), 1891.
65 x 92 cm.
Galerie Larock-Granoff, Paris.

Plate 11. **Claude Monet**

Wheatstack, Thaw, Sunset (W 1284), 1891.
65 x 92 cm.
The Art Institute of Chicago (Gift of Mr. and Mrs.
Daniel C. Searle, 1983.166). Photograph © 1997,
The Art Institute of Chicago, All Rights Reserved.

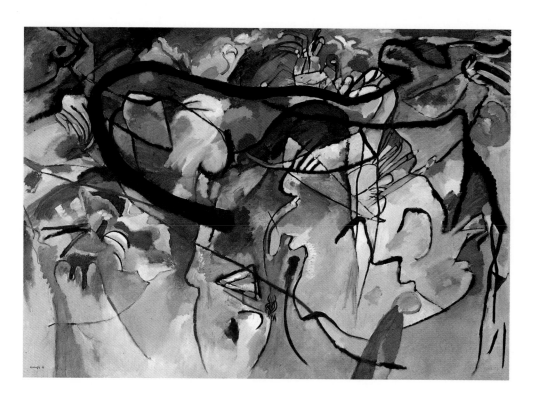

Plate 13. **Wassily Kandinsky**

Composition V, 1911.
190 x 275 cm.
Private collection. By permission of Artists
Rights Society.

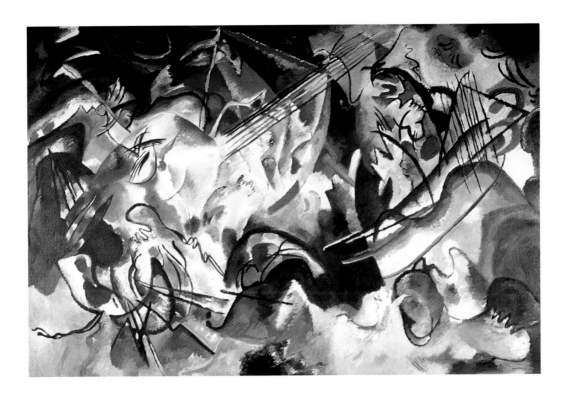

Plate 14. **Wassily Kandinsky**

Composition VI, 1913.
195 x 300 cm.
Hermitage Museum, St. Petersburg. By permission
of Artists Rights Society.

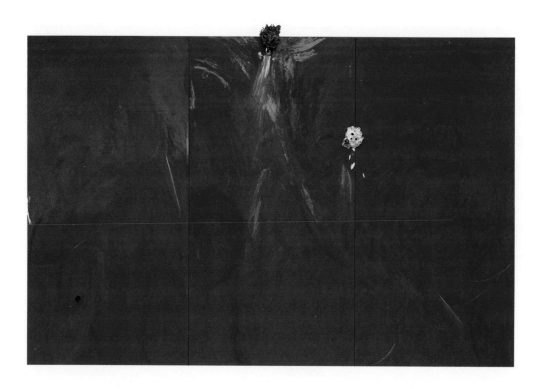

Plate 15. **Mimmo Paladino**

Silent Red [Rosso silenzioso], 1980.
Oil and objects on canvas, 300 x 465 cm.

Plate 16. **Mimmo Paladino**

Untitled [Senza titolo], 1989.
Oil on canvas and wood, 108 x 88 x 15 cm.

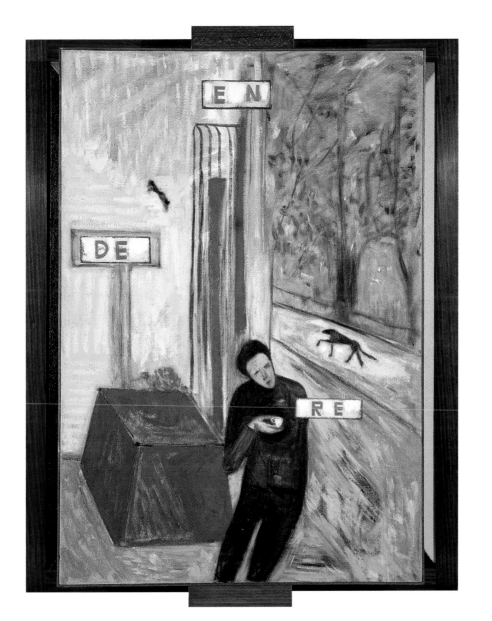

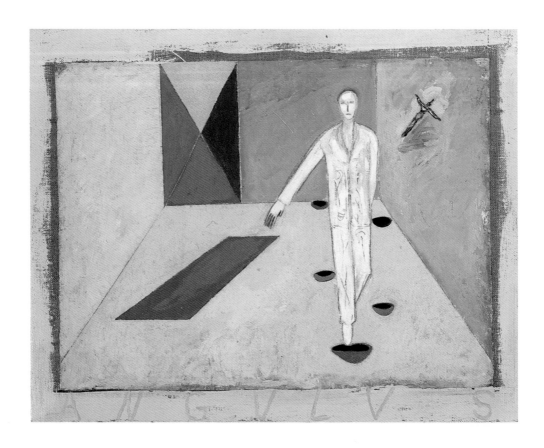

Plate 17. **Mimmo Paladino**

On Tiptoe [In punta di piedi], 1990.
Oil on canvas, 48 x 62 cm.
Private collection. Courtesy Sperone Westwater,
New York.

Plate 18. **Mimmo Paladino**

Souvenirs, 1990.
Mixed media on canvas, 66 x 62 cm.
Collection Gian Enzo Sperone, New York.
Courtesy Sperone Westwater, New York.

Plate 19. **Mimmo Paladino**
Untitled (Mask) [Senza titolo (Maschera)], 1990.
Bronze, 88 x 25 x 13 cm (frontal).

Plate 20. **Mimmo Paladino**
Untitled (Mask) [Senza titolo (Maschera)],
1990. Bronze, 88 x 25 x 13 cm (lateral).

Adumbrations

Imagine light.

Try framing it for your inner vision. Try bringing it forth—or, as the case may be, letting it come forth—to fill that vision and fulfill its intention. Put into play your utmost phantasy in service to such a vision of light. Spur your phantasy on past every limit, as though it were a winged steed drawing you ever higher, on toward the purest of visions, the vision of light.

Of light itself. Not the light intercepted by impermeable objects and reflected from their surfaces: for in this case light will itself have been contaminated, its pure passage—the pure passage that light itself is— compelled to convey the colors and shapes of those objects. Vision, rather, of the light that would precede all such contamination, light as it would have been before being put in service to things. Pure light. A light still completely untouched by things. A light that, even if traversing space, would itself have acquired no spatiality in this passage, this ever free passage. Such light could not but be pure radiance: a radiance that would not be the radiance *of* anything or *of* any place. And yet, though it could not but be pure radiance, such light could in the end not *be* anything at all: for—to redeploy the ancient phrase in an abysmal formulation—it would be *beyond being,* that is, if it *were* at all and were not precisely beyond being. Such light would be pure radiance and at the same time pure passage, time providing indeed the only possible connection, the horizon to which all that one could say of it would eventually have to be referred. Hardly a ground for expectations: What could one expect of a saying, a language, that in the end is moored only in that pure passage that one calls *time*? Lest all words dissolve, one will always need, then, to come back to the vision itself, which, if it is possible at all, must be an inner vision. Because, to be sure, pure radiance must remain untouched by

all but the mind's eye. Also perhaps because it is only in imagination that one could hope to leap to a beyond of being.

Most assuredly, there can be no representation of light itself, granted that representation is always of something that can be sensibly present, setting it forth in a kind of repetition of an actual or possible presence to sensible intuition. To the extent, then, that painting is oriented—in whatever way—to pure light, it will never have been representational; its operation will never have been confined to setting before one's vision a representation of something one could see, as it were, in the flesh. It will never have been simply, exhaustively representational, even granted a rigorous distinction between representation and mere copying or reproduction. On the other hand, most painting does include representational aspects; and without exception painting is indisputably presentational, setting something before one's vision, inviting one to take it up in one's vision, even if what one is to see is never identical with what is set before one's vision in the forms and colors of the painting. Could one not determine painting as taking place between the possibility and the impossibility of imagining light itself? Could one not determine it as presenting that which is itself unpresentable, unpresentable as itself, in its purity? Does painting not present light itself—the pure passage of pure radiance—as if it could be imagined, leaving open the question of pure imagination? Does painting, from its very inception, not turn back from imagining light itself, setting out on a different course, or rather setting out in a different way toward the same destination, like sailors who, when wind is lacking, take to the oars? Will the painter not always have turned back from the pure vision, stepped aside into the protective shade, and sought to return through the shadows to the vision of light itself? Or rather, to *a* vision of light itself, a vision of it itself, even if not simply *as* itself, a vision of light as it comes from beyond being to let things shine forth. In painting, according to such a determination, the light that brings visibility to things would itself become visible without being utterly contaminated and set merely in service to things.

But what of the question put to painting? What of the questions just ventured in the guise of possible determinations of art? Can one simply begin with the question, putting it—without question, without any question of the question—to painting? Or will one not already have put in force a preconception of painting, predetermined it, from the moment one asks about the origin of painting or about its meaning? Does not the very form of the question already predelineate a range of possible answers? Are there not preconceptions burdening even the question "What is painting?" despite its semblance of utter generality and lack of predetermining connections? For—one can assert, putting aside the form of the question—it is not certain, not self-evident, that painting is such as to have a meaning, an origin, or even a "what," that is, something like an essence, something that would answer the question "$\tau\acute{\iota}\ \acute{\epsilon}\sigma\tau\iota\ \ldots\ ?$", something that would delimit painting in such a way as to mark a boundary decisively separating it, for instance, from sculpture. It is not certain—and painting attests to this uncertainty—that the boundary is impassable, that painting properly excludes, for instance, everything sculptural. It is not certain that there is nothing sculptural about painting. It is not certain that painting is set apart in a propriety closed off to everything other.

One may insist nonetheless on retaining these classical questions, but only on the condition that, before being put to painting, they be opened beyond the classical determinations of meaning, origin, or essence. By way of such opening and deconstruction, one could then come to put appropriately to art the question, for instance, of the origin of the work of art. One could pose it even as the question of the truth in painting. But then, in every such instance, especially in such instances, the utmost vigilance will be required if one is to elude the countless traps that would reenclose the question in one or another classical determination.

Yet suppose, instead, that the question to be put to painting were to be unfolded from painting itself. Suppose the formulation of the question were to involve only a shade more than what is said in *painting,* merely

doubling the word by unfolding it, opening it to itself, almost just repeat-
ing it in what would almost be simply tautological. Suppose the question
were suspended between two differently tensed participles, asking merely
about the painted in the painting. Suppose the question were to be
oriented to the merest of differences, to the shade of difference corre-
sponding to a certain excess in and of painting, taking the nominal parti-
ciple (*painting*) in its various registers. *In* painting there is an exceeding *of*
painting, an exceeding of what is depicted or figured in the painting.
Suppose the question were only about this excess to be differentiated from
what is merely represented—that is, again, about that which is painted in
painting. In this case one could, to be sure, not claim to have stationed the
question, in advance, beyond all the traps that threaten to reenclose it in
the classical determinations. Especially if one let the question expand, as it
will almost of itself, until it asks "What is painted in painting?", then one
will have to mark the same reservation in this "what" as in that belonging
to the seemingly most general questions. But the advantage is that the
opening of the "what"—the deforming of essence, one may call it—will be
determined by a concrete directedness to painting, indeed, as always in
art, by a directedness to singular paintings with which one's vision can
engage. The very opening of the question to be put to painting can thus
be carried out in the face of painting itself, that is, in the most concrete
directedness to singular paintings engaged by one's vision. The question
would be opened beyond the classical determinations precisely in and
through a turn to the very things themselves that would be put in ques-
tion. Without supposing that it could ever simply match the spectacle
itself, the question could at least be specified and articulated in a move-
ment proceeding from the painting itself. Even though certain points of
the painting might prove not to lead back to discourse at all. Even though
at certain points the painting would have to be abandoned to itself and
the blank spaces, as it were, merely marked in the discourse, marked by a
supplementary discourse.

▼ ● ◆

Short of the turn and the visual engagement it opens, there are only adumbrations. Short of the turn, one would venture to say what evokes the turn, what calls questioning to the shades. Pretending that the evocation could simply be declared before coming into force, before evoking thought.

Above all, then, one will say that the genius of the painter has recourse to shades. Even when it would be a matter of painting light itself. Precisely then. Precisely when he would paint the pure passage of pure radiance.

▼ ● ◆

Picture the scene. It is on the southern coast of Sicily, on a plateau above the city and within view of the sea. The city is now called Agregento, but in the time of Empedocles its name was Acragas. In ancient times the plateau was a sanctuary, and even today the ruins of its great temples are among the best-preserved to be found anywhere. Imagine standing near these Greek ruins, looking out from that once sacred place, out over the city and on beyond to the sea. It is summer, midday: the intensity of the sunlight is almost unbearable to the unshaded eye. Everything about the scene attests to this intensity: the fire felt on every exposed surface of one's body, the blinding flashes reflected from the smooth stones with such intensity as to veil their very surface, the calm sea glistening in the distance, sparkling with such intensity that it could seem to be nothing but sheer radiance, as if the sea itself had withdrawn behind the very brilliance of its shining. Imagine how you might be driven back by the flames. In phantasy put yourself there where you can both feel and see the blazing light and sense being driven into retreat. Picture yourself then stepping back into the shade of an ancient olive tree, withdrawing your gaze from the distance, confining it for a moment to the sparse vegetation and rocky soil enclosed by the sharply contoured umbra.

In picturing this scene and letting a certain play of imagination

commence around it, you will already have intuited what shade preeminently *is*, even if holding back the word that names its gift and that expresses this intention fulfilled in advance. It is not just palpable but indeed elemental, in the sense in which fire and earth are elemental: shade gives *relief* from direct sunlight, from its blazing, blinding effects. *Shade gives relief:* as such the word may name either the shadow cast by something that blocks the direct sunlight or, by extension, the object itself, especially when the shade is something fabricated from an opaque material. If cast within an illuminated expanse rather than enclosing an interior, shade gives relief also in the sense of outlining an area or shape sharply contrasted with the sunlit surroundings, and thus, even in what one may take as pure nature, it foreshadows the mode of sculpture in which forms and figures are distinguished from a surrounding plane surface, the mode in which they are shown, as one says, in relief.

The Old French root *relever,* to relieve, lets one see unmistakably that, even if engaged through retreat, relief has to do, in the end, with lifting, raising, elevating—as, for instance, in a sculpted relief or, following Derrida's translation, as in the operation that Hegel names *Aufhebung,* the operation of all operations, the operation at work in every operation, at work in all and every work. Everything—without exception—must be raised into relief, for, as Hegel says, one can no more see in absolute light than one can in absolute darkness.[1] This is why shade and the relief it gives are absolute imperatives. Only where there is shade can anything be seen: only through the operation of shade does there arise contour, outline, delimitation, form itself, the very configuration of self-showing as such, which solicits and directs the vision that comes to sweep across things.

—————

1. "But, in fact, if one represents this very seeing more exactly, one can easily become aware that in absolute clarity one sees just as much, and as little, as in absolute darkness, that the one seeing is as good as the other, that pure seeing is a seeing of nothing. Pure light and pure darkness are two voids which are the same thing. Something can be distinguished . . . only in determinate light" (G. W. F. Hegel, *Wissenschaft der Logik,* vol. 21 of *Gesammelte Werke* [Hamburg: Felix Meiner Verlag, 1985], 80).

Painting is determined by the absolute imperative of shading. For the painter everything depends on communication with the shading, with the raising into relief, through which things come to show themselves in a self-showing that is their very emergence into presence. The painter must be capable of learning the secrets—the alchemy—of that mixing of light and shade by which being is configured. The painter must be so adept at consorting with the shades that he can himself mix them with light so as to reconfigure being, producing as if by magic what otherwise only nature produces. This is why *genius,* which names precisely the expropriation that the self of the artist will always already have undergone, is so readily taken to have its origin in nature, as in Kant's determination of it as the inborn *ingenium* through which nature gives the rule to art.[2]

In consorting with the shades, the painter's orientation is not toward representation, neither toward representing darkness by way of shading nor toward representing objects by mimetic reproduction. What the painter brings forth is shading itself, its operation, the mixing of light and shade, through which (in which, from which, by way of which—none of these prepositional phrases suffices alone, nor perhaps even together, to express this most subtle yet most decisive hinge) things come to show themselves in their delimitation. Such production, the bringing-forth (ποίησις) that renders painting poetic—this the painter carries out by reconstituting in a quite different register the very shading that is brought forth, by reconstituting it as art rather than nature (to pose this peculiarly unstable yet persistent opposition here at the very locus where it arises). Or rather, granting the self-expropriation that will always have come into play, one can say more properly that what is poetic in painting comes to pass through the painter, in the sense not of agency but of passage.

Shade pertains not only to light and darkness as such but also to color, to the lightness and darkness of color. Whether in art or in nature,

2. I. Kant, *Kritik der Urteilskraft,* in *Kants Gesammelte Schriften,* ed. Preussische Akademie der Wissenschaft (Berlin, 1902-), 5:181.

the spectacle is inseparable from the shading of color. Thus one refers to shades of color, to shades of *a* color, to shades of blue. In this connection *shade* may aim at sheer singularity, at the singular display of color before one's eyes on a singular occasion; yet one soon learns that *this blue, this very shade of blue,* fails utterly to say that at which one's expression aims, or rather, precisely by saying it the expression leaves it untouched, abandons it to itself. A similar, though not identical, elusiveness will arise in connection with every discourse on painting, on any singular painting, and to this extent there will always be, as Derrida says, two paintings in painting,[3] as there are—speaking roughly and in a way that would violate the very difference being marked—two blues, one seen, the other said. More commonly, however, *shade* denotes not a singular but a species, though most often one not subject to further differentiation, a species at the threshold of singularity. A difference of shade may come down to the very minimal differentiation possible in the field of color, that is, to a mere shade of difference, a difference so minute that it seems not to be difference itself but only the shade thereof, a mere shadow-image of difference. Thus, *shade* can come to designate a trace, as distinct, for instance, from a fully delineated form, as distinct by its very indistinctness, by what it lacks of presence.

Thus, in reconstituting traces, in painting shades, the genius of painting does not represent objects, does not portray them in a presence comparable to that which they could also have in nature. Except in modern abstract painting, there are, to be sure, objects in the painting, and yet, even in what seems the most representational of paintings, what is painted never simply coincides with the objects depicted. This doubling is

3. Derrida writes of "what, at a stroke [*d'un trait*], does without or goes beyond this language, remaining heterogeneous to it or denying it any overview." He continues: "And then, if I must simplify shamelessly, it is as if there had been, for me, two paintings in painting. One, taking the breath away, a stranger to all discourse, doomed to the presumed mutism of 'the-thing-itself,' restores, in authoritarian silence, an order of presence. It motivates or deploys, then, while totally denying it, a poem or philosopheme . . . "(Jacques Derrida, *La vérité en peinture* [Paris: Flammarion, 1978], 175–78).

the hinge on which everything turns, this doubling that sets what is painted aside from everything depicted or figured in the painting. Aside from and yet bound to the object depicted: for what is painted is also not simply light itself as itself. The genius of painting will always have turned back from pure light, from imagining it, having recourse, instead, to the shades in order thereby to come to paint light itself, even if not quite as itself. One could say that painting is medial: what is painted is neither simply light itself nor objects themselves but rather light as it comes from beyond being to let objects shine forth. What is painted, thus rendered visible in a way that it rarely is in nature, is the light that confers visibility on things. The difference between what is painted and what is depicted or figured in the painting tends toward the limit at which it would disappear, and yet the very possibility of painting, of what is poetic in it, depends on the preservation of this difference, even if finally it is only a shade of difference. What is painted is aside from things yet bound to them. It confers visibility on things without itself being absorbed into the service of merely conveying their colors and shapes. As conferring visibility on things, what is painted is no longer just light pure and simple but rather is differentiated into perhaps more elements than one could ever have imagined without actually encountering them in painting itself; it is only in turning to painting that one can begin to discern how the genius of painting reconstitutes this phenomenon, sometimes with mere traces of objects, perhaps even without depicting any objects at all. This highly differentiated phenomenon I shall call *shining,* thus translating—while reopening—the Platonic determination of beauty as τὸ ἐκφανέστατον (the most shining, that which most shines forth). The word is intended to resonate across a broad range of senses much less explicit in it than in its German cognate: shining, look, appearance, semblance, illusion. Thus, it is meant also to allude to—and to reopen—the Hegelian and Heideggerian determinations of beauty precisely as they echo the Platonic word.[4]

4. Hegel determines beauty as the sensible shining of the idea. In Heidegger's *The Origin of the Work of Art,* linked explicitly to Hegel's *Aesthetics,* beauty is redetermined as the

It goes perhaps entirely without saying that eluding reenclosure in the classical determinations requires, above all, reopening those determinations in their depth while also exposing them to the force of what can be called—deferring the requisite differentiations—modern painting.

▼ ● ◆

Painting is always at the limit. Consorting with shades, its genius sets its sights on the most meager and remote of images: shadows lie at the very extreme of the continuum of ever more remote images, of images that image less and less of their original. Shadows lie at the limit beyond which nothing would any longer be an image of the original at all. Shadows are, too, at a certain limit of movement and life, animated only and entirely by that which casts them. Painting sets its sights also on shades of color, on differentiations that are at the limit of specification and perhaps even, in the passage toward singularity, at the limit of discourse.

Yet painting is at the limit in a more originary way, set within the very divide where the poetic moment of painting (and hence painting as such) unfolds. Painting is engaged with the difference—even if only a shade— that separates what is painted from what is depicted or figured in the painting. It operates at this limit, produces its work by setting it forth from this limit. In this connection *limit* no longer designates a point (for instance, the terminal point of a linear continuum) nor even a continuum of limit-points, assembled, for instance, into a circle that would limit something by encircling it. Rather—remaining within this figural discourse, which cannot but duplicate the very structure it expresses—the limit might be said to assume, in this connection, the shape of a narrow band delineated by two lines that can be (and will have been) variously determined

shining of truth as set into the work of art. I have discussed these determinations in *Stone* (Bloomington: Indiana University Press, 1994), chap. 1; *Double Truth* (Albany: State University of New York Press, 1995), chap. 10; and *Echoes: After Heidegger* (Bloomington: Indiana University Press, 1990), chap. 7.

and that can perhaps never be fixed once and for all. On one side lies that which is depicted or figured in the painting, the objects, persons, scenes, actions, or, in the case of the more abstract work, shapes and configurations of color. On the other side is light itself, not purely as itself but rather as it comes to confer visibility on such things as are depicted or figured in the painting, thus light as the highly differentiated shining that makes things visible as such. Painting installs itself in the interval between these sides, in the band formed by the two lines marking off things, on one side, and the shining that confers their visibility, on the other. It is imperative to painting that it hold open the interval, not just keeping the two sides distinct (while also joined, as would be the case if—continuing the figural discourse—only a line ran between them), but insuring that they remain separated, discontinuous, ever differing if only by a shade. The response to this imperative is decisive: both for painting and for theoretical discourse on painting, this response determines a broad range of possibili-ties—for understanding but also for misunderstanding. As long as the interval is firmly sustained, there will be a basis for resisting the reduction of painting to mimetic representation, for such a reduction—either in painting as such or in the self-understanding arising from painting or in a theoretical reflection—would effectively reduce what is painted to what is merely depicted in the painting, driving the poetic element entirely out of painting. Within the tendency toward such reduction, one may find the difference being covertly reopened within the very density of representa-tion, as when, in certain instances at least, one distinguishes the spiritual in art from the mere objects or figures in the painting.

Because painting is set at the limit, because of the limit at which it is set, its temporality and spatiality are distinctive. Although it neither runs its course in time nor is fully deployed in space, painting that depicts a scene normally includes indication concerning the time and place (both in multiple registers) of the scene. More significantly, what is painted has, as a rule, its temporal and spatial characters, for the shining conferral of visibility cannot but spread across the scene, even in its differentiation from that scene. To the extent that time is the final horizon in reference to

which beings as such come to be interpreted and articulated, to the extent that time is, in Heidegger's phrase, the meaning or truth of being, painting will be bound to paint time. For the light itself that comes from beyond being to confer visibility on things will be *of time,* its shining upon things a shining inseparable from time, even if not the time of common opinion, even if not the time of metaphysics.

One of the more open ways in which time comes to be painted is that in which the momentary is rendered permanent. Painting can disclose that which comes and goes instantaneously, not by halting its passage and representing it (falsely, one could say) as though it were static, but precisely by setting it, in its very instantaneity, into the work, by setting the instantaneity itself into the work as a moment of what is painted in the painting.

Hegel, for instance, notes how painting can hold on to objects that do not stay on (*verweilen*) sufficiently for us ordinarily to give them explicit consideration, how painting can hold them fixed and even detain them (*festhalten* contains all these possibilities), not in order to falsify their instantaneity by exchanging it for permanence, but rather in such a way as to make the instantaneity as such visible. Here especially, says Hegel, painting must deploy the magic of shining (*die Magie des Scheinens*) in order to concentrate what is most ephemeral and momentary.[5] Hegel does not hesitate to celebrate such painting and to regard it even as a moment in the most exalted painting: "In supreme art we see fixed the most fleeting shinings of the sky, of the time of day, of the lighting of the forest; the shinings and reflections [*die Scheine und Widerscheine*] of clouds, waves, lakes, streams; the shimmering and glittering of wine in a glass, a flash of the eye, a momentary look or smile, etc."[6] The passage is remarkable: one could read it almost as a description, in advance, of precisely

5. Hegel, *Ästhetik,* ed. Friedrich Bassenge (West Berlin: Verlag das Europäische Buch, 1985), 2:210.
6. Ibid., 2:189.

that at which Impressionism, at least in its inception, will aim. Except that in this context Hegel is referring to only one of two extremes: in the principle of artistic treatment in painting, there are two extremes that stand in opposition—on the one hand, the fineness of singular appearances, but, on the other hand, the depth of the subject matter. Hegel insists that in painting itself, this opposition does not simply remain fixed, though, appealing to the unrestricted particularization operative in painting, he forgoes venturing to say just how the opposition comes to be broken down. For the most essential reasons, it does not lie within his purview—however it might in deed be in painting—to consider that painting the most fugitive and effervescent shinings might prove to be a way of painting the depths, by drawing them to the surface and confounding the very opposition between surface and depth.

Painting is at still another kind of limit, or rather, it is set within this other limit, itself delimited while also set apart from the other arts, set in its proper relation to them. No doubt there is, as Derrida notes, a certain collusion between the classical questions regarding art as such and the hierarchical classification of the individual arts,[7] and it is hardly necessary today to stress that vigilance and a critical reopening of questions must be brought to bear on the mutual delimitations of the arts no less than on the question of art as such. In fact, already in the *Critique of Judgment* the systematic division of the arts proves to harbor elements of indecision, even aporias, especially acute in the case of painting. Not only, for instance, does Kant find it necessary to set painting into relation with landscape gardening, only to waver indecisively as to whether the latter can indeed be considered a fine art; he is also driven to include under what he calls painting in the broad sense such things as the decoration of rooms with tapestries, the art of dressing tastefully (with rings, snuffboxes, etc.), and a room ornamented by, among other things, ladies' attire so as, at some luxurious party, to form a kind of painting. What is even more

7. Derrida, *La vérité en peinture,* 27.

remarkable is that even when thus broadened, so it seems, beyond virtually all limits, painting still proves to lack what would seem an utterly essential moment, namely, the art of color, which in the Kantian system of the arts ends up entirely outside the boundaries of the visual arts, more akin to music than to painting proper. Little wonder, in view of such indecisive results, that Kant twice warns his reader that his is "only one of a variety of attempts that can and should still be made."[8]

The difficulties that arise in the Kantian division of the arts are by no means merely a result of certain now-quaint customs and associations imposed on Kant by his century. On the contrary, they are linked to a certain systematic grid that Kant sets at the basis of his analysis by proceeding through an analogy between the arts and communicative speech, in which thought, intuition, and sensation, respectively, are conveyed. Yet even the deployment of this grid reaches only so far, and the more thoroughly one takes up Kant's analyses of the division of the arts, the more one recognizes in these analyses a series of profound openings to the arts both in their specificity and in their resistance to systematic division, at least to a system in which each of the so-called individual arts would form a discrete member within a hierarchical series.

The most rigorous attempt to assemble the arts into such a system is found in Hegel's *Aesthetics.* In this system the arts are not just separated by rigid boundaries into discrete, essentially unrelated forms. Though each art has its propriety as such, there is a series of dialectical transitions leading over from the negativity of one art to the positive form of another, and it is this series of transitions that has the effect of assembling the so-called individual arts into a system.

8. Kant, *Kritik der Urteilskraft,* 5:321 n. The other warning, also in a footnote: "All of this the reader should judge only as an attempt to combine the fine arts under one principle—in this case the principle of the expression of aesthetic ideas (by analogy with a language)—rather than regard it as a decisive derivation" (ibid., 5:323 n.). I have discussed these matters in some detail in "Mixed Arts," in *Proceedings of the Eighth International Kant Congress,* ed. Hoke Robinson (Milwaukee: Marquette University Press, 1995), I.3:1093–1104.

One could say equally that the system articulates the various artistic genres through which the goal of art as such is achieved, namely, the sensible presentation of spirit. Art is set in the fold between the sensible and the spiritual, in the divide, the interval, concentrated in the word *Darstellung:* by way of what is sensibly presented (depicted, in the case of painting), there is produced a presentation of spirit, of that which animates all manifestation, its specular system conferring all visibility, in both the most general and the specific sense pertinent to painting. Such is the poetry of art as such, its magic, its genius.

The adequacy of the presentation is what, above all, determines the position of each art with respect to the others within the hierarchy. The hierarchy is by no means simply linear or unidirectional. This is shown most clearly by Hegel's insistence that art reaches its perfection in Greek sculpture, in which spirit is presented as perfectly as is possible *in art,* that is, sensibly; yet, along another line, the highest form of art is most decidedly not sculpture but rather the so-called romantic arts (painting, music, poetry), which present also, though inadequately, a dimension of spirit completely outside the purview of sculpture and resistant to art as such, namely, interiority, subjectivity.

In the system painting arises, then, at the point where art first comes to present subjectivity, advancing beyond sculpture in precisely this respect. In painting, what is painted is particularized subjectivity, which the genius of the painter brings to shine forth, as spirited, in and through the objects depicted in the painting. Hegel excludes the abstract sense that such presentation might be taken to have: it is not a matter simply of rendering the inner life intuitive (*anschaubar*) through physiognomy and figure. Rather, the appropriate external expression is found only in the individual situation of an action (*Handlung*) or the passion in a specific deed (*die Leidenschaft in bestimmter Tat*), through which what is sensed first receives its explanation and becomes recognizable.[9]

9. Hegel, *Ästhetik,* 2:229.

By virtue of presenting subjectivity in the wealth of its particularization, painting is differentiated from sculpture in an essential way; by virtue of the more adequate character of such presentation, it is also superior to sculpture. For in sculpture spirit shines forth only in the objective mode belonging to the sculpted work. What sculpture presents is only spirited individuality without the differentiation and particularization of interiority, of the inner life. Sculpture implants the substance of spirit in the human figure, setting this figure and this substance in a harmony to which is pertinent only the universal and permanent elements in the bodily form as they correspond objectively to spirit. Thus, marking the limit that distinguishes it from painting, marking too the negativity that drives the transition to painting, Hegel says that sculpture lacks "the point where subjectivity appears [*der erscheinende Punkt der Subjektivität*], the concentrated expression of the soul as soul, the glance of the eye [*der Blick des Auges*]." Precisely for this reason sculpture does not need "the painter's magic of color [*Farbenzauber*]."[10] It is not, then, just because Hegel identifies sculpture so thoroughly with Greek sculpture, mistakenly taken not to have been colored, at least not when at its zenith—it is not only for this reason that he regards sculpture as having no need of color. But also for essential, systematic reasons: because sculpture does not yet broach subjectivity and particularity, it has no need of the delicacy and variety of nuances that color provides for rendering visible the immense wealth of particular characteristics, for instance, "the whole concentration of mind in the soulful glance [*Seelenblick*] of the eye."[11]

In the transition to painting, spirit comes to be presented outwardly (in the painted work) *as inner* (as particularized subjectivity)—that is, the transition to painting has the effect of transforming the external shape into an expression of inner life. This transformation involves two essential moments. In the first place, the real sensible appearance (*Erscheinung*)

10. Ibid., 2:92.
11. Ibid.

must be cancelled, superseded (submitted to *Aufhebung*), and transformed into the pure shining (*zum blossen Schein*) of art. Then, as the second moment, color must be brought into play, color with its differences, transitions, and blendings (*Unterschiede, Übergänge und Verschmelzungen*)—in short, its shading, the shades of color. Hegel succinctly expresses what comes about in the transition to painting, in the advance across the limit separating sculpture from painting: "Therefore, for the expression of the inner soul painting draws together the threefold of spatial dimensions into a surface as the first inwardizing of the external and presents spatial intervals and shapes by means of the shining of color."[12]

But what if—now—the conceptual resources that determine this systematic division of the arts are exhausted, not only such oppositions as inner/outer in correlation with subjective/objective, along with universal/particular and spirit/nature, but even, in the end, the concept itself, the very recourse that would be had to the concept, the detour, as it were, back to presence? Could painting still be delimited by way of limits like the one with which Hegel marks the transition from sculpture to painting? And what of the propriety of sculpture, of painting, of the other so-called individual arts? What is to prevent the alleged transition from one art to another from turning into an intrusion of one art into another, that is, invasive impropriety? Should one seek to prevent it and to fix the boundaries anew? Or is the very desire to prevent such intrusions not itself governed by the same resources as those that empower the Hegelian system of divisions? Is this desire not linked, in the end, to a maintaining of the very classical questions about art? For the question "What is painting?" brings with it the expectation, if not the presupposition, that there is a "what" proper to painting, one into which improper moments deriving from other arts do not intrude. Suppose the question and its expectation were put aside? Would this not come down to deciding to think rigorously

12. Ibid., 2:18f.

a phenomenon that seems more than manifest in the arts themselves, namely, their mixing, as when, for example, Mendelssohn composed music to be mixed into Shakespeare's *A Midsummer Night's Dream*?

This would also be a way of returning to Kant's insight that, for instance, there is something like painting within poetry. Kant notes in this regard that, whereas in poetry presentations are aroused in the imagination by words, in the visual arts (*die bildenden Künste*) these presentations assume the guise of actual or semblant objects of sensible intuition.[13] Opening a vision of images that the visual arts can present in sensible intuition, poetry has within it a kind of protopainting and protosculpture; these, in turn, already open, within poetry, the space in which painting and sculpture as such can come to supplement poetry.

To say almost nothing of what happens in deed in painting itself. Especially since Hegel. Only that it can itself pose questions regarding its relation, for instance, to sculpture—not as theoretical questions but as something set into the painted work itself, a question painted, not voiced or written. Also, that painting can show something about its limit, about its being at the limit, most openly through the frame that provides the painting its limit, that transposes the sense of limit into the domain of painting.

Today it is known that the so-called Impressionists took a keen interest in the frames used for their paintings. Monet especially. For example, he is known to have actually removed collectors' frames from works of his own borrowed for exhibition and to have replaced them with frames of his choosing. He is known also to have prescribed that two of the *Wheatstack* paintings in the series exhibited in Paris in 1891 were to have white frames.[14] Such intervention in the framing of his work is hardly surprising in view of what his painting ventured.

13. Kant, *Kritik der Urteilskraft,* §51.
14. See Charles F. Stuckey, *Claude Monet: 1840–1926* (New York: Thames and Hudson—copublished with The Art Institute of Chicago, 1995), 17f.

SHADES–OF PAINTING AT THE LIMIT

▼ ● ◆

Everything in painting is singular. Even if several paintings in a series depict what can, from a certain point of view, be designated as the same object, the object remains nonetheless singular in each of the paintings, and, even in the series taken as a whole, it remains a singular thing repeatedly depicted. When, on the other hand, painting unfolds its poetic moment—always already, from the moment it arises as painting as such—it doubles sensible singularity in a way that, for the most part, is quite different from the movement to the concept opened by the inception of speech. This is why one must be hesitant to ascribe to what is painted the character of a meaning and to put to painting or to *a* painting the question of its meaning. Even while opening the interval by which what is painted is set apart from what is depicted in the work, painting remains in a certain proximity to the visible singular.

In discourse on painting, this proximity to the singular needs to be retained and reconstituted within the element of discourse. As to some degree it always is: even the most insistently theoretical discourses, those of the *Critique of Judgment* or the *Aesthetics,* for instance, are driven to introduce discussions of singular works of art, considered usually as examples.[15] Yet even to construe them as examples is—short of rethinking the very sense of exemplarity—to risk situating the painted work not only within very classical conceptual oppositions but, more significantly still, within a frame inappropriate to painting as such.

The discourses that follow undertake, though in quite various ways, to retain and reconstitute the proximity of painting to the singular. They are addressed, respectively, to three phases in what is called the development of modern painting. Yet, in the interest of proximity to the singular,

15. See, for example, *Kritik der Urteilskraft,* §14, which is entitled "Elucidation by means of examples [*Erläuterung durch Beispiele*]."

their focus is narrowed to three painters, Claude Monet, Wassily Kandinsky, and Mimmo Paladino, indeed to only a few works of each, clustered in each case within a very brief period: in the case of Monet, the years 1889–91; in that of Kandinsky, 1911–13; in the instance of Paladino, 1989–93. The discourses are also linked to certain singular events, exhibitions at which the works could be engaged visually and a discourse around them launched in view of the singular works themselves: an exhibition of Monet's series paintings held at The Art Institute of Chicago in 1990; a showing of Kandinsky's extant *Compositions* at The Museum of Modern Art in New York in 1995; and what could perhaps be called a staging of Paladino's work at Forte Belvedere in Florence in 1993.

Even if today one hesitates to characterize discourse on painting by recourse to the classical conception of theory (θεωρία as taken over in modern thought would seem all too intent on casting its vision beyond all singularity), the discourses that follow do venture to hover between an engagement with the singular works and what could—by a certain displacement or recovery of the sense of θεωρία—perhaps again be called theoretical discourse, now determined by the question of what is painted in painting. For this reason I do not hesitate to bring also into play—critically, of course—what these painters *say* of painting and of their painting, in letters and in texts, either supplying a kind of theoretical supplement to their work or putting forth something like a program in relation to which their work would be situated.

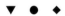

In painting there are only shades. At its limit painting reduces the solidity of actual objects (sculpture) to mere shades on a surface. Or rather, not to *mere* shades, but to shades that, through the magic of color, are made to come forth as though they were actually there before one's vision. It is the genius of painting to bring shades forth in this way and to let the shining in which they come forth become also itself visible. This is the poetic moment of painting.

It is also a moment of which the poet sings in a kind of protopainting that turns painting upon itself, sketching in imagination its self-portrait.

As in the picture Homer gives of Odysseus bringing forth the shades condemned by δίκη itself to inhabit that region beyond all limits, beyond life itself. Sailing to the outermost bounds, Odysseus and his companions arrive at a land perpetually wrapped in mist and cloud, and it is here, in a place where the bright sun never casts its rays, that Odysseus, digging a pit to be filled with libations and with the black blood of the sacrificed sheep, can bring forth the dead, the shades of Hades. He is in search of Teiresias, whose initial question to Odysseus is: Why have you left the light of the sun and come to behold the dead in this joyless region?[16] This χῶρος (= χώρα) is joyless because only the living can experience joy. Yet even the dead yearn for a taste of life and joy: all the shades want to drink the blood, and it is precisely by offering it, while also guarding it with his sword, that Odysseus is able to bring forth the phantoms so as to speak with them as though they had come to life. But only *as though:* longing to embrace the soul (ψυχή) of his dead mother, Odysseus tries three times to put his arms around her, but each time she slips through his arms, as he says, like a shadow or a dream (σκιῇ εἴκελον ἢ καὶ ὀνείρῳ).[17] Brought forth as though alive, she and the others, even once-mighty Achilles, remain mere phantoms of worn-out human beings (εἴδωλα καμόντων),[18] mere shades.

Like those brought forth as though to life by the genius of the painter.

16. *Odyssey,* 11:94.
17. Ibid., 11:207.
18. Ibid., 11:476.

ONE Shades of Time
Monet's *Wheatstacks*

In October 1886 Monet wrote from Belle Isle to his future wife Alice Hoschedé in Giverny telling of a letter (apparently lost) that he had just received from Durand-Ruel; in the letter his dealer told him that he was out of his element on this wild Atlantic island (south of Brittany), advising him to return and then to spend the winter in the Midi, "because," as Monet recounts it to Alice Hoschedé, "my business is the sun. Well!" Monet objects, "they will end by overwhelming me [*m'assommer*] with the sun!"[1]

The following month Monet did return to Giverny, indeed with some forty paintings on which he had worked during the Belle Isle campaign. Also, despite the reservation expressed to Alice Hoschedé, he followed Durand-Ruel's suggestion about the Midi, though it was not until the following winter, in January 1888, that he went to paint in the Mediterranean town of Antibes. Judging from what he wrote to his future wife and his friends during his stay in Antibes, which continued until early May, he did indeed end up being quite overwhelmed by the Mediterranean sun, not just by having come to such a place but precisely in and through his attempt to paint there. It was, on the one hand, a matter of fascination bordering on entrancement, yet an experience, on the other hand, of exposure, even of a certain assault. In a letter to Alice Hoschedé dated 1 February 1888, Monet wrote of the "eternal and resplendent sun" in

1. All references to Monet's letters and to his paintings follow the designations in Daniel Wildenstein, *Claude Monet: Biographie et catalogue raisonné,* 5 vols. (Lausanne: La Bibliothèque des Arts, 1979-91). The letter cited is no. 726.

Earlier that month Monet had written to Caillebotte about Belle Isle: "I have been here for a month and am working hard. It is a superbly wild country, with its frighteningly heaped up rocks, with the incredible colors of its sea; I am carried away with it, though this makes it difficult for one like me accustomed to painting the Channel, and who had established a routine, but the Ocean is quite another thing" (no. 709).

Antibes.[2] In letters to her over the next few days, he referred to "this sun, which, for several days, has been of an excessive force"; he complained of the eyestrain that had resulted from working in such sunlight and that had made it impossible for him to read in the evenings. He reported that even the straw hat purchased for relief against the sun's brightness had not prevented him from continuing to be fatigued by the excess of sunlight.[3] Not that his fascination was curbed: on 12 February he wrote to his friend, the art critic Gustave Geffroy, "It is so beautiful here, so clear, so bright [*lumineux*]! One swims in the blue air; it is frightening."[4] The frightening luminosity had the effect of provoking Monet's painting, yet at the same time it proved to overburden the painter and to exceed his painting. The letter written in Antibes to Rodin is most telling: "I wear myself out and struggle with the sun. And what a sun here! It would be necessary to paint here with gold and gemstones. It is wonderful."[5]

A few years later, in 1895, Monet will visit Norway. The months of February and March he will spend exploring the area around Oslo and painting in and around the fjordside town of Sandvika. When he leaves on 1 April to return to Giverny, he will take with him a number of paintings of houses and of the fjord and more than a dozen paintings of Mount Kolsaas, all done from the same perspective but showing the mountain under different conditions and at different times. What he will write from the north echoes much of what he wrote from the Mediterranean south. It will still be the sun on which he repeatedly remarks, "a resplendent sun," "a superb sun," as he will write in letters to Alice Hoschedé.[6] Monet will not find it easy to set to work in the strange northern landscape. Writing to Alice Hoschedé on 24 February, he will explain that it is impossible to

2. Letter 824.
3. Letters 828, 832.
4. Letter 836. Cf. Gustave Geffroy, *Claude Monet: sa vie, son oeuvre* (Paris: Macula, 1980), 191.
5. Letter 825.
6. Letters 1269, 1270.

arrive in such a country and set immediately to work. Not because of unwillingness or lack of preparation: "My canvases are prepared; I know where I ought to go at different hours, if the weather permits, for there are some places that I have seen in cloudy weather that are not feasible in the sun, since the snow is so brilliant and blinding for the eyes."[7] Again, it will be the sun that—at least— threatens to overwhelm. It seems even that Monet will go to almost any lengths to evade it: "I painted part of the day today while it was snowing constantly; you would have laughed to see me entirely white, my beard covered with icy stalactites."[8] Monet will have to struggle not only for relief from the brightness of the sun's direct or snow-reflected light (he will observe that in Norway nearly everyone carries sunglasses) but also against the effect of the warmth of the sun's rays: "What I am afraid of is the ardor of the sun, which melts the snow on the roofs."[9] Midway of his visit he will have recognized that this northern landscape—for all its fascination and even though not artistically inaccessible for him—is nonetheless not his element: "It would be necessary to live here a year in order to do something good and only after having seen and gotten acquainted with this country."[10]

Monet will return to Giverny in April 1895, as he had from Antibes in May 1888, as he would again in May 1889 following his Creuse Valley campaign. The Giverny home and property, which he has been renting since 1883, Monet finally buys in November 1890, at the very time when he is at work in a nearby farmer's field painting what will be the first of his series in which the full conception of series painting is realized. After 1900 Monet will not often leave Giverny on painting campaigns.[11] For the rest of his life his motifs will be almost exclusively those to be found in the

7. Letter 1272.
8. Letter 1274, to G. Geffroy, 26 February 1895.
9. Letter 1275, to Alice Hoschedé, 27 February 1895.
10. Letter 1274.
11. Two notable exceptions are his third trip to London, January–April 1901, and his stay in Venice, October–December 1908.

SHADES-OF PAINTING AT THE LIMIT

gardens at Giverny, especially those to be seen from the paths around the water-lily pond. Even in the previous decade, the 1890s, a great deal of his painting is done at Giverny and on local motifs, including several major series. Everything would suggest that as a painter Monet was most thoroughly in his element in Giverny. Far from the excessive sunlight of the Mediterranean coast and from the blinding, snow-reflected light of the Norwegian landscape.

But what does Monet paint in and around the shade of Giverny, in this element to which his painting seems to be ever more drawn? What will he have painted? What is painted, for instance, in the works exhibited at the Durand-Ruel Gallery in May 1891, especially in the fifteen paintings (of the twenty-two included in the exhibition) that have virtually the same subject? Or in what could be seen at the exhibition held at The Art Institute of Chicago in the summer of 1990: in a single room an assemblage of fourteen paintings of wheatstacks?[12]

These two exhibitions, nearly a century apart, were exceptional in showing numerous *Wheatstacks* together, though indeed they did not by any means show all or even most of Monet's paintings in which such objects provide the motif. The two exhibitions did not present the same group of *Wheatstacks,* though there was certainly some overlap.[13] Neither

12. The exhibition "Monet in the '90s" was actually organized by the Museum of Fine Arts, Boston. The catalogue (Paul Hayes Tucker, *Monet in the '90s: The Series Paintings* [Boston: Museum of Fine Arts—in association with Yale University Press, 1989]) includes two *Wheatstack* paintings that were not shown at the exhibition in Chicago (W 1274, 1282); the catalogue does not include one of the earlier *Wheatstack* paintings shown in Chicago (W 1214). The objects depicted in these paintings have been designated by a succession of different names in English: initially by *haystack* (e.g., in Charles S. Moffett's "Monet's Haystacks," in *Aspects of Monet,* ed. John Rewald and Frances Weitzenhoffer [New York: Harry N. Abrams, 1984]); then by *grainstack* (e.g., in the 1990 exhibition at The Art Institute of Chicago); most recently as *wheatstack* (in the 1995 Monet exhibition at The Art Institute of Chicago). The last of these translates most accurately *meule de blé,* which is the appropriate designation. Virginia Spate calls them *stacks of wheat* (*Claude Monet: Life and Work* [New York: Rizzoli, 1992]).

13. Tucker says that it is impossible to identify five of the fifteen *Wheatstacks* shown in

did they present the paintings within the same context. In the 1891 exhibition Monet included, along with the fifteen *Wheatstacks,* four paintings of fields in Giverny, a painting from his Creuse Valley campaign (*The Rock*), as well as two figure paintings (of a woman with a parasol).[14] On the other hand, the much larger exhibition in Chicago focused on Monet's series paintings and included, along with the fourteen canvases from the *Wheatstack* series, numerous canvases from several other major series produced in the 1890s (*Poplars, The Rouen Cathedral, Cliff Paintings, Mornings on the Seine, Japanese Bridge*). In both exhibitions, however, the character of the *Wheatstacks* as constituting a series was underlined.

Stacks, though of a slightly different sort, show up in Monet's paintings from early on, indeed long before he came to Giverny. There is a painting from 1865, *Haystacks at Chailly at Sunrise* (W 1989–55 bis: *Meules près de Chailly, Soleil Levant*) (figure 1), that is not without certain foreshadowings of the *Wheatstacks* that Monet will paint more than two decades later. Not only is this painting linked thematically to time, to a time of day, but also, compositionally it is less remote from the later paintings than one might expect: a series of bands depicting field, town, and sky are laid out horizontally across the painting; through these bands the haystacks jut upward, their verticality accentuated by that of the church tower in the distance. The two narrower bands of color that stretch across the sky just above the horizon and thereby announce sunrise constitute perhaps as much the visual focus of the painting as do the haystacks; and they are indeed almost the same color as the haystacks. Yet

the 1891 exhibition (*Monet in the '90s,* 275 n. 41). House insists that of the fifteen shown, all belonged to the group dated 1891 (John House, *Monet: Nature into Art* [New Haven: Yale University Press, 1986], 213). Moffett, on the other hand, positively identifies eleven of those included in the exhibition, identifying two others as probable inclusions. Of these thirteen, only one—and it is a probable inclusion—belongs to the earlier series (W 1217) (Moffett, "Monet's Haystacks," 157 n. 6). Of the thirteen thus identified, six were also included in the exhibition in Chicago (W 1269, 1277, 1278, 1280, 1281, 1289). The exhibition in Chicago included three canvases outside the group dated 1891 (W 1213, 1214, 1271).

14. Tucker, *Monet in the '90s,* 99.

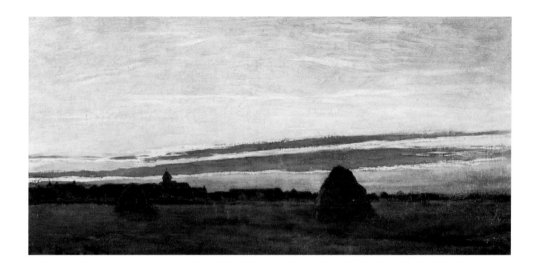

Figure 1. **Claude Monet,** *Haystacks at Chailly at Sunrise*
(W 1989–55 bis), 1865. 30 x 60 cm. San Diego Museum of
Art (Museum purchase).

the stacks do not themselves gather the light and thus the time of day
(made itself visible) but remain only in a more extrinsic relation, literally
pointing to the bands of color. Only the very slightest reflection is to be
seen on the left side of the haystack in the foreground.

The earliest such paintings done in Giverny, one group from 1884 (W
900–902), another from 1885 (W 993–995), also differ in certain respects
from those of the great series that Durand-Ruel was to exhibit in 1891.[15]

15. The paintings of haystacks from the 1870s are discussed by Grace Seiberling, *Monet's
Series* (New York: Garland, 1981), 311 n. 3.

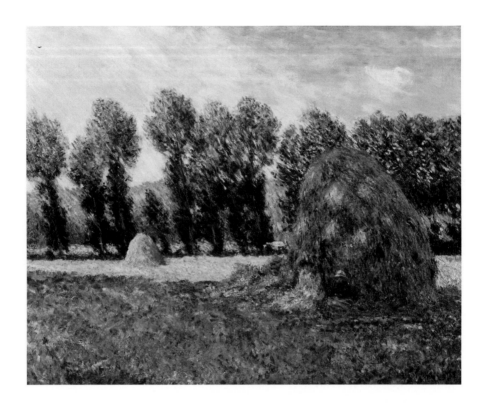

Figure 2. **Claude Monet**, *The Haystack* (W 994), 1885.
65 x 81 cm. Ohara Museum of Art, Kurashiki, Japan.

The paintings from 1884–85 show the stacks in front of a line of trees. In these paintings the stacks are in fact—as in the 1865 painting—haystacks, two or three of them in each painting. Some also include human figures; for example, there is one from 1885 (W 994) (figure 2) that shows in the

foreground two people reclining against a large haystack.[16] There is another group of *Haystacks* (W 1362–64) that were painted after Monet's return to Giverny from the campaign that produced the *Rouen Cathedral* series. The paintings of this group, thus postdating the Durand-Ruel exhibition (all three are dated 1893), are much more akin to those of 1884–85 than to those shown at the 1891 exhibition.

All of the *Wheatstacks* included in that exhibition as well as those shown in Chicago nearly a century later come from the period 1889–91. During this time Monet produced at least thirty such paintings: there are four dated 1889, three dated 1890, twenty-two dated 1891, and one undated. They fall into two groups: a first, small group of three to five paintings, two of them shown at Petit's Monet-Rodin exhibition in the summer of 1889;[17] and the series proper, from which all or nearly all of the paintings for the Durand-Ruel exhibition in May 1891 were taken.[18]

Both groups from 1889–91 consist exclusively of paintings depicting wheatstacks (*meules de blé*), not haystacks (*meules de foin*). Such stacks were constructed from sheaves of wheat and normally remained in the field from harvest time in late July until late winter, when the sheaves were sent for threshing.[19] Typically they stood some fifteen to twenty feet tall, the upper part conical in shape and often thatched.[20] In Giverny such wheatstacks were to be found practically at Monet's doorstep; a photograph from 1905 (figure 3) shows several of them near his house. There is a story that, while Monet was painting the *Wheatstacks,* he actually paid a farmer to delay sending the sheaves off for threshing until he could finish his paintings.

One could be tempted, then, to identify what is painted in the *Wheatstacks* with precisely these objects, the actual wheatstacks that stood

16. Wildenstein identifies the people as Alice Hoschedé and Michel Monet.
17. House, *Monet,* 199, 244 n. 47.
18. Ibid., 199. Cf. above, note 3.
19. Spate, *Claude Monet,* 205.
20. Tucker, *Monet in the '90s,* 83-89.

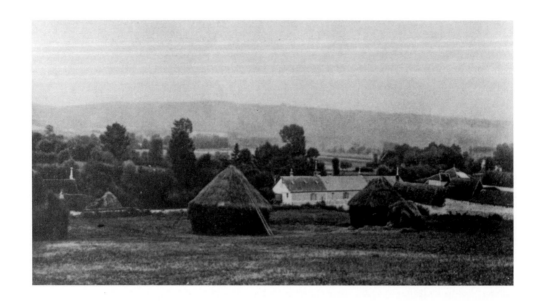

in the farmer's field at the time Monet executed the paintings. Yet, even before examining the paintings and beginning to attend to what is at work in them, one can be assured that they are not just reproductions of those particular objects that Monet once saw in Giverny. Even though indeed he set up his easel in the farmer's field where he could observe the wheatstacks as they appeared at different times of day and under different atmospheric conditions, to identify what he painted with these particular

objects would be to confuse painting with photography, in fact with a merely technical, reductive concept of photography. For painting does not reproduce objects, copying them, as Hegel says, in a superfluous labor that can produce only inferior imitations of things to be found already in one's garden or in the countryside beyond.[21] On the contrary, painting arises only when the depiction of objects in the painting is determined, not by the intention merely to produce a copy of something seen, but by the unfolding of a double having to do with light itself, even if in falling across the depicted scene it assumes more the guise of a shadow. Aside from the things depicted yet bound to them, this double constitutes what is painted in the painting.

What is to be said, then, about the relation of Monet's paintings to those particular, actual wheatstacks? How is one to weave a discourse pertinent both to Monet's *Wheatstacks* and to the wheatstacks that once stood in the farmer's field in Giverny? Such discourse would only venture to duplicate in its own register what Monet's painting accomplishes in deed, in the work: effective circulation between the inside and the outside of the painting. There is perhaps no moment in painting—not even the moment when the magic of color lets a scene open from the surface of a canvas—that is more enigmatic, more riddlesome, than this circulation between inside and outside,[22] especially considering that, in painting such

21. Hegel, *Ästhetik,* 1:51f.

22. Derrida has taken up this issue in his discussion of the criticism brought by Meyer Shapiro against the interpretation of a painting by Van Gogh that Heidegger presents in *The Origin of the Work of Art.* Shapiro's criticism is that Heidegger wrongly attributes the shoes depicted in the painting to a peasant woman, whereas, according to Shapiro, they are in fact Van Gogh's own shoes. The "debate" between Heidegger and Shapiro thus has to do with restitution, with restoring the shoes (in the painting) to their rightful owner (outside the painting). Derrida's text exposes just how uncritically, even naively, Shapiro moves between what is inside and what is outside the picture, as if there were no frame separating them. One of the voices in Derrida's text puts it thus: "Thus Shapiro is mistaken about the primary function of the pictorial reference. He also misjudges [or: is unaware of— *méconnaître*] a Heideggerian argument that should ruin in advance his own restitution of the shoes to Van Gogh: art as 'putting to work of truth' is neither an 'imitation' nor a 'descrip-

as Monet's, the very establishing and unfolding of the inside, of the painting itself, is carried out in and through such circulation. Here one can appropriately recall the words with which Heidegger opens the Afterword to *The Origin of the Work of Art:* "The foregoing reflections are concerned with the riddle of art, the riddle that art itself is. They are far from claiming to solve the riddle. The task is to see the riddle."[23] Can one perhaps best *see* the riddle in painting, listening at the same time to the fragments of discourse with which the painter marks this riddlesome circulation?

There can be no doubt but that Monet executed his *Wheatstack* paintings with a view to actual wheatstacks, in fact those particular ones that stood in a farmer's field in Giverny in 1890. Indeed, in virtually all his landscape painting, Monet was insistent to an unprecedented degree on having the landscape in view; working outdoors even under harsh conditions, he painted rapidly, moving from canvas to canvas in order to keep pace with the changing light and atmosphere. Yet this insistence on the view served solely to facilitate what Monet called *rendering:* in view of particular, actual, natural things, a certain apprehension of them is to be rendered in and as painting. The circulation would run full circle in moving from the view of things to the rendering effected in and as the painting. The path of this reiterated circling is not predetermined but rather is determined only in the circling itself, determined in a moment that one could call poetic—or enigmatic, riddlesome. Or blind.

tion' copying the 'real,' nor a 'reproduction,' whether it represents a singular thing or a general essence. For the whole of Shapiro's case, on the other hand, calls on real shoes: the picture is supposed to imitate them, represent them, reproduce them" (*La vérité en peinture,* 356). As to Heidegger, his attribution of the shoes to a peasant is shown—reducing somewhat the polyphony of Derrida's text—to serve quite a different purpose, not to return the shoes to their actual owner outside the painting, but to draw the work that depicts them toward its essential connection with the earth: "The value of proximity plays a decisive role in this text and in Heideggerian thought in general. The shoes of the peasant are *closer* to that earth to which a return had to be made. But in principle the same trajectory would have been possible with city shoes" (ibid., 409).

23. Martin Heidegger, *Der Ursprung des Kunstwerkes,* in *Holzwege,* vol. 5 of *Gesamtausgabe* (Frankfurt a. M.: Vittorio Klostermann, 1977), 67.

The rendition in which the reiterated circling finally issues will be set apart from the things that the painter will have had in view. Not only because the rendition will never be a copy of those things, but also for reasons having to do with the very bearing of a work of art, as indicated by its withdrawal from direct involvements with surrounding things (in contrast, for instance, to use-objects, which have their very sense in such involvements). In the case of a painting, such a withdrawal operates even with respect to objects in view of which the painting has been executed, the wheatstacks before which Monet set up his easel when painting the *Wheatstacks*. In this regard Heidegger refers to the *Insichstehen,* the *Insichruhen,* of the work, its self-repose, one might say. This self-repose also involves a withdrawal from the artist, or rather, a self- withdrawal of the artist, whose most proper intention is to release the work, to let it stand forth as a work: "The work is to be released by him to its pure self-repose." At least in what Heidegger calls—not unproblematically—great art, "the artist remains inconsequential [*etwas Gleichgültiges*] as compared with the work, almost like a passageway that destroys itself in the creative process for the work to emerge [*ein im Schaffen sich selbst vernichtender Durchgang für den Hervorgang des Werkes*]."[24]

The self-repose of the work, if interpreted in this fashion, would provide a basis for understanding—without necessarily excluding all

24. Ibid., 26. Without denying or even reducing the self-repose of the artwork, even its self-repose with respect to the spectator, one would need to mark at another level of this relation a distancing that would operate to quite different degrees in the various arts. It is with respect to such a distancing that Benjamin contrasts "the screen on which a film unfolds with the canvas of a painting." He explains: "The painting invites the spectator to contemplation; before it he can abandon himself to his associations. Before the movie frame he cannot do so. No sooner has his eye grasped it than it has already changed. It cannot be arrested" (Walter Benjamin, *Illuminationen,* vol. 1 of *Ausgewählte Schriften* [Frankfurt a. M.: Suhrkamp, 1955], 164). Thus, the motility of the work would involve an inverse proportionality with respect to its contemplative distance. Another distantiality would be that of the work to that which is depicted in it. Here again Benjamin contrasts painting with the film: "The painter observes in his work a natural distance from what is given [*das Gegebene*], the cameraman penetrates deeply into its web" (ibid., 158).

nonartistic motivations—what was at stake in Monet's repeatedly exposing himself to perils and hardships for the sake of his work, scaling a vertical cliff at Étretat, painting through a hailstorm on Belle Isle. The self-repose of the work would also provide a basis for interpreting what Monet reportedly said to the journalist Maurice Guillemot, who in 1897 accompanied the painter to the site where he was working on fourteen paintings in the *Mornings on the Seine* series: "I would like to prevent anyone from seeing how it is done."[25]

The self-repose of the work does not, however, exclude its giving some indication regarding its origin. Indeed, Heidegger insists that the createdness of a work is such as to be itself created into the work; that is, the createdness ("that it is created") will always be somehow manifest in the work, from the work.[26] One might suppose that, just as a frame can make visibly manifest the self-repose of a work, so the signature of the artist can provide a way in which the work's createdness can be made manifest from the work. This is the direction in which one might take up a remark that Spate inserts in the course of an extended descriptive analysis of one of the *Wheatstacks:* "The whole painting then is composed of the interpenetrating, contrasting scales of colour which suggest not only that Monet perceived the motif as an indissoluble whole, but that this wholeness can be experienced only in time. Yet the signature— which can, as it were, cause the painting to unravel into skeins of colour—makes it clear how much this experiencing of nature is also a matter of creating artifice."[27]

▼ ● ◆

Monet began painting the series proper in late August or early September 1890; the first reference to his work on these *Wheatstacks*

25. Cited in Wildenstein, *Claude Monet,* 3:79.
26. Heidegger, *Der Ursprung des Kunstwerkes,* 52.
27. Spate, *Claude Monet,* 208.

occurs in a letter to Geffroy dated 7 October 1890, though clearly he had begun work on the paintings a month or two earlier. It appears that he worked with intense concentration throughout the fall and the winter, painting of course outdoors, though almost certainly finishing his canvases in his studio. As with other such projects, he worked on several canvases simultaneously, moving from one to another as the conditions and time of day changed. In early February 1891 he invited Durand-Ruel to come to Giverny to see the results of his latest efforts, an indication that he had brought the series to some kind of conclusion by that time. This campaign of 1890–91 produced at least twenty-five of the *Wheatstacks.*

The conception of series painting did not originate with Monet. Neither was he the first actually to produce series paintings. As early as 1869 Courbet, for instance, painted some thirty variations on the single pictorial motif of a crashing wave. In 1876, at the time when Monet was just venturing to do series paintings, Morisot exhibited five works all deriving their motif from a harbor locale on the Isle of Wight; her works can perhaps be considered the first exhibited series of Impressionist landscapes.[28] Monet's initial ventures into series painting were to produce only three or four paintings with similar motifs, though by 1882 he had engaged the conception to such an extent that he produced fourteen paintings taking their motif from the scene of an abandoned Napoleonic coast guard's post overlooking the English Channel at Petit Ailly (W 730–743). By the time of his Belle Isle campaign, he not only was producing something like series paintings but also seems to have come to a firm grasp of the conception itself. Thus, writing to Alice Hoschedé on 30 October 1886, he explained: "I know very well that really [*vraiment*] to paint the sea, one must observe it every day, at every hour, and from the same place."[29] At Petit's Monet-Rodin exhibition in 1889, fourteen paintings from Monet's Creuse Valley campaign were shown; all have very similar motifs, and they constitute most decidedly a series. If they did not

28. See Stuckey, *Claude Monet: 1840–1926,* 194, 201.
29. Letter 730.

yet quite measure up fully to the conception of series painting, the fault lay primarily, if not exclusively, in the way they were exhibited: though hung together, they were placed in a large room along with many other works, whereas at Durand-Ruel's exhibition in 1891, the *Wheatstacks* were hung together in a small room and thus allowed to have their full impact as a series.[30] To this extent one may say that it was with the exhibition of the *Wheatstack* series in 1891 that the full conception of series painting was first perfectly actualized.

Compositionally the *Wheatstacks* are very simple. In the foreground they picture one or two wheatstacks set on a field. Beyond the field stretches an irregular line of trees, houses, and barns, which are silhouetted against the hills in the distance. The scene is closed off at the top by a strip of sky. Thus, the paintings are composed basically of three horizontal bands: the field, which takes up the lower half of the canvas; the hills with the trees and buildings silhouetted against them; and the sky. Each of the upper bands is approximately half the width of the band formed by the field.[31]

The horizontal bands are interrupted by the verticality of the wheatstacks, though in several of the paintings the apex does not reach into the top band. In the series proper there are fourteen canvases that show two wheatstacks, one somewhat larger than the other. They are identifiable as the same stacks throughout the series; though one may presume that Monet executed all the paintings in view of the same two stacks, the sameness of motif can be marked without engaging the move-

30. "In 1888 he had shown ten views of Antibes at Boussod et Valadon, and in 1889 fourteen Creuse paintings were hung together at the Monet-Rodin exhibition, but in a large space and in the context of many works. The *Haystacks* were hung together in a small room, and the viewers were dazzled. Although there were seven other pictures in Monet's 1891 show, the *Haystacks* were spoken of as a series with its own integrity by Monet, Geffroy, Byvanck, and others. It is clear these paintings were meant to be experienced as a group" (Moffett, "Monet's Haystacks," 142–43).

31. There are two paintings in the series that have somewhat different compositions because of the unusual angle from which the wheatstacks are painted (W 1272, 1273).

ment from inside to outside the paintings. In the paintings there is considerable variation in the spatial relation between the two stacks, presumably as a result of Monet's varying the location of his easel: in several of the paintings the two stacks are side by side, the smaller stack to the left of and slightly behind the larger one; but then, at least if one follows a certain group of the paintings through a certain order, it is as if the smaller wheatstack moved around behind the larger one, reappearing finally on the right side; correlatively, it is as though—and, presumably, because in fact—Monet had moved his easel around in front of the larger stack, circling from left to right.[32] When they are regarded together, even if only in formal, compositional terms, a certain movement can come to replace the sheer spatiality, the massive immobility, that the wheatstacks have within any single painting in the series. Almost as if to underline their spatiality, their capacity to persist unchanged through the days and even throughout entire seasons.

There is also variation in the distance between the two wheatstacks, presumably—venturing the move from inside to outside as a presumption—corresponding to variations in the distance at which Monet set up his easel. Along with these variations, there are considerable differences between the ways in which the wheatstacks are placed on the various canvases; on some a considerable portion of one stack or the other is cut off by the edge of the canvas.

The other eleven paintings in the series proper picture only one wheatstack, identifiably the same as the larger stack in the paintings showing two. In the single-stack paintings too there is considerable variation in the angle and the distance from which they are painted. In three of these paintings the wheatstack is so close that it occupies as much

32. The two wheatstacks are more or less side by side in W 1266, 1267, 1268, 1270, 1274, 1275, and 1276. The relevant ordering would run then from these to W 1277, 1278, in which the smaller stack appears still to the left of, but partly obscured by, the large stack; to W 1272, 1273, in which the smaller stack has just emerged on the right side of the larger one; to W 1279, in which it is almost fully visible to the right of the larger stack.

as a third of the entire canvas; in all three it is cut off by the edge of the canvas, concealing its right side in two of the paintings, losing its apex in another. Running through a certain course, it is as if the single wheatstack approached from out of the distance, finally swerving either upward or to the right as it came very close.[33] Again, seeing the *Wheatstacks* together can make the wheatstack shed its massive immobility, can set it in motion. Almost as if to underline its massive immobility and to prepare the contrast with the ever-changing light that the paintings let spread over the wheatstacks.

In the smaller group from 1889 there are fewer of these kinds of variations, though of the five paintings placed in this group by Wildenstein three display two wheatstacks, the other two showing a single wheatstack set in front of a much nearer line of trees, reminiscent of the setting of the *Haystacks* of 1884–85.

In the *Wheatstacks* there are no human figures. The stacks stand alone in the field, complete in themselves, without any trace of the human form of those who have built them and who will make use of them. And yet, the field with its wheatstack(s) is linked to the houses and barns shown in the distance. The slopes of the conical tops of the stacks are always parallel to the ridges of the distant roofs; in many cases the stacks partially obstruct the view of certain buildings, touching them, as it were, on the surface of the painting, while in others they are linked to them compositionally by a band of trees.[34] These compositional relations cannot but evoke others: the wheatstacks have been built by the people whose houses and barns are shown at the edge of the field, and they promise

33. In this case the course would proceed from W 1286 to a group in which the wheatstack appears at about the same distance (W 1280–1284, 1287), then to W 1285, finally to the three paintings in which the stack appears quite close and is cut off either at the right (W 1289, 1290) or above (W 1288).

34. These relations are especially clear in Monet's preparatory sketches for the *Wheatstacks.* Tucker reproduces two of these in *Monet in the '90s,* 94 (fig. 39–40). At least nine such sketches are reproduced in Wildenstein, *Claude Monet,* 5:89-91 (Sketches 178, 179, 188, 189, 191–195).

sustenance in the months to come. In their massive presence they gather the days of planting, tilling, and harvesting by which those who cultivate the field provide for the time to come in the annual cycle. Gathering what has passed of the year, their immobile shapes encompassing what has been brought forth in preparation for the days that the year holds still in store, the wheatstacks make visible the fertility of the land; they bestow visibility upon the fecundity of the earth.

▼ ● ◆

But what is painted in the *Wheatstacks?*

In one of his final retrospections, Monet writes: "I have always had such a horror of theories that I have only the merit of having painted directly before nature in my search to render my impressions [*à rendre mes impressions*] before the most fugitive effects."[35] Setting theories aside, painting directly before nature, Monet would paint his impressions of—his impressions before—nature's most fleeting effects.

Thus, Monet—along with several of his associates, including Renoir, Morisot, Pissarro, Sisley—is called an Impressionist. It is well known that this designation originated at the time of the first independent exhibition organized by Monet and associates (the "Société anonyme des artistes peintres, sculpteurs, graveurs, etc.") in 1874. Among the paintings exhibited by Monet was one entitled *Impression: Sunrise* (W 263). It was the journalist Louis Leroy who facetiously adopted the term as the title of his critical review ("Exhibition of the Impressionists") in which he excoriated works such as *Impression: Sunrise* as somewhat inferior to wallpaper.[36] Despite its origin, the designation had a certain appropriateness, and by the time of their third exhibition, in 1877, the artists had come to refer to themselves as Impressionists.[37] By the time of the fifth exhibition, in 1880,

35. Cited in Moffett, "Monet's Haystacks," 148.
36. Wildenstein, *Claude Monet,* 1:70.
37. Stuckey, *Claude Monet: 1840–1926,* 202.

Monet reportedly came to insist on the designation: to an interviewer he is supposed to have said— perhaps in hopes of compensating a bit for not participating in the exhibition, submitting paintings, instead, to the Salon jury—that he "is always and wants always to be an Impressionist."[38] Yet the very currency that this designation gained and still retains, even today, should perhaps serve as a warning that what it once could say, what Monet himself would have said in this word, may have been obscured precisely by the apparent obviousness that the word now has, especially as the name of an artistic movement, as *Impressionism.*

Dispensing with theories, Monet's painting would render his impressions before nature's most fleeting effects. The painter's view would stop at the surface of nature; it would adhere to that surface, rendering it in the painting. The painting would not be prescribed by theory, as though applying certain principles or rules could come to replace the enigmatic circulation that the painter must undergo between the inside and the outside of his painting. Neither would painting's rendition of the surface be such as to invite that second vision, the vision of θεωρία, that would be cast behind the surface in order to discover what is painted, what is finally presented in the image. There is nothing beyond the painting, no meaning to be conveyed somehow by its contours and shades or by the rendering of surface that they effect on the surface of the painting. There is no original sense that would be imaged in the sensible work, making sense palpable to sense. In Monet's painting there is no such classical doubling of sense, no opening of meaning behind the sensible image. Not even an opening that the work would itself effect, as the play of a signifier can open a field of meaning that will not have preceded it, that it will not merely have translated. In Monet's painting there is not, then, even such doubling as that definitive of language.

Beyond the painting there is nothing. The fact that the paintings render the surface of particular, actual, natural objects serves to underline that they are not such as to open, behind the rendered surface, a domain

38. Cited in ibid., 206.

of universality, of meaning, at least none that would go much further than that correlative to the mere identification of the objects as wheatstacks. Beyond the universality of the name there is nothing more, which is to say that it is a universality in service to, drawn back to, the particular. The same may be said of the descriptive titles borne by many of the *Wheatstacks:* rather than opening a second vision beyond the painting, they serve precisely to draw one's vision back to its surface, to that surface of nature rendered, for example, by the painting bearing the descriptive title *Effect of Hoar-Frost* (W 1277) (plate 8). Indeed, it is this fugitive effect, and not simply the massively immobile wheatstack as such, that Monet would render in the painting.

Monet's is an impressionism, then, in which things would be rendered in their fleeting sensible presence, leaving the concept aside and submitting the object as such to the conditions of its palpability to sense. It is a painting that, to this extent, produces purely beautiful works, in a sense of beauty akin to (though less formal than) that delimited most rigorously in the first part of the *Critique of Judgment.*

In such impressionism things are to be rendered as they show themselves rather than as sensible images that would present a meaning transcending the sensible presentation. Thus it is that such impressionism carries out *in the work of art* the same inversion that thought—a thought that can perhaps no longer simply be called philosophy—has had to address since Nietzsche: the inversion of the hierarchical opposition that has always subordinated the sensible to the intelligible. Not only does such impressionism carry out the inversion, but also it broaches the other moment of the double move required at the limit of metaphysics: by remaining at the surface, inhibiting the passage to meaning, such painting begins the work of twisting the sensible free of the intelligible, the work of twisting free from the very schema of opposition that has governed Western thought as well as the Western interpretation of art, if not always art itself. Such painting, Monet's impressionism, begins the work *in the work,* quite aside from all theories, all philosophy—even if the year in which Monet began the *Wheatstack* series was also the very year in which

Nietzsche composed *The Twilight of the Idols,* the text in which he has been regarded as having most decisively thought the double move of inverting and twisting free.[39]

There is nothing beyond the painting, nothing behind its surface. There is only the surface and at the surface a rendering of the sensible presence of things, of their self-showing. Beyond the painting, behind the surface, there is no depth of meaning but only the depth of the sensible, its palpable thickness. Here one might think, first of all, of the depth that Merleau-Ponty finds in Cézanne's painting, the depth that Cézanne is said to have sought all his life. It is not simply the depth of perspectivism but rather an exteriority consisting in the envelopment and mutual dependence of things, in the enigma "that I see things, each one in its place, precisely because they eclipse one another, and that they are rivals before my sight precisely because each one is in its own place." Depth thus understood is, Merleau-Ponty continues, the experience "of a global 'locality' where everything is at the same time, a locality from which height, width, and depth are abstracted, of a voluminosity that one expresses in a word by saying that a thing is there."[40] It is a matter, then, of a depth that belongs to the sensible order rather than translating a dimension of a conceptually determined objective space, a dimension that, from within the sensible, could be only simulated and not truly represented. It is a matter of a spacing within the sensible, a spacing proper to the sensible. This is the depth that Cézanne may be said to have sought, the depth that Merleau-Ponty could find in his painting.

But the depth of Monet's painting—if just as elusive—is something different. In the *Wheatstacks* what is painted is not voluminosity, though it

39. I refer to the section of *Twilight of the Idols* entitled "How the 'True World' Finally Became a Fable" (Nietzsche, *Werke: Kritische Gesamtausgabe,* ed. Giorgio Colli and Mazzino Montinari [Berlin: Walter de Gruyter, 1969], VI.3:74-75), especially as interpreted by Heidegger (*Nietzsche* [Pfullingen: Günther Neske, 1961], 1:231–54). I have discussed this section of Nietzsche's text in *Delimitations: Phenomenology and the End of Metaphysics,* 2nd ed. (Bloomington: Indiana University Press, 1995), chap. 13.

40. Maurice Merleau-Ponty, *L'Oeil et l'Esprit* (Paris: Gallimard, 1964), 64-65.

belongs no less to the sensible order than does this depth sought by Cézanne. It is a different sort of doubling that Monet paints at the surface of his canvases, one that leads his painting in a direction quite different from that of Cézanne and of Cubism.

What, then, is the depth that Monet paints in the *Wheatstacks*? What is the doubling that occurs at the surface of these paintings? How is that surface exceeded? What is the excess (if indeed it is a *what*)? And what comes to be shown by way of the doubling and the excess? What is painted in the *Wheatstacks*?

In the catalogue for the 1891 exhibition, Geffroy described the wheatstacks in the paintings as being like mirrors and fulcrums. They are, he says, transitory objects on which are reflected, as in a mirror, the sudden bursts of light, the last rays of sunlight, the surrounding mist, the fallen snow; they serve as a fulcrum for light and shadow, sun and shade circling about them.[41]

During the 1891 exhibition Monet was interviewed by the Dutch author Willem Byvanck. According to Byvanck's report, Monet called his attention to the two portraits of a woman that were shown along with the *Wheatstacks.* Monet noted that it was the same woman in both paintings, "but painted under different atmospheric conditions [*au milieu d'une atmosphère differente*]." Monet continued: "I could have done fifteen portraits of her, as I did of the stacks." Then he concluded: "For me it is only the surroundings [*les alentours*] which give true value to the subjects."[42]

One may say, then, that in the paintings the wheatstacks gather and concentrate the surroundings, granting a place where the surroundings can come to be mirrored, a site around which the surrounding light and shade can circle. Thus it is that the surroundings give the subjects their true value. Yet, it is clear that by surroundings Monet does not understand primarily the other objects that occupy the landscape along with the

41. Cited in Tucker, *Monet in the '90s,* 100. See also Geffroy, *Claude Monet,* 316.
42. Cited in Moffett, "Monet's Haystacks," 145.

wheatstack(s); neither does he mean the landscape as a whole. Indeed, if one sets out to render the truth in painting, to paint with exactitude directly before nature, then one must admit that there is no such thing as a landscape. This, at least, is what Monet reportedly told Byvanck: "Here is what I proposed: above all I wanted to be true and exact. A landscape, for me, does not exist *qua* landscape, since its appearance changes every moment; but it lives through its surroundings [*par ses alentours*], through air and light, which varies continuously."[43] The surroundings that Monet would paint as they are gathered and concentrated by the wheatstacks are not other objects alongside the wheatstacks but rather the surrounding air and light, the enveloping atmosphere in which every thing belonging to the instantaneous landscape would show itself.

This orientation is confirmed by the well-known letter that Monet wrote to Geffroy on 7 October 1890, just after he had begun painting the *Wheatstacks:*

> I am working hard. I am persisting with a series of different effects (of wheatstacks), but at this time of year the sun goes down so quickly that I cannot keep up with it. . . . I am becoming such a slow worker that it makes me desperate, but the further I go the more clearly I see that I must work hard in order to succeed in rendering what I seek: "instantaneity," above all the envelope [*l'enveloppe*], the same light spread over everything, and more than ever I am disgusted by things that come easily at first try. Finally, I am more and more enraged by the need to render what I feel. . . .[44]

What he seeks above all is the *envelope.* The word was common among artists of the time. In an article on Monet written in 1889, Le Roux explains: "In the freedom of the open air, color changes according to the light and its relation to the environment [*voisinage*]. This is what, in the jargon of the studio, is called the atmosphere, the envelope."[45] The

43. Cited in ibid., 149.
44. Letter 1076.
45. Cited in Seiberling, *Monet's Series,* 92.

envelope is—in the words of Monet's letter—the same light spread over everything, spread everywhere. Or rather, since Monet also seeks instantaneity, it is the spread of light as it appears in the moment, the instantaneous appearance of the spread of light over everything. And yet, light that appears, light whose very spread over everything visible becomes itself visible, is no longer simply light but also an envelope of air: the mist, for example, by which the light is so diffused that hardly anything in the distance remains visible; or the crisp, transparent air of a clear winter day that lets the light shine brilliantly on the side of a wheatstack. The envelope is neither simply light nor merely the surrounding air, the atmosphere; rather, it is the spread of light throughout an atmosphere, the shining that governs the visible presence of the things that are enveloped by the atmosphere suffused with light.

In Monet's letters and in interviews he often mentions the envelope. For instance, in 1888 he writes to Alice Hoschedé from Antibes: "What I will bring back from here will be sweetness itself, white, pink, blue, all of it enveloped in this fairytale-like air."[46] In conjunction with an exhibition in Montmartre in 1889, which may have included one of the first *Wheatstacks,* a long interview with Monet was published in *Gil Blas,* in which the painter again draws attention to the importance of the envelope: impressionism involves, above all, the painting of the envelope, of the vibration of the light that palpitates around objects.[47] In 1895, while Monet was in Norway, an article about him appeared in the Oslo newspaper *Dagbladet,* in which he is reported to have said in an interview: "The motif is something secondary for me; what I want to reproduce is what there is between the motif and me [*ce qu'il y a entre le motif et moi*]."[48]

In the *Wheatstacks* the spread of light, the shining, may be gathered and concentrated by the wheatstack's reflecting the light, returning it, not so as to make some thing doubly visible, but so as to render visible the

46. Letter 827.
47. Stuckey, *Claude Monet: 1840–1926,* 217; also Wildenstein, *Claude Monet,* 3:14.
48. Wildenstein, *Claude Monet,* 3:65.

light itself. Thus in W 1271 (plate 1), which in the Chicago exhibition bore the descriptive title *Midday* (in W: *Meules au Soleil, Milieu du Jour*), one sees the light of the noonday sun glistening along the edges of the wheatstacks; thus the stacks come to mirror the light itself, to make visible that which itself makes everything visible; or rather, they come to mirror the light as its shine is spread from above over the wheatstacks and the field, enveloping them with a brightness that makes them scintillate.

But the envelope is never just sheer light, as one is reminded by the shadows that the wheatstacks cast even at midday. Thus Geffroy could say not only that the wheatstacks are like mirrors but also that they serve as a fulcrum for light and shadow, sun and shade. This is what the wheatstacks become most manifestly in W 1269 (plate 2), which in the Chicago exhibition bore the title *End of Summer* (in W: *Fin de L'Été, Effet du Soir*) and which was among the *Wheatstacks* shown at the Durand-Ruel exhibition in 1891. In the painting the time of day is, it seems, very late afternoon, for the shadows cast by the wheatstacks (and grouped with those cast by the trees beyond them) are so long that they extend to the edge of the canvas. The result is a series of bands consisting alternately of light and of shadow and stretching diagonally across the field, interrupting the horizontal composition: an adumbration of the wheatstacks' interrupting of light.

The wheatstack in W 1280 (plate 3) is both mirror and fulcrum. This painting too was shown in both exhibitions; in Chicago it was called *Snow Effect* (in W: *Effet de Neige, Le Matin*). In the painting the single wheatstack is located on the left side of the canvas; interrupting the sunlight streaming onto the scene from the left, it casts across the field a shadow that extends almost to the lower right-hand corner of the canvas. On the left side of the wheatstack, along the side of its conical upper part, the morning sunshine glistens: one sees the shining of the morning light on the wheatstack.

In one of the last and most remarkable paintings in the series, one seen in both exhibitions and bearing, at least in Chicago, the single title *Sunset* (W 1289: *Meule, Soleil Couchant*) (plate 4), the wheatstack has

become so large that it fills most of the right half of the canvas. Its right side is cut off by the edge of the canvas; that is, the wheatstack and the entirety of the long shadow that it casts extend beyond the canvas, thus installing at the right-hand border a region of invisibility. Again it is a matter of shading, of a fulcrum not only for light and shadow but also now for visibility and invisibility; for in contrast to the invisibility along the right-hand border of the painting, there is an intense visibility of light along the entire visible edge of the huge wheatstack. At this edge the fading sunshine is so intensely visible that its shimmer broadens and blurs the line that otherwise would simply enclose the wheatstack and mark it off from the background. Furthermore, it is as if this intense shimmering along the edge of the wheatstack were communicated across the entire scene, spread over everything, spreading over everything a shimmering of pinks, oranges, and yellows that has the effect of making the light and the atmosphere more visible than the things themselves that are enclosed by the atmosphere and otherwise made visible by the light. Now the spread of light across the scene is more visible than the hills and habitations in the background. Even the field on which the wheatstack is set is dissolved into shimmering color, and one sees almost no things at all, only a trace of their visibility remaining as if to mark their dissolution into the shimmering. What one sees is the instantaneous envelope, the spread of light over all things, the shining that makes things visible but that now, becoming itself visible in the painting, lets only a trace of those things still be seen.

Another very remarkable *Wheatstack,* shown in both exhibitions and entitled *Sunset, Snow Effect* (W 1278) (plate 5), presents two wheatstacks, the smaller one behind and to the left of the larger, a portion of its right side hidden behind the larger stack. Here even more than in the painting of the giant wheatstack at sunset (W 1289), everything is dissolved into shining. Except for the two wheatstacks around which the shining is gathered, virtually every thing has disappeared into a spread of fading light rendered pinkish-blue by the snow that covers everything. It is as if there were a complicity between snow and light: they cover everything, spreading their envelope almost as if it were a pinkish-blue cloud, as it

appears to become in the upper left corner of the canvas, contrasting there with the larger segment of sky that is dissolved into shining orange and red. In the painting shining is visible everywhere, while its very visibility renders virtually invisible all the things over which its light is spread.

Another *Wheatstack,* shown in both exhibitions and entitled, at least in Chicago, *Snow Effect, Overcast Day* (W 1281: *Effet de Neige, Temps Couvert*) (plate 6), reverses the order painted in the two *Wheatstacks* at sunset. Now the intense, even though fading, light is lacking, replaced by the dull light of an overcast day. Now one sees what is rarely visible in the *Wheatstacks:* a pale sun barely shining through the clouds, shining dully, or rather, not really shining, not casting any rays of sunshine through the clouds. Now, too, one sees with considerable distinctness the things in the distance, the trees, the houses and barns, the hills beyond them. Another winter *Wheatstack*—shown at the Chicago exhibition (W 1283, no descriptive title) (plate 7)—carries this reversal even further. Still it is overcast, but now the sun has set and evening is approaching. And now, as the spread of light over everything is withdrawn, as the shimmering colors have faded away leaving on the snowy field and the wheatstack only a few bright traces to interrupt the monotonous grays and browns, the things in the distance become, it seems, even more distinctly visible. The less light there is, the more distinctly things appear.

In the *Wheatstacks* it is not, then, simply a matter of rendering things as they show themselves in the moment. What is painted is rather the spread of light over all things, that is, the shining itself, that which ordinarily lets things be visible while itself remaining largely unseen. Monet paints the shining, lends it a visibility, lets it now be seen. Yet it is seen in a certain relation to the visible things over which it is spread, the things that ordinarily gain their sensible presence precisely through such shining but that now—at the moment when Monet paints the shining itself, as the cost of rendering the shining itself visible—cannot but disappear behind that shining. The doubling that occurs at the surface of these paintings is thus such as to add to the sensibly present that shining by which things become palpable to sense; and that addition occurs, not by the installation

of a dimension of shining, a depth, *behind* the sensibly present things, but rather by Monet's painting the shining over these things, by his reversing in the painting the ordinary relation in which one sees the things without seeing the shining that lets one see them. This reversal is only confirmed by the other reversal that was noted in the transition to those *Wheatstacks* in which the shining is withdrawn and the things in the distance are allowed again to become distinctly visible.

At least granted that the *Wheatstacks* are to be seen together—of which (even aside from the impression that they make when actually seen together) there can be little doubt. For when interviewed by Byvanck during the 1891 exhibition, Monet stressed the relation of each painting to the series as a whole. One of the *Wheatstacks,* he tells Byvanck, is successful to a degree that may allow it to stand alone (probably W 1289, which presents the huge wheatstack at sunset—or, more precisely, the wheatstack that appears huge because of its proximity):[49] "Look at that picture, in the middle of the others, which immediately attracted your attention; that one is perfectly successful—perhaps because there the landscape gave everything that it was capable of giving." Monet contin- ues: "And the others?—There are some that are truly not bad; but they acquire all their value only by comparison with and in the succession of the entire series."[50] Unfortunately, there is insufficient evidence to determine the exact order and arrangement in which the series and the other paint- ings exhibited with it were hung by Monet at the Durand-Ruel exhibition, though it seems unlikely that the *Wheatstacks* were hung as a simple cycle from summer to winter (as listed in the catalogue);[51] the seriality is more complex, or at least more uncertain, than, for example, that of the 1896– 97 series *Mornings on the Seine,* which proceeds simply from a scene in

49. Moffett, "Monet's Haystacks," 158 n. 38. But apparently, as Moffett observes, even this painting is necessary to the group, granted Byvanck's remark: "This picture taught me to see the others; it invigorated the others with life and truth."

50. Cited in ibid., 151.

51. House, *Monet,* 215.

predawn light through its appearance at various successively later times of the morning. Even though one can be assured that the *Wheatstacks* are to be seen together, one remains less certain how they are to be seen together; and any serial ordering or grouping of the individual paintings remains provisional and precarious.

How one groups and orders them will determine, then, how one interprets the transitions and reversals between the individual paintings and how in each case seeing the *Wheatstacks* within the series (or within a portion of the series) is made to supplement its interpretation. But whatever supplement may thus be brought to bear on the interpretation of the individual *Wheatstacks,* it will serve only to supplement what can be said of that doubling that Monet accomplishes by painting the shining over the sensibly present things, by painting the *shining of the sensible.* In the paintings this shining is made to double the visible, is rendered itself visible, precisely in being gathered around the wheatstacks. What is painted in the *Wheatstacks* is a gathering of the shining of the sensible. One could call it, in a very ancient sense, a λόγος of visibility. But in this sense λόγος is anterior to the classical doubling of sense that produced such determinations as meaning and intelligibility. The fact that such classical production was accompanied by a demand for the expulsion of painters is perhaps indicative of the force with which painting can resist the classical doubling, opposing to it a doubling of sense within sense. In an opposition of work to theory.

▼ ● ◆

There is also something else gathered around the wheatstacks in these paintings, another depth, a compounding of their doubling. It is not something other than the shining of the sensible, certainly no depth of meaning behind that surface. Monet himself names it in the passage cited above from the well-known letter to Geffroy. He calls it *instantaneity.*

What Monet says with this word animates and orients much of his painting from early on: the painter would render scenes or effects that are

so fleeting, so ephemeral and contingent upon the immediate occasion, that they can be caught only in an instantaneous glance.[52] Among all the paintings to which this sense of instantaneity is especially pertinent, perhaps none exemplify it more beautifully than one from the late 1860s or early 1870s[53] entitled *The Red Kerchief: Portrait of Camille Monet* (W 257) (figure 4). In this painting the multiple, complex framing of the window through which Camille Monet is seen accentuates her location outside the immediate space of the painting; her being set outside this space duplicates inside the painting, at its focal point, the very elusiveness of such fleeting occasions (outside painting), which the painter must try to capture in his glance so as to render them in painting. The occasion depicted is indeed a momentary one: walking past the window, Camille, for just an instant, turns her head toward it and casts a momentary glance through the window. One senses that just a moment later she will have turned her glance away and hurried on past the window, out of sight, her passing glance having been as momentary as any particular configuration of the falling snowflakes. But in this instantaneous glance she reflects back to the painter, from within the painting, precisely the instantaneous glance that he would have to exercise in order to catch and so to render such an affair of the moment.

In the *Wheatstacks* it is a matter of the instantaneity of the envelope, a matter of the *time* that belongs always to the shining of the sensible.

52. In this respect Monet is a painter of modern life, in the terms elaborated in Baudelaire's celebrated essay of 1863 in praise of the illustrator Constantin Guys. For Baudelaire modernity is that which is ephemeral, fugitive, contingent upon the occasion: "This ephemeral and fugitive element, subject to such frequent metamorphoses, you do not have the right to despise or ignore. By disregarding it, you necessarily fall into the void of an abstract and indefinable beauty, such as that one woman must have had who lived before the first sin was committed." To the painter of modern life Baudelaire assigns the task of distilling from the ephemeral and fugitive element "the mysterious beauty involuntarily lent to it by human life" ("Le Peintre de la Vie Moderne," in *Oeuvres complètes* [Paris: Gallimard, 1961], 1163f.).

53. Stuckey dates it: "probably late 1860s–early 1870s" (*Claude Monet: 1840–1926,* 48). Wildenstein includes it with the paintings from 1873.

Figure 4. **Claude Monet**, *The Red Kerchief: Portrait of Camille Monet* (W 257), circa 1873. 100 x 80 cm. © The Cleveland Museum of Art, 1997 (Bequest of Leonard C. Hanna, Jr., 1958.39).

According to a much later report, Monet referred the idea of the *Wheatstack* series back to an experience that he had had several years earlier while doing a painting of the church at Vernon with the sun breaking through the mist: "I felt that it would not be trivial to study a single motif at different hours of the day and to note the effects of light that from one hour to the next modified so noticeably the appearance and the coloring of the building."[54] In the *Wheatstacks* it becomes, then, a matter of painting the envelope of light at different hours of the day, of painting the different envelopes of light that spread over things at different times.

In a sense the envelope is determined by the time, not only by the time of day but also by the time of year, the season; these are the times that are designated by the descriptive titles, in some cases one or the other time, in other cases both. For example, in the *Wheatstack* that in the Chicago exhibition was entitled *Snow Effect, Sunlight* (W 1277—with the somewhat different title *Effet de Gelée Blanche* [Effect of Hoar-Frost]) (plate 8), nothing distinct can be seen in the distance. The trees, the houses and barns, the hills beyond them—all are enshrouded by the envelope of light spread over them, by the light of the winter day, the light of midday, as the relatively short shadows of the two wheatstacks show. These shadows—functioning as a sundial, adumbrating within the painting the very time determining it—are even shorter in another, somewhat similar *Wheatstack* entitled simply *Winter Effect* (W 1279: *Effet d'Hiver*) (plate 9). Here nothing is visible in the distance, not even the vaguest contours of the trees, buildings, and hills, but only the scintillating envelope of the light of winter and of midday. It is time—the time of day and the time of the year—that determines the envelope, that governs the shining. Because what is painted in these two *Wheatstacks* is the shining of the sensible in

54. Cited in Tucker, *Monet in the '90s*, 77. Tucker notes that this account is not without inaccuracies, that, for example, it was in fact the church at Vétheuil, not the one at Vernon, that Monet painted with the sun coming through the mist. In fact, Monet did paint such pictures of the church at Vernon, but only later (e.g., W 1390: *Church at Vernon, Fog*, 1894). Presumably the painting Monet had in mind was W 518: *Vétheuil in the Fog*, 1879.

winter at midday, it is such as to enshroud all things in its very visibility.

Much the same may be said of the two great *Wheatstacks* at sunset discussed above (W 1289, 1278) (plates 4, 5). It is the time of day that determines the envelope of light to spread over things—in the first of these paintings—as a shimmering of pinks, oranges, and yellows, dissolving the field into a shining through which one can still only barely discern the habitations in the distance. The dissolution into shining goes even further and the envelope of spreading light begins to resemble a pinkish-blue sea when its time is not only sunset but also winter, as in the second of the paintings.

Likewise in another of the *Wheatstacks* shown in the Chicago exhibition, one that has no descriptive title but almost certainly belongs to dusk (W 1285) (plate 10). Everything in the distance is reduced to a uniform blue, and the wheatstack is now barely distinguishable from the field in which it is set. What remains at this time of day is little more than just three horizontal bands of color (corresponding to the sky, the hills, and the field), with the lower band, extended in the conical form of the wheatstack, jutting up into the other two bands. Dusk almost reduces the scene to its formal, compositional elements, though determining also the shades that are blended into that form.

Not only is the shining of the sensible determined by the time, but also that shining, as it is gathered around the wheatstacks, makes the time visible, insofar as time can be lent a visibility, this pure form of inner sense (as Kant would have it) contaminated by the shining of the sensible. It is not only a matter of the sundial effect of the shadows cast by the wheatstacks, but also of the kind of effect that one finds, for example, in one of the *Wheatstacks* exhibited in Chicago with the title *Thaw, Sunset* (W 1284) (plate 11): though most of the trees near the habitations are still bare, both the melting snow and especially the distinctively green hue of the hills beyond portend spring. Here Monet paints the coming spring-time, makes it visible in the shining of the sensible. Just as the wheatstacks themselves, visibly linked to the houses of those who have built them, gather the times of planting, tilling, and harvesting by which those

inhabitants of the land have provided for the seasons to come.

What is painted in the *Wheatstacks*? In each a time is painted, a time of day as determined by sun and shadows, a time of year as shown by the color of the foliage, by the presence of frost or of newly fallen snow, by the thaw and the distant promise of green. When one sees the *Wheatstacks* together, one sees various times made visible, times that determine the very shining of the sensible in which those times too are lent a certain visibility. One may even say that when one sees the *Wheatstacks* together, one sees, beyond the individual paintings, time as such, time itself made visible, or rather, gathered from the times that the paintings make visible. It is a time to be distinguished from the abstract now-time that science has inherited from the history of metaphysics. And it is to be distinguished from inner time, from the time of the flow of consciousness, from the time that Kant first put forth as the form of inner sense. It is to be distinguished even from the originary time, the temporality, that Heidegger sought to recover behind both the objectified time of modern science and subjectivized, inner time. For originary time, if there were such, would be a time not yet contaminated by the self-showing of things,[55] a time before any shining of the sensible, a time in which the sun would not yet have shone. Not, then, the time of Monet's painting, not that time of the shining of the sensible that is painted in the *Wheatstacks*.

The time painted in the *Wheatstacks* is the time of earth and sky, times when the earth is covered with snow, times when the sun stands high in the sky, times when the trees, reaching from earth upward into the air, put forth their leaves. It is the time of the elements. It is a time insepa-rable from space, that very inseparability being announced in the massive spatiality of the very wheatstacks around which the temporal shining comes to be gathered. Above all, it is a time inseparable from that shining of the sensible.

In the *Wheatstacks* Monet paints this elemental time of the sensible.

55. I have discussed this issue in *Echoes: After Heidegger* (Bloomington: Indiana University Press, 1990), chap. 2.

He renders time visible—resisting, opposing, in and through his work, the modern philosophical theory that assigns time to an order anterior to visibility. Time is what is most fugitive, so much so that one cannot say or point to the moment without finding that it has already fled. And yet, time is always returning so that ever again it is now. Ever fleeting and ever returning—like a ghost, a shade. Not, then, so remote from painting as one might have thought: for in painting there are only shades.

In these shades of time, the *Wheatstacks,* Monet accomplishes *in the work*—and aside from all theories, all philosophy—what thought has been compelled to undertake ever since Nietzsche: a new interpretation of the sensible, one capable of preserving and extending the twisting-free of the sensible from the intelligible, the twisting-free from the very schema that would oppose to the sensible surface an intelligible depth. Except that in the case of Monet's painting, one can perhaps no longer refer even to interpretation, since it is not a matter of meaning at all, not even of meaning in the painting. For what Monet paints in the *Wheatstacks* is the time of the sensible, of a sensible whose only depth lies in its shining and in the elemental time of that shining.

TWO Thresholds of Abstract Painting
Kandinsky and the Stage of Composition

Kandinsky's *Yellow Sound* (Der Gelbe Klang) appeared in 1912 in the first (and only) volume of *Der Blaue Reiter,* which Kandinsky coedited with Franz Marc. Though never performed during the author's lifetime, it was written to be performed, its text including numerous indications concerning the precise manner of execution, even marking, for instance, one dancelike action as needing to "be rehearsed with extreme care."[1] To be sure, in such a text one could suppose that these indications and markings might be merely ways in which the text feigns a performative character that it does not—perhaps, because of certain features, could not—have. Except that a performance of it is known to have been scheduled in the autumn of 1914, though the outbreak of war forced cancellation. Nor was this the only scheduled production of the work (see *K* 231).

Still, one hardly knows what to call it or how to align it with respect to the performing arts. It has elements certainly of drama, opera, dance, and yet it is not simply any one of these, nor even all taken somehow together. Kandinsky called it a stage composition (*eine Bühnenkomposition*), including this designation with the title itself: *Yellow Sound: A Stage Composition.* For Kandinsky there is no word more evocative than *composition.* In a text published the next year, Kandinsky recalls how as an art student in Munich he "was inwardly moved by the word *composition,*" which affected him, he says, "like a prayer," which filled him "with reverence" (*K* 367). By

1. Wassily Kandinsky, *Complete Writings on Art,* ed. Kenneth C. Lindsay and Peter Vergo (New York: Da Capo Press, 1994), 281. Subsequent references to Kandinsky's writings will be to this edition and will be indicated by *K,* followed by page numbers. The first volume of *Der Blaue Reiter* has been issued in a new edition: *Der Blaue Reiter,* ed. Wassily Kandinsky and Franz Marc, new edition by Klaus Lankheit (Munich: R. Piper & Co., 1965). My citations from the German of texts included in this volume are taken from this edition.

the time this text and *Yellow Sound* come to be written, *composition* has come to name the epoch, the new stage, to which Kandinsky takes painting to be under way; it names also those paintings by which Kandinsky would carry out his most extreme effort to transport painting across this threshold.

The title *Yellow Sound* signals that the work is a composition in the domain of at least two different arts. On the one hand, it is a musical composition; even though Kandinsky did not, in the usual sense, compose the music (a note attributes it to Thomas v. Hartmann), the text involves constant reference to the music that either is played by the orchestra or is sung by the chorus (or by certain voices of the chorus or by certain other people). But, on the other hand, it is also a painterly composition, indeed in a sense that could tempt one to say that it is above all a kind of painting, an extreme kind, painting at the limit. In the theoretical essay "On Stage Composition," published with *Yellow Sound,* Kandinsky enumerates the elements used in the work; to the designation of one of these elements, color-tones and their movement, he adds as a parenthesized comment: "a special resource of the stage" (*K* 264).

The work *Yellow Sound* consists of an Introduction followed by six Scenes (Kandinsky's word is *Bild,* which can equally well mean *picture*). The work begins as if with the very material of the two arts, not in determinate form but prior to differentiation and specification. Initially there are "some indeterminate chords from the orchestra" (*K* 269). Then, as the curtain rises, there is only dark-blue twilight becoming more intensely dark blue, not as showing the color of something, but—putting in force Kandinsky's own analysis of blue in his major theoretical text *On the Spiritual in Art*[2]—as

2. "The blue, however [the contrast is with yellow], develops a centripetal movement (like a snail disappearing into its shell), and withdraws from the spectator. The eye is stung by the first circle, while it immerses itself in the second. This effect is heightened if one adds the contrast between light and dark: . . . the effect of blue is intensified by increased darkness of tone (admixture of black)" (*K* 179). Considering that *Yellow Sound* invokes blue at its moment of commencement and concludes with a bright *yellow* giant, the opposition that

withdrawing from the spectator so as to open the space of the stage and let the eye become immersed in it, the more so as the dark blue retreats into ever darker shades. Then: "After a time, a small light becomes visible in the center, increasing in brightness as the color becomes deeper." Thus, once the eye is engaged, *light appears.* One could say: light *itself* is made visible, for there are neither persons nor objects on stage, nothing to be illuminated, no things that would put light in their service, compelling it to convey their colors and shapes. Not even the chorus, which is not just behind the stage but "so arranged that the source of the singing is unrecognizable." Now the chorus sings, first the deep voices, then the high voices; then all intone the words (written, in Kandinsky's text, with ellipses):

> Somber light on the . . . sunniest . . . day
>
> [Finsteres Licht bei dem . . . sonnigsten . . . Tag]

only to be "quickly and suddenly cut off," before then concluding (now without ellipses):

> Glaringly shining shade in darkest night!!
>
> [Grell leuchtender Schatten bei dunkelster Nacht!!]
>
> (*K* 270—translation altered)

In hearing these words, or rather, now, in imagining that one is hearing these words, one should bear in mind Kandinsky's remark, in the accompanying theoretical text, that in *Yellow Sound* words are used to create a certain *Stimmung* (one can say: mood—but only at the cost of losing the connection with *Stimme:* voice) and that here the "sound [*Stimme*] of the

Kandinsky posits between blue and yellow should not go unnoticed: "In the most general terms, the warmth or coldness of a color is due to its inclination toward yellow or toward blue" (*K* 179). Since it first appeared in December 1911 (dated 1912), Kandinsky's *Über das Geistige in der Kunst* has been reissued in a series of new editions. My citations of the German text are taken from the 10th edition (Bern: Benteli, n.d.).

Thresholds of Abstract Painting

human voice" is "used purely, i.e., without being obscured by words, by the sense [*Sinn*] of the words" (*K* 264). One would assume that where, as in the chorus's singing, the voice is made nonetheless to intone words, it escapes being obscured by their sense by virtue of a coincidence between that sense and the sense (in another sense) of the mood they are being used to create.

Then: "The light disappears. It grows suddenly dark" (*K* 270).

Kandinsky's text sometimes marks an accord between the musical composition and the painterly composition at work in *Yellow Sound*. Near the beginning of Scene 1, "the background becomes dark blue (in time with the music)" (*K* 271). Simultaneously with this peculiar composition of the compositions, the background also "assumes broad black edges (like a picture)." The stage is thus enframed; it becomes a canvas on which the painter will compose a picture. Five bright yellow giants appear on the now illuminated stage, "as if hovering directly above the ground," thus, as on the two-dimensional surface of a painting, appearing to stand on the ground without, on that surface, being at ground level. It is as if they were being painted on the framed canvas that the stage has become. Or rather, one might say that they *are indeed being painted* there, using that "special resource of the stage." Yet one cannot easily ascertain whether, even when they first appear, the giants belong exclusively to the painterly composition or whether, from the moment they appear, they belong also to the musical composition. For, just a little later, "the giants' very low singing, without words, becomes audible (*pp*)," as though they had perhaps been singing all along. As the giants "sing more and more softly . . ., they become more indistinct," fading simultaneously from both compositions.

As Scene 2 opens, the light becomes "a perfect brilliant white." A bright green hill, "completely round and as large as possible" (*K* 275), is, as it were, laid on this white canvas. Now the painting begins in earnest:

> At this moment the background suddenly turns a dirty brown. The hill becomes dirty green. And right in the middle of the hill forms an indefinite black patch, which appears now distinct, now blurred. At each change in

distinctness, the glaring white light becomes progressively grayer. On the left side of the hill a *big* yellow flower suddenly becomes visible. It bears a distant resemblance to a large, bent cucumber, and its color becomes more and more intense. Its stem is long and thin. Only one narrow, prickly leaf grows sideways out of the middle of the stem. (*K* 275—translation altered)

All along there is music too. And a little later many people come on stage in ugly monochromatic garments (blue, red, green, though no yellow). As they begin to "speak with various different voices" (*K* 276), one realizes that a third mode of composition has now commenced, the mode determined by the element that Kandinsky's theoretical text describes as "bodily spiritual sound and its movement, expressed by people and objects" (*K* 264).

In Scene 3 the painting becomes purer. The text describes two movements, both of them movements purely of light: "In quick succession, brightly colored rays fall from all sides (blue, red, violet, and green alternate several times). Then all these rays meet in the center, becoming intermingled" (*K* 278). After a moment of blackness, the second movement begins: "Then a dull yellow light floods the stage, which gradually becomes more intense, until the whole stage is a bright lemon yellow." It is as if the painter's brush had dissolved into pure rays of light casting their colors on the canvas. Pure rays of light, pure colors: "During these two movements, nothing but light is to be seen on the stage: no objects" (*K* 278). Now it seems that this pure painting remains undisturbed even by objects: when, as in Scene 5, people appear on stage—"clad in tights of different colors," their hair as well as their faces "covered with the corresponding color," so as to "resemble marionettes" (*K* 280)—they appear as little more than moving colored forms. Toward the end of Scene 5, "the passage of light" (*K* 282) is accentuated: "Various lights cross the stage and overlap," as if they were long, broad brushstrokes intersecting on the surface of a composition. As indeed they are, once the "special resource of the stage" is put in play in the interest of pure painting.

Kandinsky was convinced that such painting could lead to a renewal of spirit at large, as in the final Scene where the frame falls away (the Scene is "without black edges" [*K* 283]) and in place of the picture there is

now a giant (the word is *Riese,* though the word *Übermensch* is not entirely missing from Kandinsky's texts)[3] who "reaches the full height of the stage" and whose "figure resembles a cross" (*K* 283). Then, in the darkness that seals this final picture that would be no longer picture: "The music is expressive, resembling the action on stage."

One realizes that the work is, as it were, suspended between cold dark blue and warm bright yellow, this opposition[4] constituting the primary determinant of the "direction" of the work. For the giant—or *Übermensch*—is "a bright yellow giant."

▼ ● ◆

At the limit it is light itself that would be painted, light as it comes upon and over things. If, in addition, pure painting puts in play the special resource of the stage, then light itself can become also the means: there results a painting of light itself by light itself. Yet in the end the picture thus painted would be no longer picture; it would be transposed into something other, into spirit itself, as if it were an image returning to its original.

Near the beginning of *On the Spiritual in Art,* Kandinsky poses the question of end: *Wohin* is life directed? *Wohin* does the soul of the artist cry out? Kandinsky cites two answers to the question of the vocation of the artist. One is from Tolstoy: "A painter is a man who can draw and paint everything" (*K* 130). A protracted critique ensues, linking this citation to *l'art pour l'art* and insisting that it aptly describes the view of art held both by the critics who observe "with cold eyes and indifferent spirit" and by the crowds of people who visit exhibitions without the slightest inkling that "in every picture, secretly, a whole life is concealed, a whole life with many torments, doubts, and moments of enthusiasm and enlighten-

3. See, for example, *Über das Geistige in der Kunst,* 133 n. 1.
4. See note 2.

ment."[5] The other citation is from Schumann: "To shine light into the depths of the human heart is the vocation of the artist." This citation goes entirely without comment—or rather, one might say, it is so perfectly on the mark that the entirety of *On the Spiritual in Art* can be regarded as commentary on it. It is as though the light itself that the genius of the painter sets into the painting were to be reflected in all its intensity into the depths of the human heart. It is as though light itself were concentrated in the painting only for the sake of this reflection into the human soul. It is as though the artist were called only to assist in this gathering and reflecting of light itself.

▼ ● ◆

But what about such illumination of the depths of the human soul? What about the spiritual in art? What about the presentation of spirit to which art would aspire? Is it possible today, in the *today* of Kandinsky's text and of the ventures in painting governed to some degree by this text? To say nothing of the *today* that would be determined as that of *we ourselves.*

For it is said that such art, such aspiration to present the spirit itself in and through art, is now a thing of the past. Indeed, this pastness of art was declared already—and most rigorously—by Hegel, declared as what has come to be called—less rigorously—the end of art: "In all these connections art considered in its highest destination [*nach der Seite ihrer höchsten Bestimmung*] is and remains for us something past."[6] Granted such a declaration, the decisive question would become that of the closure

5. Though Kandinsky admires Tolstoy as a writer, his admiration does not extend to Tolstoy's views on painting. In an early text, "Critique of Critics" (1901), he refers to "Count L. N. Tolstoy, the great writer and artist of the pen, who represents himself as 'one of the crowd' in matters of painting. Because only a man quite foreign to painting could define the artist's aims as he does in his book on art: The artist is a man who devotes his life to acquiring the capacity of recording (!) anything that enters his field of vision. This is actually an opinion concerning the artist's aims that is shared by the vast majority of the public" (*K* 36).

6. Hegel, *Ästhetik,* 1:22.

imposed by this end, this advent of pastness. It would come down to the question of what can escape this closure, of what can remain of art. A question, then, of the remainder of art.

Not that Hegel simply closes off the future of art. A remainder there will be: though as something past, it no longer provides that satisfaction of spiritual needs that earlier ages found in it alone, art is assured its future. In the future there will not cease to be artists producing new works of art. It is a question of what kind of future is assured to art, this future in which art will remain something past. Not that it will be constrained to mere repetition, to circulating again and again through the same forms, an endless return of and to the same. For Hegel expresses a higher hope for the future of art: "We may well hope that art will always rise higher and come to perfection."[7] What Hegel's declaration does close off is the possibility of art in its highest destination, of an art capable of satisfying the highest spiritual needs, of an art capable of adequately presenting spirit as it has unfolded in the modern age (as, to take the classical instance, Greek sculpture presented the gods of Greece). Otherwise art remains, and indeed it may in the future rise higher and come to perfection. A not inconsiderable remainder.

What is at stake in this closure is only the possibility of art in its highest destination. Such would be the closure, *granted* Hegel's declaration of the pastness of art. And yet, a century after the appearance of Hotho's first edition of Hegel's *Lectures on Aesthetics,* Heidegger insists that "a decision has not yet been made regarding Hegel's declaration, for behind this declaration there stands Western thought since the Greeks."[8] What sustains this indecision is the inseparable bond of Hegel's declaration to the metaphysics of art, that is, to the determination of art as the sensible presentation of truth. What sustains the indecision is the bond of Hegel's declaration to metaphysics itself, metaphysics as Hegel himself brings it to a certain completion, thinking through to the end what was first opened

7. Ibid., 1:110.
8. Heidegger, *Der Ursprung des Kunstwerkes,* 68.

up in Greek metaphysics. The indecision regarding the end of art is linked to the end of metaphysics, to the indecision as to whether, beyond metaphysical closure, there remains the possibility of another thinking and, in particular, of another thinking of art, one in which art could no longer be determined as the sensible presentation of truth. In this regard the *we* that functions in Hegel's declaration becomes especially problematic. In response to Hegel's declaration that "art considered in its highest destination is and remains *for us* something past," that it "has lost *for us* genuine truth and vitality,"[9] one cannot but ask about the *we,* about the unity of the *we* and, above all, about the unity between the *we* of Hegel's text and we ourselves.

But, assuming that at least a minimal sense and unity could be determined for the *we* of today, the question is: How could a decision be forthcoming for us? How could the closure be gauged and the possible remainder, the possibilities that remain for art, be disclosed as such? By thinking, one will reply. By venturing to think another determination of art, one outside its metaphysical determination. By venturing to open another space for art, by assuring it of its possibilities. In advance, it would seem. In advance of art itself.

But what about this advance of thinking, this being in advance of art? Is it in thinking that the future of art is to be assured? What about the attestation of art itself? Can art itself not testify to its possibilities by producing works in which those possibilities are actualized, even in advance of being thought as possibilities? Kandinsky is by no means the only artist to insist that, in his words, "theory is never in advance of practice in art, never drags practice in its train, but vice versa" (*K* 176). Even if, as in the case of Kandinsky, a certain thinking may prepare the conditions for an artistic advance, it is art itself that carries out the advance. Will one ever be able to think any future for art other than one that art has already begun to secure in the artwork itself? Or that art would at least have to come to secure in and through the artwork?

9. Hegel, *Ästhetik,* 1:22.

Kandinsky is the consummate theorist among painters. His book *On the Spiritual in Art* projected the schema of a transformation in painting that, in turn, was carried out—in what proved to be a paradigmatic manner—in the paintings that he produced in the wake of this work, specifically, during the period 1910–13, the culmination of his Munich period. Yet, unquestionably, the paintings have a certain priority and do not merely fill out concretely a schema projected in advance. It is presumably for this reason that Kandinsky's thinking is often as much retrospective as it is programmatic.

In focusing initially on retrospection, the intent will be to set about showing how both in his theoretical texts and in his paintings from this period, Kandinsky secures certain possibilities for art, possibilities that extend—even if never unambiguously—beyond the closure that the metaphysics of art would impose.

▼ ● ◆

The year 1913 was decisive for Kandinsky's work. It brought to a certain fruition virtually all that he had ventured in painting and in theory during his years in Munich. With the outbreak of the First World War in August of the following year, Kandinsky was to leave Munich; he would travel first to Switzerland and then would return to Russia, remaining in his homeland until 1922. Only then, in June 1922, would he return to Germany, to accept a professorship at the Bauhaus in Weimar. As one sees perhaps most forcefully in *Composition VIII* (1923), his work had by that time taken a direction quite different from that of the Munich period.

In 1913 Kandinsky finished two of his most ambitious and complex paintings, *Composition VI* and *Composition VII.* His essay "Painting as Pure Art" appeared, as well as the album *Kandinsky, 1901–1913,* which contained, along with other pieces, his text "Reminiscences" ("*Rückblicke*"). It is in this text that he looks back to two events in 1896 that, as he says, stamped his whole life and shook him to the depths of his being.

The first was an exhibition of French Impressionists in Moscow. Kandinsky singles out the painting that was decisive for him: a *Wheatstack* by Monet.[10] Up until then he had seen only realistic art:

> And suddenly, for the first time, I saw a *picture.* That it was a haystack, the catalogue informed me. I didn't recognize it. I found this nonrecognition painful and thought that the painter had no right to paint so indistinctly. I had a dull feeling that the object was lacking in this picture. And I noticed with surprise and confusion that the picture not only gripped me, but impressed itself ineradicably upon my memory, always hovering quite unexpectedly before my eyes, down to the last detail. (*K* 363)

For Kandinsky seeing the *Wheatstack* was a revelation: it revealed to him— to his surprise and confusion—the force of painting, the force with which it could stamp its impression, not just on one's momentary vision, but on the deeper level of memory. In the *Wheatstack* Kandinsky came face to face with "the unsuspected power of the palette" (*K* 363), which, he says, exceeded all his dreams. The force of the painting, he suggests, was linked to the obscuring of the object, to its being painted so indistinctly that he did not recognize it and had even the feeling that there was no object in the picture. It is because he experienced this link between the force of the painting and the disappearance—or at least obscuring—of the object in it that, in his "Reminiscences," he can confidently assert: "And, albeit

10. There has been considerable discussion as to just which of the *Wheatstacks* Kandinsky saw in Moscow in 1896. Moffett ("Monet's Haystacks," 157 n. 16) identifies it as W 1288: *Meule au Soleil,* one of the paintings in which the wheatstack has become so huge that it and its almost monstrous shadow occupy nearly the entire canvas, its apex extending beyond the upper edge. Such an identification would accord well with what Kandinsky says about feeling that an object was lacking in the picture, an impression much less likely to be made by those *Wheatstacks* (all but three) in which the entire wheatstack is contained within the borders of the picture. Lindsay and Vergo, on the other hand, maintain that it is not possible to be certain which of Monet's *Wheatstacks* Kandinsky would have seen (see *K* 888 n. 21). In the discussion the older term *Haystack* has generally been used, though there is every indication (not the least being Kandinsky's impression) that, whichever individual painting he might have seen, it belonged to the series executed in 1889–91.

unconsciously, objects were discredited as an essential element within the picture" (*K* 363).

Later, Kandinsky consistently recognized and acknowledged the significance of Impressionism as such, aside from his singular impression at the 1896 exhibition in Moscow. In Munich he promoted the exhibition of works by artists from abroad, and, as president of the artists' association Phalanx, he was responsible for bringing to Munich in 1903 a collection of sixteen paintings by Monet (see *K* 46). For Kandinsky the significance of Impressionism lies in its transitional character; in the development of painting it marks a decisive end and yet also an opening to something other. According to Kandinsky, Impressionism remains imitation of nature, even if in a specific interpretation (*K* 129); it is "the logical conclusion of the naturalistic impulse in art" (*K* 288). On the other hand, Kandinsky sets it apart from realistic ideals, referring to "the liberating strivings of Impressionism" (*K* 149). In his text "Painting as Pure Art," Kandinsky locates this move toward liberation within what he considers the second period in the development of painting, namely, naturalistic painting (which succeeds realistic painting, the first period); from within naturalistic painting Impressionism opens toward something quite other, the compositional painting that is to constitute the third period. This opening is expressed in the Impressionistic credo, which declares: "The essential in art consists not of 'what' (by which is meant nature, not artistic content), but of 'how'" (*K* 352). Again, as when he saw the *Wheatstack* in Moscow in 1896, what Kandinsky finds decisive about Impressionism is the retreat of the object. It is hardly surprising, therefore, that to his account of seeing the *Wheatstack* in 1896 Kandinsky adds a note declaring: "The 'light and air' problem of the Impressionists interested me very little" (*K* 363 n.). Considering the distance that he thus takes from the definitive concerns of Monet's work, it is also hardly surprising that he consistently accords preference to Neo-Impressionism, which he regards as reaching out still further toward the abstract (*K* 149, 364 n.). One cannot but wonder whether seeing one of Seurat's paintings, or even one of Cézanne's, would have made an equally forceful impression upon Kandinsky in Moscow in 1896. But by 1913

Kandinsky regards Impressionism as having in any case played out its transitional role. Its demise seems self-evident to him,[11] at the very time when, in Giverny, Monet is most intensely engaged with the *Water Lilies.*

But in Moscow in 1896 there was a second event that also, as Kandinsky says, stamped his whole life and shook him to the depths of his being: a performance of Wagner's *Lohengrin.* Kandinsky's description in "Reminiscences" moves almost undecidedly between music and painting:

> The violins, the deep tones of the basses, and especially the wind instruments at that time embodied for me all the power of that pre-noctur-nal hour. I saw all my colors in my mind; they stood before my eyes. Wild, almost crazy lines were sketched in front of me. I did not dare use the expression that Wagner had painted "my hour" musically. (*K* 364)

It was not only that Wagner brought the various arts together in the work, broaching the *Gesamtkunstwerk,* not only that the music was in accord with the scene and action on stage, but that Wagner's music itself dis-played a power akin to, though greater than, that which Kandinsky was coming to sense as a possibility in painting. The conclusion that Kandinsky drew from his impression of *Lohengrin* spurred him on, though the impos-sibility of immediately discovering this power was, as a result, all the more bitter: "It became, however, quite clear to me that art in general was far more powerful than I had thought, and on the other hand, that painting could develop just such powers as music possesses" (*K* 364).

There was collusion between the two events, between the conclu-sions that Kandinsky drew from them. For a link such as that which Kandinsky sensed between the power of the *Wheatstacks* and its apparent lack of an object is displayed in an exemplary way by music, which, except in extreme instances, has no object whatsoever, represents nothing. The exemplary role of music remains decisive for Kandinsky. Music is pure and free in a way to which, as it throws off the shackles that still bound even

11. "I cannot believe that there exists today a single critic who is not aware that 'Impres-sionism is dead'" (*K* 288).

Impressionism, painting can now—ought now—aspire.

There was still another event after Kandinsky's arrival in Munich. It occurred one day at dusk as he returned home, still absorbed in a study he had just completed. On entering his studio, he suddenly saw "an indescribably beautiful picture, pervaded by an inner glow." His account continues:

> At first, I stopped short and then quickly approached this mysterious picture, on which I could discern only forms and colors and whose content was incomprehensible. At once, I discovered the key to the puzzle: it was a picture I had painted, standing on its side against the wall. (*K* 369)

Dusk and the position of the painting had conspired to dissolve the object, had enchanted Kandinsky into overlooking the object; whereas in daylight and without the inattention of the previous evening, he could—as he confirmed the next day—only half succeed in making the painting produce the same effect, even turned on its side. What Kandinsky had experienced was the link between, on the one hand, the beauty and inner glow of the picture and, on the other hand, the dissolution that the object had undergone as a result of the twilight, his inattention, and the position of the picture. Kandinsky's conclusion: "Now I could see clearly that objects harmed my pictures" (*K* 370).

Such events, the conclusions drawn from them, impelled Kandinsky's work toward abstract painting, toward painting as pure art, launching an era whose closure remains even today undecidable.[12] Thus impelled,

12. Thus, there is an appropriateness in the fact that Kandinsky figures so importantly in recent discussions of abstract painting. See, for example, Catherine Cooke, "Kandinsky: Establishing the Spiritual"; Frank Stella, "The New Surface of Painting"; Hugh Cumming, "Abstract Art and the Spiritual: An International Survey"; and Peter Fuller, "Beyond the Veil, Star and Stripes." These papers are collected in the volume *Abstract Art and the Rediscovery of the Spiritual* (London: Academy Group, 1987). The volume is linked to an exhibition, "The Spiritual in Art: Abstract Painting 1890–1985," held at the Los Angeles County Museum of Art. Fuller notes explicitly that the title of the exhibition is a reference to Kandinsky's text *On the Spiritual in Art*.

Kandinsky's work enters upon the passage that would lead across the threshold into pure painting, in which the object would retreat toward dissolution and, following music, painting would become purely compositional.[13]

▼ ● ◆

The possibility of painting's developing in such a direction, toward dissolution of the object and passage toward music, does not go unforeseen by Hegel. In the *Aesthetics* he takes the force, beauty, and inner glow of a painting to depend heavily on color: "It is *color,* coloring, that makes a painter a painter."[14] What is most remarkable is Hegel's account of what he calls the magical effect of coloring or the magic of the shining of colors. This shining effect occurs, says Hegel, only when the substantiality of objects has evaporated and spiritedness (*Geistigkeit*) comes to determine how color is handled in painting. Then: "The magic consists in handling all colors in such a way that what comes forth is an inherently objectless play of shining, which forms the extreme point where coloring hovers before one's eyes [*die äusserste vorschwebende Spitze des Kolorits*], a fusion of colors, a shining of reflections, which shine in other shinings and become so fine, so fleeting, so soulful that they begin to pass over into the sphere of music."[15] The magic of coloring, which the painter effects by his way of deploying the virtually unlimited shades of color, makes the object dissolve into a play of shining in which nothing—no object—any longer shines, a shining of and in other shinings. With the dissolution of the object into the fleeting reflections of pure shining, it is as if the independence and persistence of the work were cancelled, as if it were withdrawn into subjectivity, as occurs, in Hegel's account, precisely in the transition to music, in the

13. "After music, painting will be the second of the arts to be unthinkable without construction, which even today is already the case. Thus painting will attain to the higher level of *pure* art, upon which music has already stood for several centuries" (*K* 107).

14. Hegel, *Ästhetik*, 2:213.

15. Ibid., 2:221.

passage across the limit separating painting from music.[16] And yet, one would have to insist that this passage can be no more than begun or that painting, even through the magic of color, can produce no more than a kind of mimetic foreshadowing at the threshold of the passage to music. For, however thoroughly the object may dissolve into pure shining, the work nonetheless retains a persistence and an independent existence that prevents its passage into music. However much the painting retreats into pure shining, it remains, as Kandinsky notes, "encased in an objective shell" (*K* 163), which will limit its capacity to follow music. Even if painting were to cross the threshold into pure art, it would be constrained to remain at the threshold of the passage to music.

In the profound affinity between the moment of painting described by Hegel and the transformation of painting that Kandinsky ventures, one can discern how thoroughly the artist, at least as theorist, has appropriated certain fundamental aspects of the Hegelian determination of painting. Though most likely unbeknownst to Kandinsky, who never mentions Hegel in his writings, it is as if Kandinsky were taking up, from within, certain aspects of the metaphysics of art in such a way as to extend these determinations to the limit.

Kandinsky was acutely aware just how questionable the passage to pure art was, and at the threshold he displayed the utmost hesitation: "A terrifying abyss of all kinds of questions, a wealth of responsibility stretched before me" (*K* 370). During those crucial years, 1910–13, Kandinsky's work remained, in a sense, suspended at this threshold, hovering there—not

16. Hegel says of music that "even in its objectivity [it] remains *subjective,* i.e., unlike the visual arts, it does not permit the expression [*Äusserung*] determined for it to become free and independent and reach an existence peacefully persisting, but, on the contrary, cancels [*aufhebt*] it as objective and does not allow the external [*Äusseres*] to assume over against us a fixed existence as something external" (ibid., 2:260).

only his painting but, above all, the writings that announce painting's arrival before this abyss. Even though Kandinsky attests, more than two decades later, that he painted his "first abstract picture in 1911" (*K* 785), his book *On the Spiritual in Art,* first published in the final month of 1911, still declares purely abstract painting beyond reach: "Today the artist cannot manage exclusively with purely abstract forms. These forms are too imprecise for him. To limit oneself exclusively to the imprecise is to deprive oneself of possibilities, to exclude the purely human and thus impoverish one's means of expression" (*K* 166). Even in 1913 he still looks to a future in which a new atmosphere will be created: "In this atmosphere, although much, much later, *pure art* will be formed, an art that today hovers before our eyes with indescribable allure, in dreams that slip between our fingers" (*K* 380). Thus, the very texts that most powerfully announce the possibility of abstract painting announce it only *in advance,* remaining at the threshold, setting in suspension even the paintings that Kandinsky would later consider to have passed already over that threshold.

Yet other considerations could lead one to say that a certain hesitant passage across this threshold is traced within *On the Spiritual in Art,* not in the typescript dated 1909, on which the first published edition (which appeared in December 1911 but is dated 1912) is largely based, but rather in the difference between this version and the fourth edition, which was supposed to appear in 1914 but which did not appear because of the outbreak of the war. For this fourth edition Kandinsky prepared a manuscript with the heading "*Kleine Änderungen zum 'Geistigen.'*" The "small changes" that were to have been made in the text of *On the Spiritual in Art* could in fact hardly have been more momentous. For instance, the passage just cited from this text, the passage declaring that today's artist cannot manage exclusively with purely abstract forms, is, according to "*Kleine Änderungen,*" to be replaced by the following: "Today, only few artists can manage with purely abstract forms. These forms are *often* too imprecise for the artist. *It seems to him:* to limit oneself exclusively to the imprecise is to deprive oneself of possibilities, to exclude the purely human and thus impoverish one's means of expression. *At the same time, however,*

Thresholds of Abstract Painting

abstract form is, even today, already being experienced as something purely precise and employed as the sole material in pictorial works. External 'impoverishment' is transformed into inner enrichment" (*K* 877 n. 42). Another passage in the first edition of *On the Spiritual in Art* stresses that painting's emancipation from direct dependence on nature is "in its very earliest stages"; the passage goes on to venture that, even under conditions of spiritual revolution at a fiery tempo, one might maintain "that only a few 'hours' separate us from this pure composition" (*K* 197). "*Kleine Änderungen*" adds: "*The first hour has already sounded*" (*K* 878 n. 55). Still another passage in the first edition sets painting barely even at the threshold: "Today we are still firmly bound to the outward appearance of nature and must draw our *forms* from it" (*K* 199). "*Kleine Änderungen*" adds, in parentheses: "*Purely abstract pictures are still rare!*" (*K* 878 n. 56).

At the threshold of pure painting Kandinsky hesitates, remains suspended, hovering within the passage toward pure art. Even to a degree, though differently, in the reappropriation, the revision, of his own text.

What is required while painting remains suspended in the passage toward pure art will not coincide with what is required of pure art as such. It is imperative to keep the distinction in force; for the complete exclusion of all doubling of nature that is to be effected in pure art is not something that can be achieved immediately. While painting remains suspended within the passage, at the threshold, natural forms will remain, even if themselves submitted to a certain suspension.

Passage toward pure art was for Kandinsky never a matter of purging art of all doubling. Hence, he cannot but address the question: What is to replace the missing object once it has disappeared from the picture? In a sense, Kandinsky's answer is simply: free composition, unbound construction. In "Painting as Pure Art" he writes: "Today, the tendency, which makes itself strongly (and ever more strongly) felt, consciously or even

unconsciously to replace subject matter by construction, is the first step on the path that leads to pure art" (*K* 353). And yet, to refer simply to composition has the effect, not of answering the question in a way that would resolve it, but of redoubling it, posing it again more sharply. For the further question is inevitable: composition *of* what? As well as the question: composition to *what end*? Inevitably, at least, if art is not to be reduced to mere ornament. Even while granting that ornament is not entirely lifeless, that it "has an effect upon us" (*K* 199), Kandinsky insists that for painting it constitutes a danger: "The danger of ornament revealed itself clearly to me; the dead semblance of stylized forms I found merely repugnant" (*K* 370). In the figure that he offers in *On the Spiritual in Art,* the path leading toward pure art must run "between two realms": on the one side, the realistic use of color to depict external forms and, on the other side, "the completely abstract, wholly emancipated use of color in 'geometrical form' (ornament)" (*K* 207). The artist who, completely dissolving the bond to nature, would turn exclusively to a combining of pure color and independent form "would create works having the appearance of geometrical ornament, which would—to put it crudely—be like a necktie or a carpet" (*K* 197).[17]

Therefore, there is to be no reduction to a single plane, to the mere surface of painting, of *the* painting, even though Kandinsky is thoroughly intent upon breaking with the doubling by which painting has previously produced a double of nature. He announces the commencement of this break: "Emancipation from direct dependence upon 'nature' is in its very earliest stages" (*K* 197). And yet, he stresses that the discontinuity is not so extreme as many modern critics of mimesis have taken it to be. Genuinely artistic imitation of nature is not mere reproduction: "It is clear that this imitation of nature, if it derives from the hand of an artist who is spiritually

17. Kandinsky was perhaps alerted to the danger not only of ornament itself but even of the semblance of ornament by the attack that one critic directed at *Composition II,* calling it an involuntary conglomeration of colors and suggesting that a more appropriate title for it would be "Color Sketch for a Modern Carpet" (see *K* 81f.).

alive, never remains merely a lifeless repetition of nature" (*K* 212 n.). He insists even that "it is not possible to reproduce a material form exactly" (*K* 166). He suggests that when an artist takes himself to be aiming at reproduction, it is often the case that his eyes and hands prove more artistic than his conscious intention and divert his work from reproduction to idealization and selection, which is also to divert it in the direction of abstraction. The artwork is diverted all the more sharply in this direction when idealization gives way to the stylization regarded by Kandinsky as having arisen from Impressionism: here the aim is not the beautification of organic form (as in idealization) but "the powerful characterization of it by the omission of external details" (*K* 166 n.). Even in this case, though, there remains an undue emphasis on the external, on nature.

Kandinsky emphasizes that, even in a mode of painting that remains bound to natural forms, truthfulness to nature, accuracy of depiction, is inconsequential. The artist has full license to distort natural forms in accord with the needs of his art: it is never a question of whether an external form has been distorted but "simply of whether the artist needs to use this form as it is in its externals" (*K* 211). In the artwork, in its composition, art has absolute authority over nature, an authority that, within this domain, is of the same order as that which Hegel grants to art within the broader sphere of the beautiful as such, that by which, as Hegel says, a painting of a landscape is of a higher rank than the mere natural landscape. This order of rank, in turn, derives from another, from one that is as decisive for Kandinsky as for Hegel, who expresses it most directly when he says: "For everything spiritual is better than any product of nature."[18]

Kandinsky even announces a kind of battle against nature and against some of the vehicles by which, despite the spiritedness of the artist, nature can surreptitiously intrude into the work. For instance, the colored forms in a picture can take on literary overtones in such a way that "the composition takes on the effect of a fairy-tale" (*K* 204). But then the spectator begins to

18. Hegel, *Ästhetik,* 1:40.

look for the story instead of remaining open to the pure effect of the form and color. Therefore, Kandinsky insists that a form must be found that excludes what he calls the fairy-tale effect. More generally, the form, the color, and especially the objects borrowed from nature must be handled in such a way as not to produce any narrative effect. For, once narrative enters the painting and sets it at the limit where painting would pass over into the literary, nature too will have reentered the painting and usurped the genuinely painterly operation of the work, diverting it toward depiction. Kandinsky declares: "It is easier to depict nature than to fight against it!" (*K* 204 n.). All the more reason for the painter to take every precaution to prevent his fight against nature from being diverted into depiction of nature.

Today especially, at a distance from Kandinsky's project, across an interval that, on the one hand, seems immeasurably vast yet, on the other hand, has not brought that project to decisive closure, one is impelled to ask: Why the fight against nature? Why is nature cast as the enemy of painting? Why must it be expelled from painting and its expulsion secured by every possible means? Is the depiction of natural forms so improper to painting? Yet all these questions will be interrupted by a theoretical assertion, one that ascribes to art absolute authority over nature. Everything depends, finally, on the superiority of spirit over nature. Only at the limit where this opposition begins to fissure will one be able to sustain the questions one would pose to Kandinsky's project.

It is remarkable how strictly Kandinsky draws painting back from the limit at which it would pass over toward the literary or toward a certain mixing with the literary. For Kandinsky frequently alludes to the Wagnerian project of the *Gesamtkunstwerk,* in which the individual arts, each retaining its proper character, would be brought together in the work. In *On the Spiritual in Art* Kandinsky looks ahead to such *monumental art,* as he calls it: "And so, finally, one will arrive at a combination of the particular forces belonging to different arts. Out of this combination will arise in time a new art, an art we can foresee even today, a truly *monumental* art" (*K* 155). *Yellow Sound* already borders on such a project, and indeed the theoretical

text "On Stage Composition," published along with *Yellow Sound,* refers explicitly to Wagner and to the ideal of a monumental work of art (see *K* 260).

Kandinsky's stricture against painting's approaching the literary is also remarkable in view of Kandinsky's own work, which consists both of painting and of writing, indeed of writing that, both in its extent and in its theoretical intensity, surpasses that of almost any other painter in the history of Western art. Among his writings one finds not only theoretical texts such as *On the Spiritual in Art* and "Painting as Pure Art" but also, most remarkably, texts that, within the domain of the literary, carry out— as in a kind of mimesis—what Kandinsky would execute in his painting. The most notable of his purely literary compositions are found in the album *Sounds,* published in 1912. Yet the literary purity of the prose poems that appear in this album does not exclude their being brought together with other arts, just as the purity of painting does not exclude its following the example of music: along with the thirty-eight prose poems in the album, Kandinsky includes fifty-six woodcuts (twelve in color); he is said also to have conceived of the album initially as a "musical publication" (see *K* 291). One of the poems is entitled "Earth":

> The heavy earth was loaded with heavy
> spades onto carts. The carts were loaded
> and grew heavy. Men shouted at the
> horses. Men cracked their whips. Heavily
> drew the horses the heavy carts with the
> heavy earth. (*K* 306)

The poem is evocative. It expresses what its title names, does so by calling forth a sense of earth, a feeling of it, a feeling for it, not only by way of the scene but also through such formal devices as the repetition of the word *heavy.* The scene that it calls up, the protopainting within the poem, is secondary; at least its realistic aspect is inconsequential, most of it being in fact omitted, in a way that is perhaps easier for the poet than for the

painter. The life of the scene has next to nothing to do with detailed depiction but is inseparably bound up with the evocativeness of the poem.

▼ ● ◆

Passage across the threshold into pure painting is a movement from one doubling to another, from a painting that would double nature, even if somewhat abstractly, to a painting that would produce its double from a different origin. In the sensible medium of painting, a truth would be presented more fundamental than the truth of nature. This more profound truth would be presented by being doubled in the painting. Painting would become the doubling of this truth anterior to the truth of nature.

And yet, doubling is itself, in turn, a movement across a certain threshold, as, for instance, when a painter casts his glance first at a natural scene that is to be depicted in the painting, then at the painting itself taking shape before his eyes and hands, then again at the scene being doubled by the painting, thus carrying his glance back and forth between the inside and the outside of the painting; as the viewer may also do when, looking at the painting, he calls up in imagination the natural scene depicted in it, projecting that scene beyond its painted image, even if it is a scene he has never seen or even one that could not be seen. Especially in the case of the painter, such passage across the threshold, such circulation between inside and outside, cannot but be enigmatic, riddlesome. Yet it is precisely such doubling of nature that would be suspended and aban- doned in the passage to abstract painting. The painter would no longer execute his painting primarily in view of things, either actually before his eyes or called up in memory; it would no longer be a matter of appre- hending things so as—by that enigmatic circulation—to render them in and as painting. Pure painting would minimize and finally eliminate passage across this threshold. Thus, recalling that some well-known artist "used to say, 'When painting, one look at the canvas, half at the palette, and ten at the model,'" Kandinsky responds: "It sounded very good, but I soon found that for me, it has to be the other way around: Ten looks at the

canvas, one at the palette, and half at nature" (*K* 372). But if the painter no longer crosses over between nature and the painting, what, then, is the other doubling, the doubling from a different origin, the doubling in which pure art would be constituted?

Even as Kandinsky turns to this question, taking up the theoretical stance it requires, he does not fail to mark the limits of such a stance, to suspend its results in advance, consigning them to a threshold over which they will have to be carried by art itself: "Even if overall construction can be arrived at purely by theory, nevertheless there remains something extra, which is the true spirit of creation (and thus, to a certain extent, its very essence as well), which can never be created or discovered through theory, but only suddenly inspired by feeling" (*K* 176). Nonetheless, Kandinsky clearly acknowledges that the true soul of creation, the spiritual inwardness that he is to declare essential to painting, can be awakened by theoretical declarations. Such is indeed the very intent he ascribes to his own theoretical texts: "My book *On the Spiritual in Art* and the *Blaue Reiter* [*Almanac*], too, had as their principal aim to awaken this capacity for experiencing the spiritual in material and in abstract phenomena, which will be indispensable in the future, making unlimited kinds of experiences possible" (*K* 381). Thus, these texts not only outline the theoretical matrix, the schema, of the pure painting to come but precisely thereby prepare, call forth, the very conditions that can engender a pure painting, which will come to fill and to confirm the theoretical schema, carrying it on, as it were, across the threshold.

Kandinsky begins to outline the schema of pure painting by identifying the directionality of its doubling. What is henceforth to determine painting is the turn inward, the turn to the internally essential (*das Innerlich-Wesentliche*), which is also a turn away from the externally accidental (*äusserliche Zufälligkeit*).

This turn belongs within a broader cultural turn, which Kandinsky relates even to the Socratic injunction "Know thyself" (*K* 153). Though he does not do so, he could even more appropriately have related the turn to the one enjoined by Fichte as constituting the beginning of philosophy:

"Attend to yourself: turn your gaze away from everything that surrounds you, turn it inward [*in dein Inneres*]—this is the first demand that philosophy makes of its disciple."[19] This turn, constituting the beginning of philosophy, is now to become also the beginning of painting, and painting, in turn, the harbinger of a much broader turn linked to the very character of the present age.

It is a matter of a turn away from materialism. Kandinsky misses no opportunity to denounce the "nightmare of the materialistic attitude" (*K* 128) and the age determined by it: "At such blind, dumb times men place exclusive value upon outward success, concern themselves only with material goods, and hail technical progress, which serves and can only serve the body, as a great achievement" (*K* 135). In such an age art leads a degraded life, subservient to materialistic ends. Only if the reduction of art to mere technique should prove to direct it away from the object and back toward the emotions of the artist's soul, could this degradation produce an effect capable of impelling art toward the threshold of the turn (see *K* 135–38).

On the one hand, the turn seems, for Kandinsky, to be entirely determined by the classical opposition between the material and the spiritual: denouncing materialism, he celebrates those "heralds of daybreak that augur a change" (for instance, science's arriving at the threshold where its great question becomes: Is there such a thing as matter?) (*K* 101).[20] And he announces "the great epoch of the spiritual which is already beginning" (*K* 88, cf. 219). A new day is breaking after the nightmare of

19. J. G. Fichte, *Erste Einleitung in die Wissenschaftslehre,* in *Werke,* ed. I. H. Fichte (Berlin: Walter de Gruyter, 1971), 1:422.

20. In "Reminiscences," immediately after telling of his experiences in Moscow in 1896 of seeing a *Wheatstack* and attending a performance of *Lohengrin,* Kandinsky continues (though presumably referring to later concerns): "A scientific event removed one of the most important obstacles from my path. This was the further division of the atom. The collapse of the atom was equated, in my soul, with the collapse of the whole world. Suddenly, the stoutest walls crumbled. Everything became uncertain, precarious and insubstantial" (*K* 364).

materialism, a day in which spirit will emerge into the light, a return of spirit.

On the other hand, some of Kandinsky's accounts of the turn are such as to resist this merely oppositional schema. Such is especially the case in the accounts that link this movement of the age to Nietzsche's thought: "When religion, science, and morality are shaken (the last by the mighty hand of Nietzsche), when the external supports threaten to collapse, then man turns his gaze away from the external and toward himself" (*K* 145). Here there is no mere return of the spiritual, as if it were a militant savior come finally to expel the dark forces of materialism. Rather, whatever comes—even if it will be called spirit—will be something to which one comes only by enduring the collapse brought by incessant questioning, only by persisting through—and appropriating—what Nietzsche calls the transvaluation of all values:

> Everything that once appeared to stand so eternally, so steadfastly, that seemed to contain eternal, true knowledge, suddenly turns out to have been crushed (and in places smashed to pieces) by the merciless and salutory question, "Is that really so?" Consciously or unconsciously, the genius of Nietzsche began the "transvaluation of values." What had stood firm was displaced—as if a great earthquake had erupted in the soul. And it is this tragedy of displacement, instability, and weakness of the material world that is reflected in art by *imprecision* and by *dissonance.* (*K* 103)

Thus mirroring its epoch, art is also the seer and harbinger of the future: the very imprecision and dissonance by which it reflects the epoch serves precisely to intensify its orientation to purely painterly composition, bringing it thus to the threshold of the pure art capable of signaling at large the advent of the new day.

The fundamental task of Kandinsky's theoretical work, especially of *On the Spiritual in Art,* is to proclaim this spiritual turn (*geistige Wendung*) in its bearing on art, outlining its schema in such a way as to awaken the very conditions needed for it in painting. Here is one such proclamation:

Thus we see that the *internal* [*das* Innere] lies at the heart of the very tiniest problem and also at the heart of the greatest problems in painting. The path upon which we find ourselves today, and which is the greatest good fortune of our time, leads us to rid ourselves of the external, to replace this basis by another diametrically opposed to it: the basis of internal necessity. (*K* 177)

This turn to the other basis would become now—in the *now* still extended into the future—the *a priori* of painting: before putting brush to canvas, before even beginning to envisage those forms and colors that one would paint, one would have already to have carried out the turn from outward nature to the spirit within. Only by this turn can one arrive at the other origin from which painting would now produce its double, the painting itself. Only by this turn can one reach the inner element that is to be now the very element, the content, of painting.

Artistic creation would now consist in the passage across the threshold from the interior, original content to its expression in the artistic form of a painting. It is not fortuitous that Kandinsky's most direct statement in this regard occurs in his essay on Schönberg: "The purpose of a picture is to give in pictorial form outward expression to an inner impression" (*K* 224). For, in making the turn to composition, painting follows the example of music, "which externally is completely emancipated from nature, does not need to borrow external forms from anywhere in order to create its language" (*K* 154f.). The further parallel between Schönberg's break with classical tonality and his own advance toward a pure painting that would break with nature was clearly recognized by Kandinsky, who, without their being previously acquainted, wrote to Schönberg in 1911 referring to their having—in their whole manner of thought and feeling—"so much in common."[21] Kandinsky's letter brought a cordial reply from Schönberg, who extended the discussion begun by Kandinsky:

21. Arnold Schoenberg–Wassily Kandinsky, *Letters, Pictures, and Documents,* ed. Jelena Hahl-Koch (London: Faber and Faber, 1984), 21.

Thresholds of Abstract Painting

I myself don't believe that painting must necessarily be objective. Indeed, I firmly believe the contrary. Nevertheless, when imagination suggests objective things to us, then, well and good—perhaps this is because our eyes perceive only objective things. The ear has an advantage in this regard! But when the artist reaches the point at which he desires only the expression of inner events and inner scenes in his rhythms and tones, then the "object in painting" has ceased to belong to the reproducing eye.[22]

Though Kandinsky may have been the first to appropriate and fulfill this schema *in painting,* one can discern in his theoretical elaboration of it how thoroughly he has in effect appropriated certain fundamental aspects of the Hegelian determination of painting. For Hegel, too, declares that painting involves a turn to the interior, that it expresses what is inner and spiritual rather than simply depicting what is external and natural. Painting, he says, "converts the external shape entirely into an expression of the inner."[23] He notes that even in traditional paintings of hills, valleys, forests, clouds, sky, sea, etc., "the objects painted . . . are indifferent to us because what is subjective about them [*das Subjektive an ihnen*] begins to become prominent as the chief thing [*Hauptsache*]."[24] Furthermore, as we have

22. Ibid., 23f. The correspondence continued and led to their meeting at the Starnbergersee in the summer of 1911. Their friendship flourished, and as late as 1936 Kandinsky recalls, in a letter to Schönberg, their first meeting in 1911 (ibid., 84f.). When Schönberg's pupils, among them Alban Berg and Anton von Webern, decided in 1912 to publish a volume of essays in honor of Schönberg, they invited Kandinsky to contribute. The result was his text "Schönberg's Pictures." Even before this, Kandinsky had translated into Russian a part of Schönberg's *Theory of Harmony* entitled "On Parallel Octaves and Fifths" and had provided commentary on certain passages. One such commentary touches on another parallel that he saw between his efforts in painting and Schönberg's in music. Corresponding to his conviction, expressed in *On the Spiritual in Art,* that the time is not yet quite ripe for purely abstract painting, he remarks: "There is a limit, however, to the attainments of every age." He continues: "Schönberg, too, is of this opinion: every chord, every progression is permissible, 'but I feel even today [Kandinsky is quoting from "Parallel Octaves and Fifths"] that there are certain limits which determine my use of this or that dissonance'" (*K* 93).

23. Hegel, *Ästhetik,* 2:18.

24. Ibid., 2:181.

seen, with the advent of what Hegel calls the magic of color, the object *can* indeed *dissolve* into a play of shining in which nothing any longer shines, a play of shining that would, then, serve, not to depict an object, but to express the interiority of spirit. Kandinsky expands and generalizes this moment of painting in such a way as to take *to the limit* the determination of painting as such, its most rigorous metaphysical determination.

According to Kandinsky, passage from the interior content to its expression in the artistic form of a painting does not require any theories nor even, it seems, a clear insight into the content to be expressed. Although Kandinsky stops short of dissolving the enigmatic, riddlesome character of such passage ("the true work of art comes about in a mysterious way" [*K* 213 n.]), he is confident that a certain inward listening can lead the painter from outside (the painting) to inside (the painting), a directionality now reversed so as to define also a passage from inner content to outer expression. In order for the painter to carry out passage from this outer, now become also inner, to the inner, now become also outer, he must turn his listening away from nature and its sound, even away from the voices of others: "The *inner voice of his soul* will also tell him which form to use, and where to find it (external or internal nature)" (*K* 213 n.). The painter needs only to turn his "inner ear" to "the voice of the soul" (*K* 226), a voice that will be silent, speaking directly without the mediation of words or of bodily organs, a voice by which the soul would have such immediate passage to itself as would be difficult to distinguish from the pure self-presence of a transcendental voice, of pure spiritual breath. It is precisely because of this purity of passage between inner and outer (each having become also its opposite), and especially between the self and itself (listening with its inner ear to its own silent voice), that Kandinsky is concerned that nothing intervene in the passage. The threshold must be kept unobstructed if the artist's creative passage across it is not to be hindered or diverted—that is, as Kandinsky writes in a much later text: "The entrance must be kept strictly free, and there must never be 'philosophical' barriers imposed between the work and one's interior. In a word: one must be 'naive'" (*K* 841).

What is to be said, then, of the artwork itself? What is its character? If indeed, as the published versions of *On the Spiritual in Art* continually insist, the painter today cannot entirely relinquish natural objects without depriving himself of essential expressive means, then the painting of today (of the "today" of 1910–13) will involve both abstract and natural forms. Kandinsky stresses that the operation of natural forms in the painting, of what he calls an organic element, need not have the effect of diverting the compositional character of the painting in the direction of representation. On the contrary, the organic element may enhance the abstract, indeed to such a degree that—today, at least—the double-form painting might prove the most forceful, the most expressive. Casting these forms in musical figures, as though each were only the shell of an inner sound that would resound (silently) in the soul, that would first have sounded in the soul of the painter, Kandinsky describes the effect of the double form, the double sound:

> The remaining organic element has, however, . . . its own inner sound. . . . In any case, the sound of the organic element, even when pushed right into the background, is able to make itself heard within the chosen form. For this reason, the choice of real objects is of some importance. As regards the two notes (a double sound [*Doppelklang*]) sounded by the two constituent elements of the form, the organic may either reinforce the abstract (by means of consonance or dissonance) or disturb it. (*K* 168)

In such a painting the accuracy with which the remaining natural forms depict natural objects is a matter of complete indifference. The question of distortion—raised especially against Cubism—will need to be put aside and replaced, as Kandinsky writes, "by another, far more artistic one: To what extent is the inner sound of the given form concealed or laid bare [*verschleiert oder entblösst*]?" (*K* 170). Depending on how a particular form is composed with the others in a picture, its inner sound—gauged presumably by its resonance in the soul—may be openly presented or to some degree concealed. It is most significant that Kandinsky does not regard such concealment as merely privative, much less as a mark of failure in a painting. On the contrary:

This change of viewpoint will once again lead to still further enrichment of the available means of expression, since concealment wields an enormous power in art. The combination of the revealed and the hidden will constitute a further possibility of creating new motifs for formal composition. (*K* 170)

What about the relation of the work to the artist? Kandinsky does not hesitate to say that the work arises from the artist, though "in a mysterious, riddlesome, and mystical way" (*K* 210)—that is, as can now be said, through that complex passage between inside and outside (each having become also its other) effected by listening inwardly to the silent voice of one's soul, an effecting, therefore, that literally could never be said without violation, without breaking the very silence that constitutes its purity and thus also its effectiveness. If the work is compositional, especially if it dispenses entirely with natural forms, then it arises from the artist to a greater degree, indeed in a more fundamental (though no less mysterious) way, in the way that for centuries the musical work has arisen from the composer (see *K* 379). But once the painting has arisen from the artist, it is released from him:

> Once released from him, it assumes its own independent life, takes on a personality, and becomes a self-sufficient, spiritually breathing subject that also leads a real material life: it is a *being* [*ein* Wesen]. (*K* 210)

Above and beyond its mere material existence, it has its own self-sufficiency, has what Heidegger calls the self-repose (*Insichruhen*) of the artwork.

Even the beautiful itself, the nature of the beautiful, is inscribed by Kandinsky within this passage from the spirit within: "whatever arises from inner, soulful [*seelischen*] necessity is beautiful" (*K* 214). The beautiful colors and forms of a painting at the threshold of becoming pure art will arouse in the viewer a spiritual vibration, a *Stimmung,* corresponding to that which the artist will have expressed in the painting, as if the souls of artist and recipient were musical instruments, a note on one causing the other to vibrate in sympathy. In fact, Kandinsky is quite explicit about the schema of this relation between artist and recipient. Here is the schema:

Thresholds of Abstract Painting

"Emotion—sensation—the work of art—sensation—emotion" (*K* 87). The schema is perfectly symmetrical and threatens to reduce the artwork to a mere vehicle for communicating states that, were they not so interior, one could conceive as dispensing with such external means. The schema reproduces the one that Nietzsche formulates in terms of his theory of frenzy (*Rausch*) as the state in which the artist creates his work. As Heidegger explains, commenting on and citing Nietzsche:

> Nietzsche understands the aesthetic state of the observer and recipient on the basis of the state of the creator. Thus the effect of the artwork is nothing else than a reawakening of the creator's state in the one who enjoys the artwork. Observation of art follows in the wake of creation. Nietzsche says, "—the effect of artworks is *arousal of the art-creating state, frenzy.*"[25]

Yet for Nietzsche the symmetry of the schema is precisely a way of stressing the radical nonsymmetry between artist and recipient, a way of shifting the entire perspective on art to the standpoint of the artist, launching what Nietzsche calls a masculine aesthetics. For Kandinsky, too, a certain nonsymmetry comes to appear through the symmetrical schema, though it results, not from utterly subordinating the recipient to the artist, but from a certain divergence between them, one fostered by the operation of imagination. Kandinsky mentions that the second vibration, that in the soul of the recipient, is complex. Though it may reproduce the emotion of the artist, it may do so powerfully or weakly; it may also do so in an absorbed or intermittent manner. Most significantly:

> This vibration of the receiving soul will cause other strings within the soul to vibrate in sympathy. This is a way of exciting the "phantasy" ["*Phantasie*"] of the recipient, which "continues to exert its creative activity" upon the work [*welcher am Werke "weiter schafft"*]. . . . For this reason, the individual effects of a work of art become more or less strongly colored in the case of different recipients. (*K* 258)

25. Heidegger, *Nietzsche* (Pfullingen: Günther Neske, 1961), 1:137f.—citing Nietzsche, *Der Wille zur Macht,* no. 821.

Yet even to interpret this effect as a matter of a work's being "strongly colored" by the recipient risks presupposing the very schema, the symmetry, that is here undermined. One could as easily say, as do Heidegger and Gadamer, that the reception of the work belongs essentially to the work itself.[26] Then one will also have begun undermining any tendency to construe the artwork as a mere vehicle of communication. Also one will perhaps have ventured a first step toward putting in question the determination of the artwork as presentation, specifically, as sensible presentation of a truth anterior to its presentation.

But even if the relation between artist and recipient becomes more complex, there can be no doubt but that, for Kandinsky, everything depends on the interiority of the artist: "The inner element, created by the soul's vibration, is the content of the work of art. Without inner content, no work of art can exist" (K 349).[27] It is the absolute value accorded this inner element that generates the principle of internal necessity, to which Kandinsky appeals with considerable frequency as the only principle of painting (see K 165, 169): in creating the artwork, the artist is bound only to producing what is necessary in order to express the internal, his own interiority of spirit.[28]

26. Because Heidegger disrupts the correlation between artist/recipient and production/ reception and regards artistic creation as itself involving what traditionally would have been called receptivity, he refers to the preserving of the work (*Bewahrung des Werkes*) and to its preservers: "Just as a work cannot be without being created, but is essentially in need of creators, so what is created cannot itself come into being without those who preserve it" (*Der Ursprung des Kunstwerkes,* 54). Gadamer develops these transformations into his concept of "the non-differentiation of the mediation from the work itself" (H.-G. Gadamer, *Wahrheit und Methode,* 2nd ed. [Tübingen: J. C. B. Mohr, 1965], 114).

27. This *a priori* also governs the way in which Kandinsky takes up the question of form, for example, in the text "On the Question of Form," first published in 1912 in *Der Blaue Reiter:* "Form is the external expression of inner content" (K 237).

28. On the basis of this principle Kandinsky addresses the question of criticism and in effect proposes a new concept of criticism: "*One must never believe a theoretician (art historian, critic, etc.) if he maintains that he has discerned an objective error in a work of art. And: The only thing* the theoretician can rightfully say is that until now, he has never known an instance of this or that particular employment of resources. . . . The ideal art critic . . .

But what is this interiority? What is this emotion? What are these motions in the soul, these vibrations? To what end does the artist, whether intentionally or not, express them? What is accomplished by their expression? And how can it happen that another would be touched by an expression of the artist's interiority? How could one come to interest oneself in the expression of an alien interiority?

Kandinsky is explicit that what his paintings express is not merely his own psychic states: "And I have no desire to paint my own psychic states, since I am firmly convinced that they cannot be of any interest or concern to others" (K 345, cf. 400).[29] Thus Kandinsky is not content to reduce the inner element to personality, to what is simply the artist's own (das ihm Eigene). Neither is he willing merely to add to the personal that which belongs to the artist's times, an element proper to the epoch (das dieser Epoche Eigene). Yet when he attempts to say what precisely it is that the artist expresses, above and beyond what is merely proper to the artist and what is proper to the epoch, he refers only to that which is proper to art in general (das der Kunst im allgemeinen Eigene), identifying this element only by way of the most traditional, indeed almost conventional designations: it is said to be "the purely and eternally artistic," its universality extending without limit to every epoch, every art, every nation (K 173).

Although Kandinsky thus leaves it unsaid, beyond this level, what the inner element is, he does offer a few indications as to the end for the sake

would try to feel the inner effect of this or that form, and then communicate to the public in an expressive way the totality of his experience. In this case, the critic would of course need the soul of a poet, for the poet must be able to feel objectively in order to embody what he has experienced subjectively. I.e., the critic would need to possess creative powers" (K 249).

29. Jackson Pollock, on the other hand, seems less explicit: "The thing that interests me is that today painters do not have to go to a subject matter outside of themselves. Most modern painters work from a different source. They work from within. . . . The modern artist, it seems to me, is working and expressing an inner world" (William Wright, "An Interview with Jackson Pollock," in Abstract Expressionism: A Critical Record, ed. David Shapiro and Cecile Shapiro [Cambridge: Cambridge University Press, 1990], 358f.). One might presume it one of the dangers of abstract painting that it can drift toward expression of mere individual psychic states.

of which this inner element gets expressed. He speaks of "the education of the soul" (*K* 213) and of how art "enriches the soul": "Thus, e.g., in painting, *every* color is inwardly beautiful, since every color causes a vibration of the soul and *every vibration enriches* the soul" (*K* 214 n.). Presumably, this would hold no less for the artist himself than for the recipient: if either is affected by the color of a painting, his soul will vibrate and through these inner movements will be enriched. But what is the character of this enrichment? In what does it consist? Again casting the soul in a musical figure, Kandinsky says that its "strings resound, vibrating like the strings of a musical instrument. And just as an instrument is improved, becomes finer the more its strings are made to oscillate (a 'mellowed' violin), so it is with the soul" (*K* 102). Made to vibrate by art, the soul grows. Kandinsky says even—though here precautions are needed to prevent the schema of consumption from engorging everything—that "Art is spiritual bread" (*K* 103). By way of art, by the vibrations that it calls forth, the soul becomes finer, comes to vibrate more finely.

Yet the question recurs: To what end would the soul vibrate more finely? What is the final goal? Kandinsky answers: the final goal is knowledge (*Erkenntnis*), and this goal "is attained by the human soul by means of finer [*feinere*] vibrations" (*K* 257). The attainment of this goal represents, for Kandinsky, spiritual progress, which is "progress of knowledge" (*K* 131).

In order to stress how thoroughly the metaphysical determination of art remains in force here, even if at the limit, one could say, echoing Kandinsky: the end of art, its goal, is to provide the soul with knowledge, that is, to present the truth.

Does it follow that, in the end, the artwork becomes only a means to one's own self-knowledge, even if the self thus known is irreducible to the mere personal, to what is simply its own? Does it follow that, in the end, the painting is only a mirror in which one comes to have a vision of oneself, a mere vehicle of self-portraiture? Kandinsky does not say. But some things that he does say point in quite a different direction, even if this direction remains largely just indicated and not followed up.

Consider, for instance, what he says about the dichotomy between

inner and outer, the dichotomy that governs the entire discourse followed up to this point:

> This dichotomy is, of course, only of very general significance, having a pronouncedly schematic character. But in reality, internal and external experiences cannot be so brusquely separated. Both kinds of experience have, so to speak, many long roots, fibers, branches that permeate one another, become intertwined, and as a final result, constitute a complex of enduring significance for the soul of the artist. (*K* 223)

If one were, then, to let the simple, schematic opposition erode, it would become increasingly difficult to regard the soul as a self-enclosed interiority, which could then be mirrored in its integrity by a sheerly external artwork. That which, according to the schema, would be inner and outer would be intertwined at least to such an extent that, in stressing, as Kandinsky often does, the role of feeling in art (see, for example, *K* 103), one would need to go on to consider what, in any particular instance, there is feeling *about,* feeling *of,* reattaching feeling to works and things by way of an intentional web.

Such an erosion of the rigid dichotomy would have other consequences too. Despite the spiritual, inward turn that constitutes for Kandinsky the *a priori* of painting—or rather, *through* this turn—there would be a subsequent reflection back to the "external" thing, in this case the artwork; from out of the spiritual self-recovery there would extend—in a kind of recoil—a recognition of it in its life, in its spirit. Thus one could understand how Kandinsky, denouncing all attempts to find meaning (*Sinn*) in paintings, urges one to experience "the inner life of the picture" (*K* 202). One could understand, too, how he could characterize a well-painted picture as "one that leads a *full* inner life" (*K* 211);[30] and how he could speak of his efforts to force the viewer "to become absorbed in the

30. "My aim is: to create by pictorial means, which I love above all other artistic means, pictures that as *purely pictorial objects* have their own independent, intense life" (*K* 345).

picture, *forgetful of himself*" (*K* 369—emphasis added), that is, rather than forgetting the picture by finding in it only himself. Through the education that, according to Kandinsky, painting can produce in the soul, one could come even to attend to the inner life of things as such, returning even to nature, outside painting, beginning, in the end, to hearken to such proclamations as one finds occasionally even in Kandinsky's otherwise sober, even reticent, texts, proclamations such as: "*The world sounds. It is a cosmos of spiritually affective beings. Thus, dead matter is living spirit*" (*K* 250).

If one were to take up this direction, this undermining of the simple, schematic opposition, what could, then, be said to be painted in Kandinsky's paintings? Drawn in this direction, Kandinsky could not be said simply to reverse the depiction of natural objects into a depiction of the spiritual subject. The inception of another doubling that takes place in his painting would be no mere reversal. Kandinsky's painting depicts nothing, except to the extent that its double-form (double-sound) character deposits in the painting a trace of depiction. What is painted in his paintings—without depiction—is interiority, subjectivity, but not as a self-enclosed sphere, not as another kind of being that another kind of painting is now to depict, turning merely from the outer to an inner landscape. Rather, what is painted is subjectivity as the very scene of appearing and of reception (feeling), as the place where things come to presence, as the stage where they get illuminated and, through their concealment, their shades, are composed. What is painted is light itself as it comes to make things visible, the very theatre of light, of lighting and shading, the stage of composition. What is painted borders on another truth, presentation of another truth. If indeed it remains *presentation* of this truth and not also its very opening.

▼ ● ◆

Composition. Kandinsky's celebration of the word borders on the rhapsodic: he proclaims that it resounded in his ears like a prayer, that he was inwardly moved by the word itself, his soul filled with reverence by its

evocative force. For Kandinsky this word—with all its musical resonance—comes to name the new epoch into which painting is to be ushered, indicating precisely that which in the pure painting of this epoch is to constitute a new proximity of painting to music. The sense of construction borne by the word would not be restricted to "the obtrusively geometrical," as in Cubism; Kandinsky's intent is, rather, to show, as he writes to Schönberg, "that it now offers many more possibilities which must *unquestionably* be brought to expression in the epoch which is beginning." He cites an example of such possibility: "*Thus* is *Yellow Sound* constructed; that is, in the same way as my pictures."[31]

From 1910 on, the word comes also to name Kandinsky's major paintings, both specifically (by naming a kind of painting) and individually (by constituting, with the addition of numerals, the titles, the proper names, of Kandinsky's paintings of this kind). As a species or kind of painting, compositions are to be differentiated from two other kinds, both of which are essentially impressional-expressional. Those called *impressions* express the impression of external, natural things, while those called *improvisations* express inner events, that is, transfigure impressions of internal nature into painterly expression. Thus, both impressions and improvisations involve a certain directness; improvisations, in particular, arise for the most part suddenly and unconsciously. Compositions, on the other hand, do not arise in such a direct, relatively unmediated way. Their temporality is different: compositions express feelings formed over a long period of time, then at first taken up in preliminary sketches, and then "slowly and almost pedantically examined and worked out." In a composition it is not just a matter of impression, not at all a matter of immediacy or of largely unconscious spontaneity. On the contrary: "Here, reason, the conscious, the deliberate, and the purposeful play a preponderant role." Nonetheless, these factors remain essentially mediating, and assigning

31. Schoenberg-Kandinsky, *Letters, Pictures, and Documents,* 57. The letter cited is dated 22 August 1912.

them a preponderant role does not transform painting into calculation, since compositions remain expressive of feelings, even if of feelings extended across a formative span and taken up preliminarily in sketches. For this reason feeling remains decisive, as Kandinsky affirms by adding: "Except that I always decide in favor of feeling rather than calculation" (*K* 218).

Because of the role that reason, the conscious, the deliberate, and the purposeful play in Kandinsky's *Compositions,* it is in these paintings, above all, that one would expect to find fulfilled and confirmed, in the element of painting itself, the schema outlined in the theoretical texts, even though the *Compositions* are decidedly irreducible to mere concrete fulfillment of a prior schema. More specifically, one would expect the *Compositions* to be set within the passage toward pure art. The mural-like scale and the brilliance of their colors (even in instances where the colors are in a sense muted) make the *Compositions* an incomparable offering to one's vision. Especially when, as at the exhibition held at The Museum of Modern Art in New York in 1995,[32] all the extant *Compositions* are shown together. For then one sees, too, that there are connections between the individual *Compositions,* at least between the first seven, all dating from the period 1910–13—connections that are neither simply semantic nor merely pictorial or figural but that suspend such alternatives in the interest of a new turn of painting. Displaying also many of the preliminary sketches for the *Compositions,* as in the exhibition at The Museum of Modern Art, provides a powerful means for identifying, for instance, objects that are deliberately obscured in the *Compositions* themselves. On the other hand, it is not self-evident that the preliminary sketches *are to be seen* along with a *Composition,* that is, that apprehending a *Composition* ought to include deciphering it by recourse to the preliminary sketches. Especially if one suspends the schema that puts artist and recipient in a symmetrical relation by which the artwork would evoke in the recipient the same state

32. See the catalogue: Magdalena Dabrowski, *Kandinsky: Compositions* (New York: The Museum of Modern Art, 1995).

as in the creating artist, then it is anything but self-evident that to appre-
hend, interpret, or, in Heidegger's sense, preserve a painting involves
retracing in the opposite direction the path by which the painter came to
compose it. Apprehending the painting in its truth, opening one's vision to
what is painted in the painting, *could,* on the contrary, even require that
one not decompose what the genius of the painter has composed. If,
nonetheless, one chooses to refer to the preliminary sketches and to other,
apparently related paintings, one will need to do so with a certain reti-
cence and in such a way as always to circle back to the *Composition* itself,
granting it the last word.

In Kandinsky's paintings from 1910 on, objects begin gradually to
retreat or dissolve. Yet, during most of the period 1910–14, Kandinsky
stops short of completely dispelling all objects from his paintings: for, as he
explains in a 1914 lecture, "objects, in themselves, have a particular
spiritual sound" (*K* 396), which resounds evocatively in the soul and thus
bestows on such objects a capacity to serve as material for art, indeed a
capacity for more forceful evocation than Kandinsky thought possible at
the time by means of purely abstract forms. Hence, during this period
Kandinsky's painting remains suspended between presentation of natural
forms and composition of purely abstract forms. His paintings thus contain
both abstract and natural forms; they are double-form paintings, works in
which a double sound (*Doppelklang*) sounds. Yet, as concretely deployed in
the paintings, this doubleness proves to be a matter, not so much of
distinct forms (objective and abstract) seen to interact in the painting, as
rather of single forms that in the painting hover between natural and
abstract.

The dissolution by which objects come to hover in this fashion occurs
largely through obscurings of the object, through veiling of the images,
that is, through the enormous power of concealment; these operations
are—or can be made—manifest in the paintings themselves, and discourse
on the work of concealment need not be oriented to the genesis of the
work, even though traces of that genesis, as in the preliminary sketches,
may in fact facilitate identification of certain instances in the paintings

themselves. The most immediate effect of obscuring the object is a kind of dematerializing: images of material things are veiled in such a way as to draw one's apprehension toward the spiritual sound that the obscure objects still let resound in the spirit. Yet this dematerializing occurs, not through the representation of something other than the material, but precisely through the deployment of the painterly materials. The painting is attuned to the world of spirit by the way in which its materials are configured, by the way in which its forms and colors are laid out on the canvas.

Kandinsky provides a splendid example in two paintings both entitled *All Saints I*, both dated 1911. In one of the paintings (figure 5) the forms are sharply outlined and the objects are distinct. Even if this imitation of Russian religious painting is less traditional than it might at first appear to be, the various figures—human and otherwise—are distinctly outlined and colored. The other painting (figure 6) depicts the same scene, but now the forms are obscured, though many remain recognizable, especially through comparison with the other painting. But what were faces with individual features are now little more than expanses of color, as, for instance, with the two standing figures located on the right that constitute the focal point of the painting. Other objects such as the city atop the mountain are more thoroughly dissolved, to such an extent that there remain only a few red and white horizontal stripes in their place, marking that place, though hardly in a determinate enough way as actually to suggest the objects that have dissolved into these stripes of color. With several other figures it is as though they had been engulfed and dissolved in the swirling masses of color.

The relatedness between the painterly obscuring of objects and the dematerializing that intensifies the spiritual resonance of the painting is something utterly different from the classical transition from an image (brought to a certain effacement) to a meaning. Kandinsky denounces every attempt to find the meaning of a painting, denounces such attempts because they lead one precisely away from the painting. What he calls for, instead—indeed what he takes a painting to call for—is an engagement

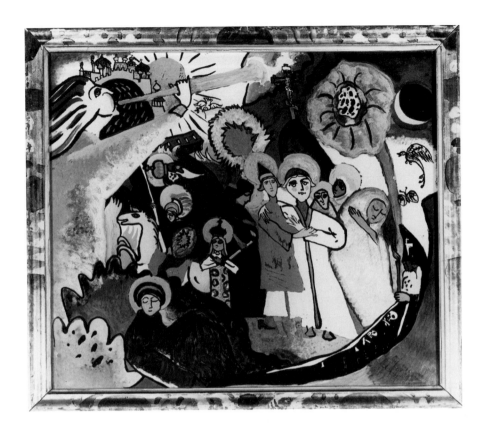

Figure 5. **Wassily Kandinsky,** *All Saints I* [Allerheiligen I], early summer 1911. Tempera and silver and gold bronze on glass, 34.5 x 40.2 cm. Städtische Galerie im Lenbachhaus. By permission also of Artists Rights Society.

SHADES-OF PAINTING AT THE LIMIT

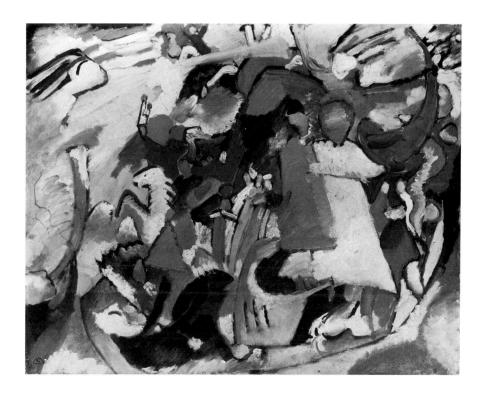

Figure 6. **Wassily Kandinsky**, *All Saints I* [Allerheiligen I], July–August 1911. Oil and gouache on cardboard, 50 x 64.8 cm. Städtische Galerie im Lenbachhaus. By permission also of Artists Rights Society.

with the painting in which one experiences its inner life rather than seeking some meaning that, from outside the painting itself, would govern the painting (as an original governs its image) and would allow one a certain mastery capable of leaving behind the concrete deployment

occurring in and as the painting itself. If one could simply say what a painting means, then one would, in a decisive sense, have gone beyond the painting itself, beyond what it offers up to one's vision. Indeed, if abstraction in painting were such as to call for such a move, if it were such as to make imperative an essential reference of the painting to a meaning detached from everything painterly, then one would have to say that Kandinsky's painting—both in theory and in practice—is anything but abstract. Kandinsky even suggests that it has now become incumbent upon the painter to compose his paintings in such a way as to close off certain exits by which otherwise the spectator might escape the painting in favor of a presumed outside. An example has already been noted: the deployment of form and color and especially the imaging of natural objects need to be handled in such a way as *not* to produce a narrative effect; for, once the spectator begins extracting a story from the painting, he will have grown insensitive to the pure effect of the painting's form and color. The exclusion of narrative does not entail the exclusion of temporality from the painting. On the contrary, Kandinsky explains how a certain temporality is composed into the painting precisely through the work of concealment: "Thus, I dissolved objects to a greater or lesser extent within the same picture, so that they might not all be recognized at once and so that these emotional overtones might thus be experienced gradually by the spectator, one after another" (*K* 396). And yet, Kandinsky says explicitly that in certain of the *Compositions* there is, if not a narrative, at least a theme (see *K* 399), which is semantically more engaging than the temporality constituted merely through gradual, successive recognition of obscured objects. One cannot but wonder: How is it possible for a painting to have a theme without the theme becoming detached from the inner life of the picture and assuming the status of a meaning governing the painting from outside? How can pure painting have a theme, one that can be explained in a title, which, as something linguistic, is set quite apart from everything painterly? For the only outside that bears on such painting is the interiority of spirit itself.

This question, above all, requires that one turn to the *Compositions,* engaging one's vision in the inner life of the paintings themselves and letting one's discourse be directed by that vision, restraining the movement to meaning that constitutes the very operation of language, putting it in service to a movement back into the painting itself, even while recognizing that discourse never coincides with vision.

It is in the *Compositions* from this period that one finds most forcefully displayed a painting in the passage toward pure composition, a painting suspended in that passage and secured there by its double-sounding forms.

Composition II was finished in 1910. Destroyed during World War II, it is known today only through a black-and-white reproduction (figure 7) and through several preliminary studies and sketches. Among the sketches, one is a painting of the same extent as and half the size of the *Composition* itself; this sketch thus provides an indication of the coloring of *Composition II.* Its forms correspond closely to those of the *Composition,* though as in the *All Saints' Day* paintings an obscuring can be seen to occur in the transition from the sketch to the *Composition;* perhaps most notably, the four human figures standing together in the lower left are clearly discernible as such in the sketch but in the *Composition* are obscured to such an extent that their number and even their identity as human figures is unclear.

Kandinsky is explicit: "*Composition II* is painted without theme, and perhaps at that time I would have been nervous of taking a theme as my starting point" (*K* 399). Presumably his concern would have been to avoid introducing into the painting anything like a narrative that would have distracted the spectator from the inner life of the painting itself, though in the passage just cited he goes on to identify the themes that were indeed taken as the starting point of some of the subsequent *Compositions.* With respect to these *Compositions* the question will become most urgent: How can a *Composition* have a theme without distracting the spectator away

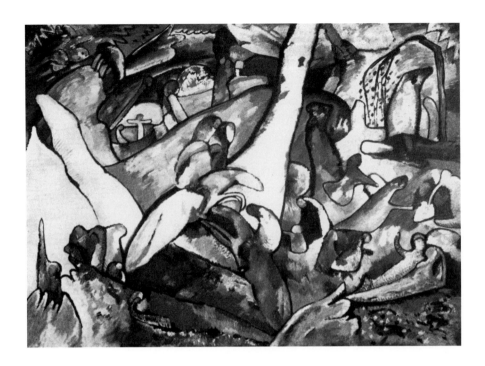

from the painting itself and violating its very character as pure art? Though it has no theme, *Composition II* has an important bearing on the later, thematic *Compositions,* not only because of its iconographic relatedness to them but also because, though without a theme, it provides certain indications as to how a *Composition* could be thematic.

To say that *Composition II* has no theme does not entail that no aspects, no looks, take shape in it. As long as natural, objective forms remain, however thoroughly obscured, there will be what could be called a *trace* of depiction in the painting, in distinction from depiction in the sense that would entail directing one's vision beyond the painting to that which is depicted in it. As long as painting retains its double-form character and does not become purely abstract, the painting will show certain scenes, however dreamlike,[33] dematerialized, spiritualized they may appear as a result of the obscuring of images. *Composition II* shows two scenes, shows them in their disparity, in their difference: on the left is a catastrophic scene, on the right an arcadian scene.[34] The disparity is shown by the respective coloring of the two scenes: on the one side, dark and ominous, dominated by blues in the upper left portion of the painting; on the other side, bright and sunny, predominantly yellow.[35] The difference is marked graphically by the almost vertical form that divides the painting into two parts of almost equal size, though by its slight inclination it also effects a kind of rotation that establishes the upper left and lower right areas as the focal points of the respective scenes. This almost vertical form

33. In the 1918 Russian edition of "Reminiscences," Kandinsky forges a connection between *Composition II* and the dream image: "In confused dreams there sometimes appeared before me intangible fragments of something that, though indefinite, at times frightened me by its power. On occasions I dreamed of harmonious pictures that left me on awakening with only an indistinct trace of fantom details. Once, in the throes of typhoid fever, I saw with great clarity an entire picture, which, however, somehow dissipated itself within me when I recovered. . . . Finally, after many years, I succeeded in expressing in *Composition II* the very essence of that delirious vision—something I realized, however, only recently" (*K* 890 n. 40).

34. These descriptive designations are used by Dabrowski (*Kandinsky: Compositions,* 27). Yet if the scene designated arcadian is taken to be that of the emergence of the spiritual, it becomes questionable whether the arcadian ideal of a quiet, simple life is genuinely appropriate.

35. This coloring is seen in the painted sketch, and since in other respects the sketch corresponds very closely to *Composition II,* one assumes that the latter would also have had such coloring.

Thresholds of Abstract Painting

has been variously identified as a tree trunk, a rock, and a road;[36] other identities can also be found for it, and its multiple identity attests to the work of concealment—in a positive, not privative sense—in the painting.

The catastrophic scene pictures dark clouds and lightning. The site above which the storm rages is itself one of collapse and destruction: the city and its domed churches (all of them obscured) are collapsing around an apocalyptic figure standing with outstretched arms, a yellow figure (at least in the painted sketch), reminiscent of the bright yellow giant in the final scene of *Yellow Sound.* The arcadian scene is focused on two reclining figures at the lower right, and they, along with several flowing figures, give the scene its lyrical, peaceful character. The tree trunk/rock/road separates the two scenes as though it were also a wall, and it appears undecidable whether the two horsemen are attempting to leap over the wall (only to collide with one another) or are engaged in combat on the wall.[37] Again, it seems, concealment is at work in the work.

The tree trunk/rock/road/wall also appears to have the form of an arch, which opens a depth in the painting. It is (also) a bridge arching over a form that, though not entirely distinct as such, can, by comparison with earlier as well as later paintings, be identified as the blue mountain.[38] The primary movement within the painting, especially visible on the arcadian scene, is a passage of humanlike figures, not across the bridge, but under it, through the arch that it forms.[39] In contrast to the horsemen leaping or battling above them, these figures are flowing through the arch from left to right, from the site of catastrophe into the garden of arcadia. In these

36. See Dabrowski, *Kandinsky: Compositions,* 27.
37. See ibid., 28.
38. This form gets its name from the 1908–09 painting that is entitled *The Blue Mountain* and that depicts this mountain. The blue mountain reappears in *Composition IV, Composition V,* and *Composition VI,* and even in *Composition VII* (which otherwise is largely abstract). In these later *Compositions* it comes more and more to assume the guise of an abstracted trace.
39. Although the arch character of the form is less evident in the painted sketch, one can discern more distinctly in the sketch the humanlike figures approaching from the left side as though to pass under it.

SHADES-OF PAINTING AT THE LIMIT

ghostlike, spiritlike figures—one could also call them shades—the entire painting is in a sense concentrated: what is shown in and through their movement is the advent of spirit, its arrival upon the scene, a scene that it itself already defines. What is shown is both the operation of spirit (always already at work) and, in Kandinsky's terms, the transition from the collapsing materialism to the new epoch brought by the reawakening of spirit. What is painted in *Composition II* is spirit itself in its advent. What is painted is thus identical with that which the very painting also enacts: the advent of spirit. Is this to say, then, that *Composition II* has in fact a theme? Or is it a matter of beginning to circumscribe what is painted in all the *Compositions* of this period, which, therefore, could not be the distinctive theme of any individual *Composition*?

 Composition IV (plate 12) was completed in 1911. According to the Handlist prepared by Kandinsky's companion Gabriele Münter, it was given an alternative title, *Battle*.[40] Though Kandinsky does not mention *Composition IV* in the passage in his 1914 lecture where, denying that *Composition II* has a theme, he then goes on to name the theme of *Composition V* and that of *Composition VI*, one would presume that the title *Battle* functions with respect to *Composition IV* in much the same way as the themes named function with respect to the two subsequent *Compositions*. There are a number of preliminary studies, some of them restricted to small areas of the painting and showing such areas much more distinctly than they appear in the painting. A painting more than half the size of *Composition IV* and entitled *Cossacks* is quite similar to the left half of the *Composition*. In addition, there is a short text explicitly devoted to *Composition IV*; the text appeared in 1913 in the album *Kandinsky, 1901–1913,* along with "Reminiscences" and texts on two other paintings.

 Recalling Kandisky's early enthusiasm for Wagner, one notices almost immediately certain motifs of *The Ring* that appear to be taken up in *Composition IV:* the mountain with a castle atop it, the rainbow bridge, the

40. See Dabrowski, *Kandinsky: Compositions,* 31.

setting (or rising) sun.[41] Though these motifs do not as such decisively determine the painting, they are consonant with what is painted in it.

The intrinsic relatedness of *Composition IV* to *Composition II* is striking. *Composition IV* also is divided into two nearly equal parts by an almost vertical form, namely, by the lances held by the Cossacks. Again, the difference between these two sides is strongly marked in the painting. Again, the left side is catastrophic, and, though one sees heavy rain on the left side of the mountain, the catastrophe now assumes more the guise of human destructiveness, as in battle: indeed the horsemen who in *Composition II* were placed on the divide between the two sections of the painting are, in *Composition IV,* placed in the upper left area where, obscured to such an extent that there remain only some entangled black lines and two elongated purple forms suggestive of their sabres, they occupy what, as in *Composition II,* is one of the centers of the painting (and is identified as such in Kandinsky's text). Below them are two boats—warboats, one would presume, given the title of the painting. Yet boats are also vehicles of crossing, just as the rainbow, which touches them and which replaces the arch of *Composition II,* is indicative of crossing. The crossing, guarded by the Cossacks, leads again to an arcadian scene on the right side of the painting. In the area to the upper right two priestlike figures are standing. If one takes into account Kandinsky's indication that the principal movement is to the right and upward, then these figures may be taken, not just as standing on the mountain slope, but as ascending toward the peak; this aspect is especially pronounced in one of the preliminary studies, which includes only this area of the painting.[42] Above the head of the higher figure there is a yellow disc that one could fancy to be a sun, another sun,

41. In the 1918 Russian edition of "Reminiscences," Kandinsky qualifies his effusive remarks about *Lohengrin* by adding a footnote: "It was only later that I came to feel all the sickly sentimentality and superficiality of feeling of this, the weakest of Wagner's operas. Other operas by him (e.g., *Tristan, The Ring*) still held my critical faculties in thrall for many a long year by their power and uniqueness of expression" (*K* 889 n. 24).

42. See Dabrowski, *Kandinsky: Compositions,* 75 (plate 24).

high above the mountain peak. To the left of the two figures, divided by the lances, is the blue mountain, the "acute form modeled in blue," which Kandinsky identifies as the other center of the painting. In the lower right one finds still, as in *Composition II,* the reclining figures. A preliminary study for this part of the painting shows the figures as male and female; the man has his arm around the woman, and they appear to be involved in amorous pursuits.[43] In *Composition IV* itself, on the other hand, the figures are (as in *Composition II,* though differently) obscured to the point where all that obtrudes is that they are reclining and that they are human figures, though their faces are so reduced that sexual differentiation is hardly discernible.

In the text on *Composition IV* Kandinsky refers to "the running-over of color beyond the outlines," "its running-over beyond the boundaries of form" (*K* 383f.). This is one of the principal ways in which the images in *Composition IV* are obscured. This effect is seen in the figures of the Cossacks, both in *Composition IV* and in the preliminary painting *Cossacks:* color overruns the outlines of their bodies to such an extent that in *Composition IV* it is as though the body of the Cossack to the right of the lances had virtually dematerialized into a swirl of pinks, yellows, and blues. In the case of the ascending figures it is a matter, not so much of color overrunning the outline, as rather of its leaping beyond the outline: the greenish-blue of the garment on the figure to the left links him with the blue of the patch of sky directly above him; likewise, the purple of the figure to the right leaps over, as it were, to the sky (the pinkish-purplish patch) above him. In both cases this peculiar effect serves to underline the ascensional character of the priestlike figures.

Especially through the work of concealment, all the figures to the right contribute to showing—as in *Composition II*—the advent of spirit. The title or theme, battle, does not name what is painted in *Composition IV* but rather only that in orientation to which, that in departure from which, the advent of spirit is painted. In his text Kandinsky underlines a contrast

43. See ibid., 75 (plate 23).

between color and movement in the painting that, in turn, highlights the transition at work in this work: "The whole composition is intended to produce a very bright effect, with many sweet colors, which often run into one another (resolution), while the yellow, too, is cold. The juxtaposition of this bright-sweet-cold tone with angular movement (battle) is the principal contrast in the picture" (*K* 384).

As in *Composition II,* what is painted in *Composition IV* is identical with what the painting as such enacts: the advent of spirit. And in both *Compositions* one sees how thoroughly the obscuring of images, the work of concealment, serves to give the paintings their distinctive expressive force, their power to make something manifest while, as depictions, hovering at the limit of depiction, at the threshold where objective, natural forms would—but do not yet—pass over into the purely abstract.

Composition V (plate 13) also remains in passage toward purely abstract forms. In his 1914 lecture Kandinsky refers frequently to this *Composition.* But none of his references are more enigmatic than that in which he links this *Composition* to his awareness that "the highest tragedy clothed itself in the greatest coolness, that is to say, I saw that the greatest coolness is the highest tragedy." He adds: "It was in this spirit . . . that I painted many pictures" (K 398). One of the pictures he mentions is *Composition V.* Its coolness (designed to clothe "the highest tragedy") is achieved by its peculiar surface effects, by its pale, dampened colors. Kandinsky describes this effect from the point of view of the painter: "I deprived my colors of their clarity of tone, dampening them on the surface and allowing their purity and true nature to glow forth, as if through frosted glass." *Composition V* is, he says, "painted in this way" (*K* 398). The resulting transparency of many of the color zones and the flatness of the picture heighten the dematerializing effect by depriving the images of voluminosity and, to that extent, of concreteness. Through the way in which the painterly materials are deployed—in the interest of properly clothing "the highest tragedy"—abstract forms come to play a greater role in the painting, which thus advances along the threshold leading to purely abstract art.

Composition V was completed in 1911. As preparatory for it there exist only two small diagrams and a painted sketch. Kandinsky is explicit about its theme: "I calmly chose the Resurrection as the theme for *Composition V.*" He adds: "One needs a certain daring if one is to take such outworn themes as the starting point for pure painting" (*K* 399)—as if signaling that the theme would not belong to a pure painting, to a painting in passage toward pure art, in quite the same way as a theme belongs to a realistic, naturalistic, or impressionist painting. Yet the painting is filled with apocalyptic and resurrectional elements: the collapse and imminent destruction of the walled city atop the blue mountain;[44] the angels (mere traces) and the trumpets whose sounding is arousing the dead; and indeed the dead themselves being aroused. On the left just below center, three human figures are emerging from their grave, which also looks undecidably like a boat with oars, again, a vehicle of crossing, even—so it is told—for the dead. What is most remarkable about this particular scene of resurrection is the power of the upsurge that carries the human figures up out of their graves. Indeed, all the vague shapes around the boat/grave, which for the most part cannot be identified as depictions, contribute precisely through their form and color to evoking this energetic upsurge. What one sees and feels in view of this scene—in the interplay of vision and feeling that it calls forth—is less a group of images than the very upsurging as such. It is almost as if the expressiveness of the scene were just the other side of the obscuring of its images.

It is in *Composition V* that the theme most nearly coincides with what is painted in the painting. Not that what is painted can be identified with a series of events gathered under the title *Resurrection.* Not that the painting is a narrative that would tell of such a series of events. Rather, the decisive connection lies in the very essence of what is painted in these *Compositions:* the advent of spirit, which is the birth, or, rather, the rebirth, of spirit—that is, the resurrection of the dead in transfigured, spiritual form.

44. That it is such a city is clear if the image is compared with that in the 1910 work *Painting on Glass with Sun.*

Composition VI (plate 14) was completed in 1913. There are several small preparatory sketches as well as a painted study half the size of the *Composition* itself. A text on this *Composition* was also included in the album *Kandinsky, 1901–1913,* published in 1913. This text, which must have been written shortly after *Composition VI* was completed, mentions a glass-painting with the same theme; this glass-painting, which has been lost, provided Kandinsky's point of departure for *Composition VI.* Yet, according to Kandinsky's account, it did so in an unusual way, in a way quite different from that in which preparatory studies typically function in the production of the final work: the glass-painting had to become detached from him, to such an extent that it came to appear strange that he had painted it, to the point that it came to affect him just as many natural objects would, awakening within him, "by means of a vibration of the soul, purely pictorial images." Kandinsky says: "and that finally led me to create a picture" (*K* 386). Thus, the glass-painting was not just preparatory in the sense of being taken up and elaborated in the composing of the final painting; rather, becoming alien, the glass-painting's function was that of evoking pictorial images, which, without coinciding at all with those of the glass-painting, were then taken up into the *Composition.*

Composition VI, though still in passage, seems to advance along the threshold leading to purely abstract painting; or at least—alternatively—it puts into unprecedented prominence the double-form character by which it is set at the threshold. In the painted study for this *Composition* it is striking how thoroughly the objects are dissolved, indeed to such an extent that the only objective reference to the Deluge lies in the sets of lines suggestive of torrential rain. *Composition VI,* on the other hand, begins less abstractly, that is, there are natural, objective forms, which in the painting come, however, to be dissolved, obscured, leaving only traces; it is only by regressing, as it were, from those traces (and such retrospecting belongs, it seems, to the very apprehension of such a work) that one becomes aware of a beginning, a starting point. It is that starting point that is named by the theme that Kandinsky assigns to *Composition VI:* Deluge. Kandinsky himself did not fully understand at first how this theme

was related to the painting he was undertaking. In the text on *Composition VI* he writes about the difficulties he encountered in his initial efforts to compose this painting. He had tried a number of approaches: "But it didn't work. This happened," he continues, "because I was still obedient to the expression of the Deluge, instead of heeding the expression of the word 'Deluge.' I was ruled not by the inner sound, but by the external impression" (*K* 385). In other words, he remained oriented to the objects and events belonging to what is called the Deluge rather than taking them only as a starting point that the painting itself would dissolve into an expression of what is said in the word *Deluge,* that is, an expression of the very sense of *Deluge,* not of a sense in the sense of a meaning outside the painting, but rather a sense inseparable from its expression, the sense constituted in and as the inner life of the painting. Kandinsky says: "The original motif out of which the picture came into being (the Deluge) is dissolved and transformed into an internal, purely pictorial, independent, and objective existence. Nothing could be more misleading than to dub this picture the representation of an event" (*K* 388).

Yet, in retrospection, looking back to its starting point, one sees a great deal in *Composition VI.* In the upper center and, again, on the right there are sets of parallel lines suggestive of torrential rain. Those to the right occur in an area that Kandinsky identifies as one of the two centers, the other center being the delicate, rosy, somewhat blurred area on the left side of the painting; he adds that there is in fact a third center, the pink and white area (nearer to the left), "which one only recognizes subsequently as being a center, but is, in the end, the *principal center*" (*K* 387). Kandinsky notes that these colors, the pink and the white, seethe in such a way that they seem not to lie on any surface but to hover in the air. This apparent absence of surface, this merely hovering somewhere (which Kandinsky compares to being in a Russian steam bath), not only dematerializes the forms but also despatializes them, detaching them in this manner from everything objective, interrupting whatever imaging of natural forms might still be operative. To a degree, the entire *Composition* is aimed at producing such an effect: "This feeling of 'somewhere' about the

principal center determines the inner sound of the whole picture" (*K* 387).

Virtually all that one can, in retrospecting, see merely hovers somewhere in the painting, appearing to be neither attached to its surface nor aligned with the other forms around it. In the upper center one sees the bow of the ark, otherwise hidden. Various animallike figures are to be seen in almost all zones of the painting: in the lower left, a birdlike figure; just below center, a dolphin; and numerous fish, one at the very top, as if impaled on a mast of the ark, another large red one coming down across the bow of the ark, blending with it and in precisely this way being obscured. There is a snake high in the picture, as if still on dry ground, while others—all obscured—appear as if caught already by the floodwaters: a rabbitlike creature, which appears to be hovering between life and death, just as the color composing the creature is itself seething and hovering.

Also, to the left, just below the middle of the painting, there is a ghostlike figure, a spirit, a shade.

Traces of the blue mountain are still to be seen; but, in a way that obscures its image, one end of it has come to resemble the tail of some creature of the sea: thus its look is woven into this seascape of living creatures threatened by the Deluge. Above all, what one sees and feels in view of the painting is the movement: the driving rain from above and the violent undulating movement of the floodwaters. Most remarkably, this effect is produced by the obscuring and reshaping of numerous images in such a way that the form of each involves that of a wave, both organic and abstract forms repeating across the entire canvas the shape and movement of the threatening waves that one sees distinctly at the bottom of the painting.

Kandinsky refers to *Composition VI* too when, in the 1914 lecture, he speaks of "the highest tragedy" being clothed "in the greatest coolness." In the text on *Composition VI* he refers, in a similar vein, to the ways in which he went about mitigating, muzzling, the dramatic effect, for instance, by the use of flecks of different shades of pink scattered across the canvas. He concludes: "Thus, the greatest disturbance becomes clothed in the greatest tranquility" (*K* 388). These pairings, tragedy/coolness, distur-

SHADES—OF PAINTING AT THE LIMIT

bance/tranquility, in effect reconstitute what in the earlier *Compositions* constituted the two sides of the painting, the site of catastrophe and that of arcadia. Now, especially in *Composition VI,* starting with the Deluge (he refers to "that catastrophe called the Deluge" [*K* 386]), Kandinsky paints both sides together; he paints the arcadian over the catastrophic, does so in the very obscuring, dissolving, dematerializing, and despatializing of the images. What occurs as a result is in no way different from the outcome of the passage, in the earlier *Compositions,* from left to right, from catastrophe to arcadia. Thus, Kandinsky's text on *Composition VI* concludes: "What thus appears a mighty collapse in objective terms is, when one isolates its sound, a living paean of praise, the hymn of that new creation that follows upon the destruction of the world" (*K* 388). What is painted is, again, the advent of spirit. And, again, the advent of spirit is what the painting itself enacts. What is painted is also brought forth in deed in the very painting. It is not some meaning or some story outside the painting that the work would somehow signify from afar. What is painted is in the painting itself, in its inner life and in its very deed.

▼ ● ◆

In the "Cologne Lecture" (1914) Kandinsky writes, retrospectively, having referred to *Composition II:* "Thus, objects began gradually to dissolve more and more in my pictures. This can be seen in nearly all the pictures of 1910. As yet, objects did not want to, and were not to, disappear altogether from my pictures" (*K* 396). Yet, after *Composition VI* there is, it seems, a decisive change, since Kandinsky, having referred to *Composition V* and *Composition VI,* continues:

> The pictures painted since then have neither any theme as their point of departure nor any forms of corporeal origin. This occurred without force, quite naturally, and of its own accord. In these latter years, forms that have arisen of their own accord right from the beginning have gained an ever-increasing foothold, and I immersed myself more and more in the manifold value of abstract elements. In this way, abstract forms gained the upper

Thresholds of Abstract Painting

hand and softly but surely crowded out those forms that are of representational origin. (*K* 399)

After *Composition VI* Kandinsky does not—so he attests—begin with a thematic deployment of (at least some) natural forms and then proceed by way of obscuring, dissolving, etc. these forms. He attests, too, that the crowding out of natural forms, their expulsion from his paintings, is something that occurred quite naturally. A curious appeal to nature: the expulsion of nature from painting is said to have occurred by nature, as though nature had expelled itself from painting and left the painter innocent of any assault against nature.

Thus, painting would become purely abstract. Its last remaining ties to nature would be effaced. Except for the few mere traces that remain. As, just left of center in *Composition VII* (a painting of incomparable complexity), one can see still a trace of the blue mountain.

▼ ● ◆

From that point on, discourse on painting cannot but become immeasurably more problematic. Its very possibility, always fragile, always in need of reassuring reticence, cannot but become enigmatic to an unprecedented degree. For the discourse on painting that will henceforth be required will have to dispense too with all that it otherwise takes— would have taken—from nature, interrupting its links to the objects it names and to the objectively derived meanings it signifies. It seems almost as if a new language, a new kind of language, a kind that would hardly even still be language, needs to be discovered. Or invented. Or both. Together.

▼ ● ◆

It goes without saying. Today a certain closure has begun to announce itself, indeed, to impose itself. In the wake of a more excessive

Nietzsche, everything inward has come to provoke utmost suspicion, most of all the inwardness of spirit. Today one cannot forgo submitting to deconstruction such oppositions as inner and outer, spirit and nature. Today one cannot but put into question the concept and rhetoric of *expression,* and even of *presentation,* holding out against the assurance that, as Kandinsky wrote, "the work exists *in abstracto* prior to that embodiment which makes it accessible to the human senses" (*K* 394). Today a reference to spirit no longer suffices to give assurance that what is painted in painting simply preexists its being installed in the work. Today one cannot be assured that one's inner, silent voice is free of errancy nor that the presence to self whose purity once seemed guaranteed by one's inward perceptiveness is free of concealment, any more than the work of painting is, as Kandinsky discovered, free of the work of concealment.

And yet, this complex of requirements and questions will be seen not to be alien to Kandinsky's theoretical and artistic work if one is attentive to the double move that has been marked in his work. On the one hand, it is a move in which the metaphysical determination of painting is appropriated and extended to—or, at least, toward—the limit. But this move from within is paired, on the other hand, with another that would displace painting into the orbit of another truth. This other move is driven by the work of concealment, by the obscuring of objects, as, for instance, in the running-over of color beyond the outlines. Through the work of concealment the figure is made to hover between the abstract and the natural, between abstract form and natural objects depicted in their singularity. In other words, the figure is suspended between the painterly equivalents of the intelligible and the sensible.

The question is whether the future of painting beyond the closure of the metaphysics of art is to be secured—was to be secured, will be secured—by carrying through the passage to purely abstract painting *or* by securing painting within the passage, leaving it suspended there in its double-sounding form. The question is whether the very force of Kandinsky's *Compositions* (at least up through *Composition VI*) does not attest to such security in suspension.

In any case, as a new threshold looms, it will be imperative to broach a renewed interrogation of doubling as it manifoldly determines painting, an interrogation aimed at producing a schema of artistic doubling that is twisted free of the mere oppositional relations between inner and outer, spirit and nature, intelligible and sensible, truth and expression. But what then will be needed is that such a schema be suspended there at the threshold, perhaps someday to be swept across it by painting itself.

THREE · **Very Ancient Memories**
Paladino's Recondite Images

On tiptoe. Above all. Slipping by watchfully and quietly, over land-scapes shining with images, attempting to see—and even to get past seeing—without breaking the silence. Simulating, in discourse, an almost ghostly silence.

In painting there are only shades. Hence, also, silence. No word occurs more frequently in the titles of Mimmo Paladino's paintings than *silence,* threatening but also, more decisively, sheltering their silence.

The silent memories that his painting opens beyond vision are less idiomatic than has been supposed: "Even though I live in southern Italy, a place full of magic and mystery, I can't say it has a prevailing influence over me because today we receive so many stimuli characterized by an international matrix." Paladino insists, on the contrary, that his painting is nomadic; it is tempted by every limit, even that of painting itself, that within which there would have been painting proper. His painting is bound to constant passage: "But I *do* identify with . . . nomadism. For me it means crossing the various territories of art, both in a geographical and a temporal sense, and with maximum technical and creative freedom."[1]

Crossings of every limit, yet always on the track of origins, as one tracks an animal by mutely yielding to the ways of its wild nature. Tracing them in such a way as to configure the origins in painting: "I read in the paper that they are finding traces of distant Greek, Phoenician, and Arab origins in us. Isn't it extraordinary? It was in the drawing that I'm putting together."[2] Paladino's painting would evoke the ghosts that return to

1. Angela Vettese, "Mimmo Paladino" (Interview), *Flashart International,* no. 134 (May 1987), 99.
2. Mimmo Paladino, Letter to Demetrio Paparoni, in *Paladino* (catalogue to the exhibition at the Villa delle Rose, Bologna, 1990), 89.

haunt the visible; his painting would bring the shades forth as though to life, would draw the nocturnal out into the space of shining images: "One can't love the darkness where the sea glimmers."[3]

Yet he knows that every step will have been an incalculable venture, a matter of life and death. The image that he offers of himself is that of a tightrope artist.[4]

▼ ● ◆

EN DE RE.

This inscription provides a *fil conducteur* through a certain prehistory and an opening onto the first of several cycles of works to be considered. For it is seen first in an early painting (1977) for which the inscription serves as title and then, again, in the cycle of paintings that Paladino exhibited at the Villa delle Rose (Bologna) in 1990. The early painting (figure 8) depicts a young girl frightened by a kind of jack-in-the-box that has just sprung open to free a sprite—*un folletto,* Paladino calls it in a letter (30 August 1994) responding to my inquiry about the inscription. No matter how its name is rendered, it is manifestly one of those not quite human figures that frequent so many of Paladino's works. Here its uncanniness is accentuated not only by the fright shown on the girl's face but also by the contrast with the seemingly ordinary surroundings into which it springs up; the scene is that of a child playing, a comforting hand touching her left shoulder to calm her fright, all of this presumably set under the snow-covered roof of the house shown in a cutaway in the upper left section of the painting, or at least--if the cutaway is taken instead to depict a window—in a house like the one shown through the opening. Except for the cutaway/window, the entire background is red, the color overrunning the outline of the child's head and shoulders and almost dissolving that of

3. Ibid.
4. "I've always felt closer to the image of a tightrope artist than a studious artist" (Vettese, "Mimmo Paladino," 99).

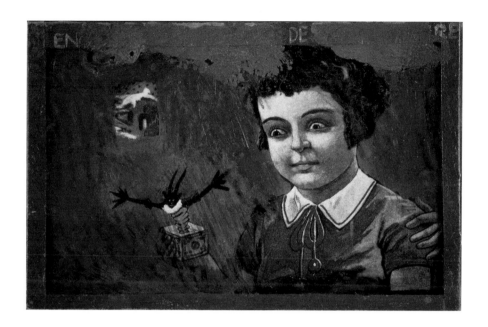

Figure 8. **Mimmo Paladino,** *EN DE RE,* 1977.
Oil on glass, 9 x 13 cm.

her right arm and of the hand with which she holds the box. It is at the very top of the painting that the inscription appears, across the entire top, extended blank spaces separating the three double ciphers; the same irregular mass of color that overruns the outline of the child's head looks as if it has been painted over the entire upper horizontal segment of the painting except for those spaces in which the ciphers appear. In his letter Paladino explains: "On the upper margin, written in gold, I had traced the ciphers [*sigla*] EN DE RE, leaving erased spaces between them, as if I had

covered the pieces of a sentence with paint; the result was like having constructed a charade. Hence, an enigmatic sentence of which a few ciphers [*cifra*] are left to interpret the depicted subject." What Paladino says of the inscription on this painting can be said equally of the title, since the inscription is precisely what entitles the painting. One can say, then, that the title consists of fragments of an otherwise hidden sentence, a sentence rendered enigmatic by an overpainting that has the effect of erasure, submitting language to a certain operation of concealment.

There is also a text entitled *EN DE RE.*[5] It was published in 1980 as a small book bearing the following authorial designation: Achille Bonito Oliva with Mimmo Paladino. The book includes reproductions of several works by Paladino, most notably a two- page replica of the painting *EN DE RE,* bound at the very middle of the book. There is no indication as to the extent or character of Paladino's contribution to the text.[6]

In the book an epigraph precedes the title page. It reads (with the ellipsis): ". . . with warm hand! [. . . *a mano calda*!]." One wonders whether this hand is not the one seen in the painting *EN DE RE,* the hand placed on the shoulder of the child as though to calm her fright at the strange creature that has sprung up before her. One wonders whether the narrative voice of the text does not belong to the very one who places a

5. Achille Bonito Oliva with Mimmo Paladino, *EN DE RE* (Modena: Emilio Mazzoli Editore, 1980). I am grateful to Claudia Baracchi for her translation of this text; I have cited her translation throughout.

6. Achille Bonito Oliva is credited with having coined, in the late 1970s, the term *Transavantgarde* to describe the work of Paladino and of four other young Italian artists (Cucchi, Chia, Clemente, and De Maria). It seems that Paladino had reservations about the term, or at least about the affinity thus supposed between his work and that of the other four artists (see Susan Sollins, *Eternal Metaphors: New Art from Italy* [New York: Independent Curators Inc., 1989], 24); in any case, his subsequent work is quite independent, with little relation to the concepts by which Bonito Oliva originally characterized the group. In a 1987 interview Paladino told Angela Vettese: "Despite the fact that Bonito Oliva made the most accurate critical analysis of my work, I don't agree at all with his essential theme of the *genius loci,* of attachment to the presumed cultural matrix of origin" (Vettese, "Mimmo Paladino," 99).

comforting hand on her shoulder and who then tells a story bearing on that frightful image.

The text presents a fabular narrative. It has to do, above all, with language and with the relation of language to authority and to subjection. Thus it begins with the language of Nietzsche, appealing to his authority, begins with a citation—marked as such—about language and authority: "'The birth of language is an act of authority, every subjection equals a new interpretation . . . in which the sense and goal existing up to that moment are necessarily obscured and even totally erased' (Nietzsche)."[7]

Thus the fable tells of language and the King and of the Palace where even the furniture consists "of words and sounds circulating according to the will of the King [RE]."[8] In the mouth of the King, words are of gold; for his teeth are all golden, and when the King speaks, his subjects are fascinated by the shine of his golden teeth. His authority over language is, it seems, his authority as such. Yet he does not speak only to give orders and thus to exercise his authority. He also makes incomprehensible sounds, emits free phonemes that could be used in various ways, and indeed his subjects are keen to discover the ways of putting these phonemes to work. Yet: "Other times the sound is pure and new, without a precise articulation, destined still to circulate freely outside of the commercial uses to which the subjects can put it." Indeed: "Only the King can speak gratuitously, can effect the arbitrariness of a gratuitous pronunciation."[9] The subject can only repeat the useful word or at best distinguish himself in the competition to interpret the obscure word sounded from the regal height. Should the subject venture to climb onto the throne at night trying to put his ear closer to the source of language, the gleam of the golden teeth and the deep (originative) sound that issues from the stomach of the sleeping King will terrify him; for the mentality of the subjects is utilitarian, "always inclined toward an economy of language, ready to employ in their every-

7. Achille Bonito Oliva with Mimmo Paladino, *EN DE RE,* 13.
8. Ibid.
9. Ibid., 17.

day commerce all possible words and sounds."[10] Theirs, one may say, is a slavish language; theirs is a language subjected to the everyday, the common, submitted to what one might call an economy of meaning.

But the language of the King is otherwise. It is a language that grants "the regality of gratuitous sound," that admits "the obscurity of the pure phoneme."[11] And so, in the night, as the King sleeps with open mouth, his golden teeth gleaming, the phonemes escape: *EN DE RE.* They echo, though quietly, throughout the Palace, and the subjects, unequal to the obscurity of these sounds, repeat them amongst themselves.

It is the third of the phonemes that orients the debate occupying the remainder of the fabular narrative. This is hardly surprising if, as seems self-evident, this phoneme names the very source of naming, names it from the source itself: "Of course, it is the third phoneme that provokes the biggest start, because it refers directly to the originary word of every power and of language itself: RE. It is pronounced with the utmost reverence or omitted and substituted by a nod of the head or a sign of the hand that indicates the throne." The question that fuels the ensuing debate concerns the other two phonemes, which "present themselves obscurely and which do not give themselves in a certain and known meaning."[12]

Proposing that *DE* is Latin, the librarian replaces the obscure regal language with the phrase "around the King," which might be thought eminently clear if it were not for the remaining, obscure opening sound *EN.* The French ambassador at court finds both phonemes in his language and comes up with the nonphrase "in of King," which nonetheless could, the narrator assures us, "find a decent articulation within the utilitarian and logocentric language of the subjects."[13] The narrator tells of what will have happened if, taking the *around* from Latin and the *in* from French, one

10. Ibid., 24.
11. Ibid., 23f.
12. Ibid., 25f.
13. Ibid., 28.

connects both to *RE,* to the King, or rather to the word for King, the name of the King. For all words occur, originate, in and around the King: "Language reaffirms tautologically the place of its own birth, the repository of all its transformations. The subjects witness the affirmation and identification of language itself, which dares to pronounce even the unpronounceable."[14] In the sounds *EN DE RE,* language says its own unsayable origin.

Someone proposes that at night even regal language takes on a more precarious syntax than by day. At night the interlocutor is missing, the language of the *RE* speaks alone, and "phantoms reappear, which were removed during the day-time exercise of power."[15]

The fable thus poses a double transgression, two directions in which language outdistances itself and breaks so abysmally with every economy of meaning that to such an economy it can seem only gratuitous. In one direction it would say its own unsayable origin. And lest that origin be stabilized and assimilated to an economy, the fable offers an interpretation of the phonemes *EN DE RE* emitted by the sleeping King, assigning them a meaning that undermines their very confinement to meaning. The interpretation is given by one called the chamberlain: *EN DE RE* means "renders King" (*significa "rende Re"*). When one who is called the master of ceremonies objects that the sentence has no subject, that it fails to say what or who it is that renders (someone) King, another who is called the court scribe (one knowledgeable of writing) identifies the subject as language itself. The sentence could thus be rewritten as: (language) renders King. And as if this reversal and the fundamental circularity (the circularity of fundament) it produces were not already compelling, the narrator goes on to observe that the King is seen only from a distance, that is, not really at all but only by "hear-say," by the words that both flow from him and take his place, replacing him and becoming the source of authority.

14. Ibid., 29.
15. Ibid.

In the other direction language—the nocturnal language of the sleeping King—lets *phantoms reappear,* frees them from assimilation to the everyday, to the common, to what can simply—clearly—be said in an economy of meaning, in an economy that assimilates to meaning everything seen, however exorbitant it may appear, however frightful and discontinuous with the ways and laws of the house. In this direction language escapes from itself to the thing in such a way as to let the thing escape the assimilation that language would otherwise force upon it. Thus the librarian recalls that the Latin *RE* means *thing,* and thus he translates *EN DE RE* as "in and around the Thing" or "in the surroundings of the Thing." Others object to this translation, since the Thing is unrepresentable, because it is that which is not known. But the reason given for the objection is precisely the point to which the translation alludes.

Language escapes itself in both directions; it is only in this escape that it opens "the possibility and the freedom of nonsense,"[16] and it is only then that it becomes regal. Escaping itself, it is as if only the empty sonorous shell were left behind in the house of language: "At the end of the debate, in a pause of absorbed silence into which the court has fallen, the jester, nodding his head and tinkling his jingle-bell cap, caracoling to the center of the receiving chamber, tosses an invitation, namely, to read EN DE RE as sound, just as it has come out of the golden mouth: EN DE RE as EN DE RE. He invites the subjects to practice Nietzsche's aphorism, to be 'superficial out of profundity.'"[17]

▼　●　◆

The inscription *EN DE RE* reappears on one of the seven paintings that Paladino exhibited at Villa delle Rose (Bologna) in 1990. This cycle of paintings was accompanied by a series of eight drawings, and the two

16. Ibid., 32.
17. Ibid., 40f.

closely related cycles were given the single title *EN DO RE*.[18] In his letter (30 August 1994) responding to my inquiries about these titles, Paladino reaffirms the title *EN DO RE* and then comments: "EN DO RE is in this case the mutation of EN DE RE through time, a mutation whose sound recalls something musical (do re mi fa etc.)." Yet the theme remains: "RE, however, remains RE, that is, REX, the REX of alchemy?"—the King with golden teeth, transmuting the commonplace into golden words. The cycle is, then, a musical variation (or set of variations) on the theme (of) *EN DE RE,*[19] another sounding that would announce the transgression of language.

The paintings in the *EN DO RE* cycle were left individually untitled (*senza titolo*). One might be tempted to regard this disentitling as a strategy by which to protect an alleged pure visibility of the paintings; that is, one might suppose that the artist left the works untitled precisely in order to ward off any encroachment of language upon them. Disentitling would be, then, his way of insisting that one attend solely to the works as they unfold before one's vision, leaving all contaminating discourse aside. And yet, disentitling is itself linguistic; and, especially when the disentitled works come to be exhibited and reproduced with the designation *untitled,* disentitling the works comes to border on titling them, on entitling them to the title *untitled.* In any case, there can be no question but that language already impinges upon the paintings of the *EN DO RE* cycle, not only through their disentitlement but also by way of the inscription *EN DE RE,* which appears on one of the paintings and which, having mutated into *EN DO RE,* supplies a title for the entire cycle.

What, then, is the function of disentitling in Paladino's series, if not to declare the pure visibility of the work?

18. In addition to the exhibition catalogue (see above, note 2), see also the volume *EN DO RE* (Siracusa: Tema Celeste Edizioni, 1990), which contains both reproductions of and essays on the works of the cycle.

19. The musical character of the *EN DO RE* cycle has not gone unnoticed but has indeed occasioned a musical composition, "Recondite Armonie" (cadenza for harp with percussion accompaniment) by Marcello Panni. See *EN DO RE,* 43–47. A CD recording has been produced by Edipan (PAN–3013 stereo).

Disentitling serves to denounce the possibility of a certain kind of linguistic frame. It serves to exclude, not all impingement of language upon the work, but only that kind of linguistic frame that would presume to encompass the work in such a way as to appropriate it to an economy of meaning. Disentitling the work is one way of declaring that what is gathered in the work cannot be carried over without residue into discourse, that it cannot be translated into a meaning or complex of meanings such as one might then express in a title or at least in a discourse elaborating the sense of a title. Withdrawing from language, the work remains *silent,* even as language impinges upon it, even when phonemes are inscribed in it, even when the artist himself writes about it. Beyond all that is said and written there remains an untranslatability, indeed an untranslatability more abysmal than that of any text, however foreign, however remote.

Paladino has announced the silence of the work, not only by disentitling, as in the *EN DO RE* cycle, but perhaps even more vigorously in the very titles given to three earlier paintings: one from 1977 is entitled *Silence, I am retiring to paint;* two others from 1979 and 1980, respectively, carry the same remarkable title *Silent Red* (plate 15).[20] The title is remarkable because what is said in it is that what is painted in the painting cannot be said in a discourse ordered by the word *red,* that the red that is painted is a red that cannot be said, a silent red, which is to say in a sense not red at all.

As one speaks of the red of a rose, cancelling the speech in its very performance, letting what is called the red of the rose escape. Indeed at the very top (and exactly in the middle) of the 1980 work *Silent Red,* one sees a red flower, its color accentuated by the contrast with a white flower (below and to the right), the only occurrence of any color other than red in the entire painting.

20. The 1979 work entitled *Silent Red* is reproduced in Achille Bonito Oliva with Mimmo Paladino, *EN DE RE,* 37. *Silence, I am retiring to paint* is also included (ibid., 15). Most significantly, the latter, as well as *Silent Red* from 1980, is included in the catalogue of the exhibition at Villa delle Rose where the *EN DO RE* series was shown.

Also as one speaks of the blue of the sky, which is not the blue that one says and which can be said only in a speech that outdistances itself.

The transgression of language is something that the work will always have accomplished in its retreat into silence; and if language is to allude to this silence, saying (while also unsaying) the unsayable, then language must have escaped from itself, so that transgression occurs not only from the side of the work (transgression of language—in the objective sense of the genitive) but also from that of discourse on the work (transgression of language—in the subjective, indeed in the double, sense of the genitive).

As to titles, Paladino is explicit in a letter that I received from him in January 1991: "I never give titles that convey a particular meaning, which could trap one into reading the work in strictly literary and symbolic terms." Rather, he explains: "The title of a work always represents for me the side that is disquieting [or: displacing—*il lato spiazzante*] for the interpretation of the work."

Withdrawing from language, retreating in(to) silence, the images gathered in Paladino's works refuse to display themselves openly to a vision presumed to be continuous with discourse and translatable into a complex of meaning that discourse would express. They are *recondite images.* They remain masked, retain—remain within—an element of concealment that disrupts every synthesis that would integrate them into the orbit of meaning and discourse, that would elevate their sense beyond vision rather than setting it in relief. They are exorbitant images, and their phenomenal character hardly differs from that of a mask: an appearing that conceals. Refusing all synthesis by which they would be preserved within an enduring order of meaning and discourse, these recondite images are *passing* images.

Paladino's painting gathers these passing images in such a way that they are presented as such—that is, without being submitted to synthesis and thus violated. His painting gathers them in such a way that their very passing, the very disappearance behind the mask, is set into the work so as to be presented. The logic of this painting is different: it is determined, not by a λόγος of discourse, but by a λόγος of the image, a λόγος anterior to

the classical doubling, anterior by virtue of its very adherence to the image. This logic is such as to produce a reversal, gathering the passing images into an image of passing. What is painted in these paintings is the passing of images, that is, passage into concealment, the return of the shades to the obscurity of Hades. Before these paintings one is drawn along with the shades; or, as one can equally well say, the ghosts return to haunt the very interstices of the visible. What is painted in these paintings is the waning of light itself.

In his letter (30 August 1994) about this cycle and its mutant title, Paladino calls attention to the fact that each of the seven paintings "is actually constituted by two superimposed surfaces, the first concealing partially or totally the second lying beneath." It is precisely by means of this double structure that these paintings produce the reversal and present the passing of images. The introduction of the obfuscating panel, the upper surface, sets into the very structure of the work an operation of concealment, a masking of the images on the lower surface. In all but one of the paintings there are also images on the obfuscating panels, images concealing images.

In the case of the painting on which are inscribed the phonemes *EN DE RE* (plate 16), the obfuscating panel has become so large that it almost completely covers what one might otherwise (and by comparison with the other paintings in the cycle) take to be the main surface, usurping the role of that surface now seen only at the margin: now the images that appear conceal almost entirely what lies behind them—like masks. In the letter telling about the inscription, Paladino also tells what it is that is almost totally concealed beneath the upper surface: no longer even images but "an abstract geometric surface." Though in the work two very thin edges of the lower surface can still be seen, the abstract geometric surface is virtually buried by the upper surface, sealed away almost entirely from sight, as in a tomb. And in what the letter describes as "an interior," one sees what to all appearances is a casket; on it are flowers, and above it, as if marking the grave, naming the deceased, is one of the inscribed pho-nemes: *DE.* It is as if it were saying what is quite withdrawn, as if it were

saying what it could say only by escaping itself and leaving behind merely the empty sonorous shell. It seems that the interior is the house, the Palace, of the King: next to the sole humanlike figure, the phoneme/name *RE* is set (overlapping) at just that point where his left arm, extending outside, is overpainted so as to appear to dissolve. Alterity is in play not only in the entombment of the dead but also outside, most notably in the animal, a doglike creature, that is seen walking past the opening. The alterity of the animal, its withdrawal into the shelter of concealment, returns in many of Paladino's works. An interview from 1980 provides commentary. To the interviewer's remark "In your work you represent animals . . .," Paladino responds: "I like animals because they don't communicate with men. I like their primitive nature, wild nature, which is deeply mysterious. When I begin a work I think about these things . . . the Forgotten."[21]

Seven of the eight drawings that Paladino made to be grouped with the paintings in the *EN DO RE* cycle are, like the paintings, designated as *Untitled.* In two of them there are obfuscating panels that cover the lower surface almost completely (see figure 9). Even in the other drawings there are smaller obfuscating panels, at least in all but the final work. This work, the eighth drawing, is the only one of the fifteen (paintings and drawings) that is not designated as *Untitled;* it alone has a proper title, *Apre* (*Open*) (see figure 10). The work is in four parts and is itself manifoldly open: in each of the parts the frame is opened up, as if the obfuscating panel had become a door turned on its hinges until it lay next to the other surface and in the same plane; the openness of the work is also accentuated by its being divided into four parts outside one another. Furthermore, the frames that are opened, the frames that replace, as it were, the now opened, formerly obfuscating panels, spell out the word *apre.* To this extent lan-

21. Wolfgang Max Faust, "Searching for . . . an interview with Mimmo Paladino," *Domus,* no. 711 (November 1980), 49. The ellipses occur both in the title and in the text of the interview.

Figure 9. **Mimmo Paladino**, *Untitled* [Senza titolo], 1989. Mixed media on paper and wood, 108 x 88 x 15 cm.

Figure 10. **Mimmo Paladino,** *Open* [Apre], 1989.
Mixed media on paper and wood. Work in four
parts, 100 x 50 cm each. (Second part.)

guage impinges in a new way on this work with which the cycle of drawings comes to an end.

It seems that there was also to have been—in a sense that is difficult to determine—an eighth painting. The editor and curator Demetrio Paparoni, a friend of the artist, writes of actually having seen the eighth painting in Paladino's studio in Paduli: "On the floor beside what we may conveniently describe as the *Eighth Painting* a rectangular wooden board, the same size as the painted canvas, was ready waiting to cover up the painting. Only the artist, my wife, and I would ever see this magnificent work. It greatly disturbed me that such a fine painting would be forced to withdraw into itself."[22] Paparoni goes on to tell of returning to Paduli two weeks later to discover that Paladino had drastically altered the painting. Paparoni relates that later, when he received the transparencies for use in preparing the catalogue of the exhibition at Villa delle Rose, he found that there were only seven. When he inquired about the eighth painting, he was told that it had been destroyed. But in his account Paparoni goes on to tell what he calls the "full story." The crux of the story concerns the removal of some wood from Paladino's studio by certain workmen trusted to do so without personal supervision. It was after these workmen left that the eighth painting was missing and despite a thorough search was nowhere to be found. Paparoni notes that Paladino seemed "surprisingly calm" at the painting's having disappeared as if into thin air. And he mentions, finally, that three weeks later Paladino wrote him a letter describing the work, though as if it were a work planned rather than one already executed. That letter from Paladino, published subsequently in the exhibition catalogue, begins:

Dear Demetrio,

You then will write the review of that which you will never see. TIRESIAS of the seven rooms, you will write of the eighth work which will never be.

22. Demetrio Paparoni, "Tiresias of the Seven Rooms or the True Story of the Disappearance of the Eighth Work of Mimmo Paladino's Cycle EN DO RE," in *EN DO RE*, 104.

Tail of the enigma; that which was will never be as enigmatic as that which will never be.[23]

Paladino goes on to describe the work that will never be, referring to a great, foggy sky, to trains, and to the hand of the night-wandering soldier that appears from a train. Then: "The absoluteness of the scene makes you think of the most pure Japanese ideogram, therefore writing, not painting as it was misunderstood to be." And later: "But this will be the picture that I will want to paint."

Described in a way almost indifferent to its painterly execution, which at best is set in a future that will never be (present), the eighth painting is like an ideogram, a writing signifying meanings, in any case more writing than painting. The eighth work would be such that on it too (as on *Open*) language would impinge to an unpainterly degree.

If it were. If it were not such as will never be. If it were to be, it would be the symmetrical opposite of that other painting on which language impinges to the same degree. As the eighth drawing is manifoldly open, so the eighth "painting," if it were to be, would be absolutely closed, utterly withdrawn into itself, the painted surface completely concealed by the wooden board that is to cover it. The concealment is no less decisive than would be the destruction of the work or its disappearance into thin air. Except that one will have to cancel the possibility of removing the wooden board enforcing the concealment. One will have to make sure that the board will not assume the guise of a door and swing back to reveal the painting that was to have been sealed away. One will have to guarantee the persistence of concealment. Perhaps by feigning the destruction or disappearance of the work. Perhaps by inventing stories. Or other kinds of discourse.

These are, then, the two poles that orient the *EN DO RE* cycle: unlimited openness and absolute closure, both submitted to language, to the

23. *Paladino,* 88. The review that Paladino says Paparoni is to write is of course the text on the eighth painting in *EN DO RE.*

rule, the economy, of meaning. Everything else takes place between these poles. The interval thus marked is the space of all the paintings and drawings proper to the *EN DO RE* cycle. It is the space of the passing of images, a space in which neither the openness of pure illumination nor the closure of utter darkness prevails. It is the region of shades.

▼ ● ◆

The cycle of twelve works from 1990 (oil or mixed media on canvas and/or wood) that were shown the following year at the Sperone Westwater Gallery (New York)[24] are described by the artist as "small works," as "small enigmas," as being "of a small format as if they were once Byzantine icons." These twelve small works[25] are also called "no-madic," and the suggestion is made that they "be seen as travel compan-ions to nocturnal wanderers and dreamers." These descriptions occur in a letter that I received from Mimmo Paladino in January 1991, a letter about his twelve small works—or rather, primarily about the six titles given these works.

In the small works one finds, not obfuscating panels, but supplemen-tary panels. Only two works in the cycle lack such panels, and in both cases there is an interruption of the frame comparable to that produced by the supplementary panels in the remainder of the works. One work (plate 17) has inscribed on its wide frame the Latin word *angulus* (corner, angle, nook, recess), a linguistic supplement naming accurately the space de-picted by the painting, a recessed space with two corners, with a cross hanging angularly on the wall, and with patches of color, their angles and corners quite accentuated. In this nook of a room a ghostlike figure is walking on tiptoe. A second work interrupts its frame by opening an

24. A catalogue has been published: Mimmo Paladino, *Amici* (New York: Sperone Westwater, 1991).

25. The works are in fact fairly small. With the exception of one work measuring 42 x 77 cm, none exceed 70 cm either in height or in width.

interior space: it depicts a figure passing from the visible surface of the work to an inner space behind it, a kind of open enclosure. In each of the other ten works of the series there is a supplementary panel added to the main rectangular panel of the work. The supplementary panel both extends the surface of the work and yet, precisely in doing so, disrupts the normal rectangular frame of that surface. The supplementary panel, itself also rectangular, brings an addition to the work and yet has the effect of depriving the work of its frame. While enlarging the work, the supplementary panel undoes its very delimitation as a work. In relation to the work the supplementary panel is an extension that disrupts, an addition that deprives, an enlargement that undoes.

In this double operation effected by the supplementary panels, through this production of opposed effects at the same time, the opposed effects are gathered in the work as a whole. This gathering mirrors and contributes to the presentation of images that these works carry out: the presenting of an image in its very passing, a presentation that both holds the image present and yet lets it pass, a gathering that sets into the work the passing of the image, making of the work an image of passing. Thus do the works present recondite images, masks in the very masking. Thus do the works depict images in their very passing.

As they pass up and down, reaffirming that the way up is the same as the way down. One of the works (figure 11) consists entirely of sets of steps set at various angles, one set extending into an upper supplementary panel on which there is a red mask: an image of the recondite images whose passing is gathered in all these works.

Passing not only from life to death but also—like Dionysus and the Crucified—from death to life: from a human figure in a crypt a plant sprouts upward, unfolding its leaves against the somber background (figure 12). Mixing not only life and death but also the human and the botanical.

Passing between death and life, from earth to Hades and back. Hovering between them like shades drawn forth as if to life. Hovering like ghosts. Ghostlike figures haunt several of the small works: agrarian ghosts

Figure 11. **Mimmo Paladino**, *Souvenirs,* 1990. Mixed media on wood, 63 x 62 cm. Private collection. Courtesy Sperone Westwater, New York.

Figure 12. **Mimmo Paladino**, *Ornamental Landscape* [Paesaggio ornato], 1990. Oil on canvas and wood, 56 x 63 cm. Private collection. Courtesy Sperone Westwater, New York.

(see plate 18), seafaring ghosts, crucified ghosts, woodland ghosts, ghosts on tiptoe (see plate 17). These figures border on utter expressionlessness. Their faces show none of the familiar expressions of joy, pain, anxiety, etc. that are readily transposed into language (as I have just done). It is as if these figures came from another world, from a world immeasurably remote, very ancient.

When, in order to prepare a brief text for the catalogue, I first received the transparencies of the cycle of small works, they too, like those in the *EN DO RE* cycle (except for the eighth drawing), were all designated as *Untitled.* Then, belatedly, Paladino entitled the works, and, as I was preparing my text, I received from him the set of titles as well as the letter concerning those titles. There can be no doubt but that these belated titles are not meant to name what is depicted in the works, and indeed it is in this letter that Paladino makes a point of saying that he does not give titles that convey a particular meaning within the orbit of which one's interpretation would then be trapped. Though he is careful not simply to exclude "the literary aspect" from his works—language does encroach upon them—he stresses the need for the work to affirm itself and to be only supported by the language and meaning (Paladino calls it "philosophy") that impinge upon it. As to the title, it is meant to evoke that side of the work that disquiets or displaces interpretation.

There is something odd about the belated entitling of the series of small works: there are only six titles for the twelve works. Thus, each title is given to two works, indeed to two works that in every case are very different, at least superficially. According to the accompanying letter from the artist, one title (*Souvenirs*) refers to memories ("those superficial things that provoke memories")—that is, one might venture to say, images that call up other, masked images. Another title speaks of the artist as an *Anxious Dog,* the letter confirming this identification: "the artist is anxious like a wandering animal." Still another speaks of his *Friends,* the friends of one's painting, "friends faithful to one's own painting." Friendship would require a reticent discourse, one that refused all translating appropriation, a discourse attuned to the silence of the work. Another title is to be read

"as if not to make a sound in one's calm and concentration," thus advising a certain silence, not the silence of one who would remain motionless, but of one who would wander *On Tiptoe.* Citing still another title, the fifth (*Ornamental Landscape*), Paladino says only that this "is one about which I will not say more"—that is, he says (and says he will say) nothing, that he will remain silent. And, indeed, as to the final title (*1955*) he is utterly silent, neither saying anything about it nor saying even that nothing is to be said about it, remaining silent about the silence.

Withdrawing the works into the shelter of silence, the letter itself withdraws into silence. As must, finally, any discourse on Paladino's work. Not in order simply to cancel what has been said, but to spread over it a sheen of silence, letting the work itself affirm its gathering of recondite images, letting the passing of images shine forth from the work itself.

Silencing, finally, even the injunction to silence and the invocation of that for the sake of which silence would be enjoined.

Except to say: in friendship.

And to wander—on tiptoe.

▼ ● ◆

Paladino's painting is at the limit. Most notably, indeed manifestly, it is at the limit where painting borders on sculpture. It is at that limit in a way that would be unthinkable within the orbit, for instance, of Hegel's *Aesthetics.* To pass across the limit from sculpture to painting cannot be, as for Hegel, a matter of advancing to the presentation of subjectivity in all its diverse particularity. For the figures in Paladino's works come from a region older than subjectivity, more ancient; they are figures that come to haunt all that appears to subjectivity, casting their shadows across all that comes to pass in this sphere while remaining themselves remote, irreducible—in their expressionlessness—to particular subjectivity. Neither can the passage from sculpture to painting have to do with the advent of color, with putting into play all that color can accomplish, for, in Hegel's analysis, it is precisely the project of presenting subjectivity in its diverse particularity

that generates the painter's need to employ color. Thus, the passage can be only a matter of the transition from the threefold of spatial dimensions to the flat surface.

Paladino's work is at this limit, though not at all in the sense of being delimited as painting by it. Rather, it is at this limit in the sense of *presenting* the limit, setting the passage across it *into the work itself.* Yet in putting the transition to work in the work, Paladino submits it to a nonsymmetrical reversal: what is set into the work is the passage from painting to sculpture. It is as if the work released a protosculpture that would always already have been secretly at work in painting: as when, in a work in mixed media (see plate 18), the frame itself is extended into a supplementary panel on which a grainlike wreath dangles from the arm of an agrarian ghost. Yet what Paladino's "painting" sets into the work is not just another dialectical transition, one that would be the reverse of the transition outlined in Hegel's analysis. Rather, it is a matter of hovering between the terms of transition, hovering in between painting and sculpture, rendering the limit itself questionable (not theoretically but in the work), clearing the space in which one could imagine a free mixing of painting and sculpture.

Paladino openly acknowledges such mixings. In an interview from 1987 he says: "Anyway I combine the traditional techniques of sculpture, painting, and mosaic in a way that would have been unthinkable in another era. Today an object sticking out of a canvas means we can talk about sculpture instead of painting, and basically it's neither sculpture nor painting in the traditional sense."[26] As in the works of the *EN DO RE* cycle, in which the painted surface is doubled by the obfuscating panel in a way that simulates the passage to three-dimensionality and hence the passage from painting to sculpture. Yet the doubling only simulates the transition, indeed as a way of presenting it, and thus the work remains hovering at the limit, putting the limit in question.

Thus is discourse on painting opened into discourse on what would

26. Vettese, "Mimmo Paladino," 99.

simply have been sculpture. Especially when that sculpture itself simulates such doubling as is found in the works of the *EN DO RE* cycle.

▼ ● ◆

As in a bronze mask by Paladino (plates 19 and 20).

It is double. Manifestly so.

Also it is *said* to be double, indeed by Paladino himself in a brief letter (20 January 1991) that I received from him about this remarkable bronze. As if he wanted to emphasize what is in fact palpable in the sculpture itself, as if he wanted to redouble its effect.

It is, of course, *a* double, an image. But what does it image? What does it let become manifest? What shines through the image? What form appears in it? Is the form not indisputably that of a face? But what kind of face is doubled in the image? Is it a human face? Or is it not a face to which a certain animality belongs? Why otherwise would the nose manifestly double as the head of what is unmistakably an animal?

But is it primarily a face that is made manifest in this image? Is this what is sculpted in the sculpture? Or is the image cast in the form of a face precisely in order to make manifest something else? Indeed, because it has the form of a face, one is struck all the more forcefully by the effacement that is operative, not only by way of the double form of the nose but also through the shape of the lower half of the figure and, even more, by a kind of indefinite doubling of the mouth. The effect of all these effacements is to concentrate everything in the eyes, in a vision coming from eyes behind the eyes, a vision so intense that its eyes are both double and invisible. One looks right through the eyes—the double pair of eyes—and the vision that one sees (in not seeing), the vision made manifest in the bronze, is a monstrous vision. One notices a fore-eye that looks as if it had been formed by violently tearing a hole in the fabric of the face.

One thinks, too, of a shining example in the *Aesthetics* in which Hegel tells how utterly incomparable the eye is. In the eye, he says, the soul is concentrated, indeed in such a way that the soul does not merely see

through the eye but is also itself seen there, appears there, shines forth in the eye. This is why Hegel requires, then, of art that it transform every point on the visible surface of the work of art *into an eye,* into a sight or site where spirit may shine forth. This is why he requires that art make every one of its productions into a thousand-eyed Argos.[27] And yet, Argos was indisputably a monster, made such by his possession of merely a third or perhaps a fourth eye. What must, then, be the extent of the monstrosity when the eyes are not only doubled but rendered invisible? Mere empty sites where spirit itself was to have become visible. Monstrous sites. Sites of a monstrous vision that, contrary to nature, refuses to be seen.

Yet, Paladino's bronze is not just *a* double, an image. It is a very special kind of image, an image that doubles in a very special way: in his letter Paladino calls it an "evocative mask." A mask is an image that doubles something in such a way as to conceal it: a man wearing an animal mask conceals his humanity behind the mask. But in covering it, in the very gesture of masking, he cannot but also allude to it, so that what results is a mixing of his humanity with a certain animality. A mask does not simply conceal but is, as the artist says of the bronze, also evocative.

One could hardly overlook the connection with the works of the *EN DO RE* cycle: in these works the introduction of the obfuscating panel effects a doubling that both conceals and evokes. In most cases there are images also on the obfuscating panel so as to produce a mixing of the images that appear on the two surfaces; yet this mixing is essentially connected with the operation of concealment, with the masking of certain of the images on the lower surface. The paintings and drawings in the cycle, exceeding painting and drawing in the direction of sculpture, are incipiently evocative masks. They lie already within the transition to the sculpted mask.

What, then, does the bronze mask evoke? Manifestly, it evokes a mixing of the human and the animal, as well as a mixing of these with the

27. Hegel, *Ästhetik,* 1:155f.

botanical: it is as if the mask had grown from the plantlike stalk on which it is set and as if the stalk, in turn, were rooted in the earth; and the horns that extend upwards from the mask like those of an animal also double as branches of a thorny bush. Hence a monstrous figure, embodying monstrous vision, mixing vision and invisibility in an unprecedented way, mixing up in other ways, too, what nature would keep distinct. Most obtrusively, it masks the humanity of the face and infuses monstrosity into the eyes. By showing, perhaps most strikingly, the horns doubling as branches yet extending from a head neither simply human nor simply inhuman, it mixes up the human with the plant and the animal in such a way as to erode through its manifest visibility the distinctions that the language and concepts of European humanity automatically put in force, whatever the spectacle. Thus it confounds, not in the sense of merely jumbling, but in the archaic sense of bringing to ruin, leaving only the ruins of these otherwise impregnable structures. It withdraws the force of the distinctions, almost as if reaching back to a time when they were not yet in force, a past that would never have been present and that would belong no more exclusively to history than to nature. The bronze mask is—in the words of Paladino's letter—"dug out of very ancient memories."

▼ ● ◆

The intensity of the sunlight was nearly unbearable, almost as in Sicily.

And yet—

It would not be easy to count up all the ghosts that came to haunt Forte Belvedere in Florence during the exhibition of Paladino's works held there in summer 1993.[28] Nor could one readily ascertain just how many monsters had been called up from the depth, up into the brilliant sunlight

28. The exhibition took place from 9 July until 10 October. A catalogue has been published, though it is incomplete and does not show the works in their setting at Forte Belvedere: *Mimmo Paladino* (Florence: Fabbri Editori, 1993).

illuminating the fort and its grounds. An immense number and variety of works were shown, several distinctive series or cycles of paintings and a vast collection of sculptures ranging from colossal to miniature and executed in various materials (bronze, limestone, wood, plaster, etc.). One could not imagine a more artful placement of the various works at the diverse locations offered by this splendid setting (see figure 13): the various rooms within the fort, many of them affording such distinctive views of the city that such views tended to become only slightly displaced members in the series of views offered by the works exhibited in the rooms; the garden areas immediately surrounding the fort, settings in which the pastoral might open onto an older, wilder nature; out beyond the garden, extending frontally up to the boundary marked by a low wall (which is only the upper portion of the wall surrounding the entire site), a more barren, gravel-covered area, itself wilder, more remote from the human world; and the magnificent terrace on the front of the fort, where, especially if Belvedere had been more castle and less fort, one would have expected dramatic performances to be held and where, as the centerpiece of the entire exhibition, Paladino had prepared the setting of a drama. Above all, one could not imagine a more appropriate site for these works dug out of very ancient memories: set high above the city, Forte Belvedere looks out directly upon the ancient city of Florence, a view of which is necessarily incorporated into one's view of many of the sculptures, especially those located on the terrace or on the forward area.

Is there a tense in which to write of such an exhibition? One will say perhaps that it is past. The exhibition took place in the past and presumably is to be written about (as I am now doing) in the past tense. For one who visited the exhibition at Forte Belvedere, for one who lingered there among its figures and images, a return now to the fort can only reinforce one's conviction that the exhibition is past: one will not be able to wander across the grounds without a compelling sense of the *absence* of the exhibition once seen there. Yet that sense, the compulsion that it exercises on one's memory, indeed the very absence of the exhibition—all of this belongs to the present in which one returns to the fort, a return that

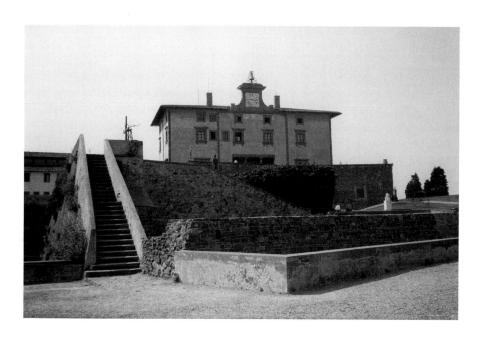

Figure 13. **Forte Belvedere**, Florence.

cannot but be also a return (now, in the present) to the exhibition, even if its time proper is past. Even if one does not return to the fort, even if one relies entirely on a remembrance now detached from the site, consulting only notes and photographs taken during the exhibition, one's writing will be directed to the presence of the exhibition, to what comes to presence in the sculptures and paintings, to what is set into the works in such a way as to shine forth in and through them. Writing will be engaged by the presence of the exhibition, and its tense needs to be thus determined, though it by no means follows that such determination will simply yield what is ordinarily thought of as the present tense. Certainly it will not, if by

present tense one understands a mode of happening limited to a present moment, lacking all bearing toward what is called the past. Not only because one may have found at the exhibition works that already had an effective past (as in the case of the monstrous bronze mask discussed above, which I had seen and indeed already written about prior to the exhibition); but also because the exhibition belongs to a past that will not again become present, for it is so essentially bound to its site at the fort that even to exhibit exactly the same works in some other setting would constitute an utterly different exhibition. Writing must come out of that past, out of it into engagement with a presence that cannot be only of the present. Such writing requires perhaps an unheard-of tense, one that can at best only be simulated.

At the front right corner of the entire site there stands on guard a horse with a birdlike head (figure 14), as if protecting from intrusion the entire precinct, populated by its sculpted figures and painted images. Or as if he were a lookout, posted to announce an expected arrival; the horse figure is turned to the east, toward Greece.

Set on this very remarkable site, there is something elemental about the exhibition as a whole. It is as if the intense sunlight came from beyond to reveal the elements as never before, in their elemental affinity with light itself. At the front left corner of the site a huge bronze disc is set at an angle into the barren ground (figure 15). It looks indeed like something that has arrived from another world, the only sign of its relation to the human world being hidden from direct view, set on the back side in the form of a human head from whose blossomlike ear a stream of water runs into a bucket on the ground. Yet even with its semblance of being extra-terrestrial—even perhaps through that semblance—the huge disc draws one's vision downward to the earth into which it has penetrated, displacing the clods that now lie on the surface next to it, almost as if to underline the rift that it has opened in the earth.

Water is also artfully drawn into the precinct—remarkably, considering the elevation of the fort above the Arno, which separates it from the most celebrated district of Florence. Not only are there sculptures into

SHADES—OF PAINTING AT THE LIMIT

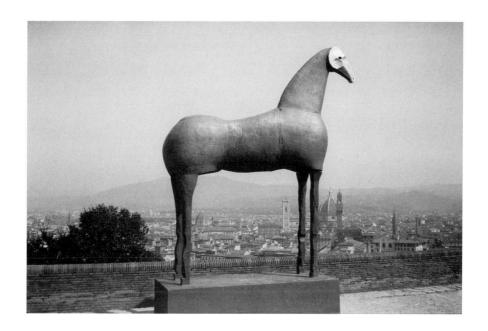

Figure 14. **Mimmo Paladino**, *Horse* [Cavallo], 1991.
Bronze, gold, and goldleaf, 400 x 60 x 400 cm. From
the exhibition at Forte Belvedere, Florence.

which, as with the huge bronze disc, small streams of water are incorpo-
rated, but also in one case the sculpture is actually set floating in a pool, or
rather, one might say, the pool of water is incorporated into the sculpture,
becoming part of the work itself (figure 16). A ghostlike figure, without
explicit sexual differentiation, is standing on a small platform, which floats
in the pool, in which the lightest of lily pads can be seen growing. Leaning
against the figure is a large bronze disc, the diameter of which only slightly
exceeds the height of the figure. Extending from the side of the disc

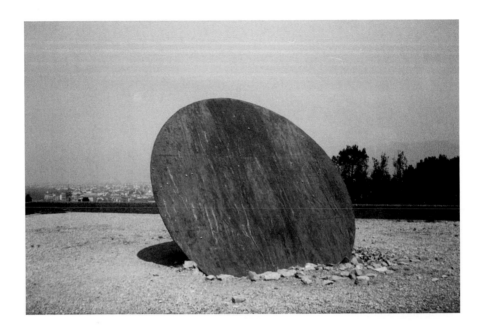

Figure 15. **Mimmo Paladino**, *Untitled* [Senza titolo], n.d. Bronze, 200 x 200 cm. From the exhibition at Forte Belvedere, Florence.

opposite the figure is the head of an animal; from its mouth a stream of water comes angling down into the pool, binding the composition together by means of the very element that it both appears to defy (because of the apparent weight, especially of the disc) and yet lets appear in its elemental aspect.

The fire of heaven engulfs the entire precinct: the intensity of the sun's rays makes things shine so brightly that one will have sought shade as relief not only from the summer heat but also from the near-blinding

luminosity; to say nothing of the fire that will have let the figures be cast, in the foundry of course in the case of the bronzes, but first of all in the artist's own work—what would once have been called the fire in the soul of the artist. Fire is also to be found inside, in the flames leaping from the ends of the fingers on some sculpted hands; it is as if these hands were those of the artist, the flames giving them the power to shape material into an artwork.

The other element is inscribed in the precinct, literally, the letters of the word *respiro* (breath, [fig.] respite) being set up in the garden area, not far from the pool with its floating figure (figure 17). Even before reading the letters, one will already have gotten a sense of the airy character of the site: here, high above the city, there is always a gentle breeze, and relief is offered not only from the intense heat but also from the press of the everyday, which is not lacking even in this city most dedicated to art.

The inscription on the site of the works, itself one of these works, at least in something like the manner of a parergon, corresponds to the inscriptions seen on some of Paladino's paintings in the two cycles dis- cussed above. In every case it serves notice that Paladino's is not an art of pure visibility, that language impinges on the works even though in the end they remain abysmally untranslatable.

There are other works too that recall the *EN DO RE* cycle and the cycle of small works. An entire room in the fort is taken up by a series of paintings showing ghostlike figures reminiscent of several of those in the small works. The room has no windows and is dark except for the illumina- tion shining directly on each of the paintings (see figure 18). With only one exception, the frame of each painting is hinged to a wooden cover, a door, that could be—though in the exhibition none are—closed. If the door were closed, it would obfuscate the surface of the painting, and thus in that event it would function like the obfuscating panels on the paintings in the *EN DO RE* cycle, except that it would *conceal entirely* the images painted on that surface (as in the missing eighth painting). The very presence of the door, even though open, serves to present the possibility of closure, of a concealment that would make the images pass. There are

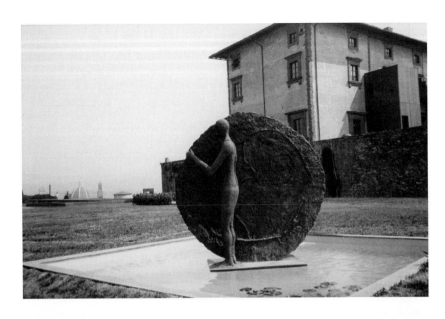

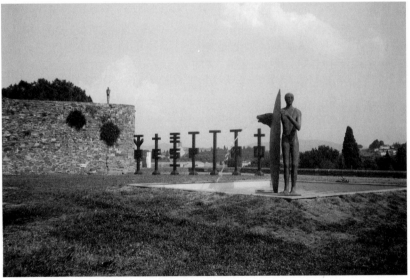

SHADES-OF PAINTING AT THE LIMIT

also sculptures—two among the twelve limestone figures on the terrace (see figure 19)—in which the main figure is partially covered by an obfuscating panel on which other images are sculpted; structurally, they are sculptural equivalents of the paintings in the *EN DO RE* cycle.

Another room displays seven very large paintings (all are 305 x 220 cm) that are quite similar and clearly form a series (see figure 20). The paintings are predominantly white. Yet the white does not function as a background for the various images appearing in the paintings (most of them unrecognizable, though one can discern a forearm, some hands, and a human head). Rather, the white is painted over the images. This overpainting is emphasized by the contrast with the small patch of background (tan canvas) that is left exposed near the top of each painting; with one partial exception, the images appearing on the tan canvas (most of them suggestive of gesture) are not painted over. If one takes the overpainting in white to be the primary operation in these paintings, then they may be regarded as carrying out and presenting a kind of erasure, making the images fade away, making them pass, while also, precisely through the overpainting, setting the passing of images into the painting itself, presenting such passage, such retreat. The paintings let passing come forth in the work, let concealment appear. As a concealed face can appear by way of a mask: it is not surprising that the sculpture lying in the middle of the room where these paintings are set up is a human figure also overpainted in white (through which one can see here and there the underlying material, wood); and piled atop the figure along its full length

Figure 16. **Mimmo Paladino**, *Untitled (Fountain)* [Senza titolo (Fontana)], 1987. Bronze, 205 x 87 x 195 cm. From the exhibition at Forte Belvedere, Florence.

Figure 17. **Mimmo Paladino**, *Untitled (Fountain)* [Senza titolo (Fontana)], 1987. Bronze, 205 x 87 x 195 cm. With *RESPIRO* in the background. From the exhibition at Forte Belvedere, Florence.

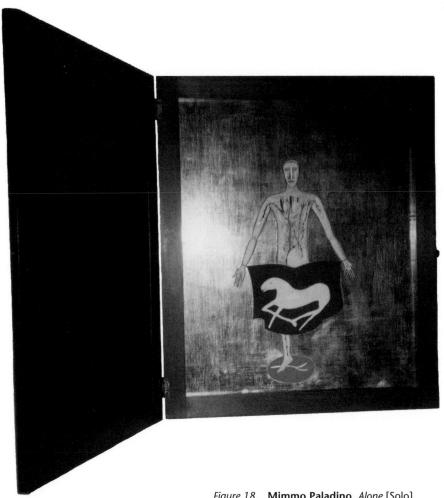

Figure 18. **Mimmo Paladino**, *Alone* [Solo], 1992. Oil on canvas on vellum on wood, 67 x 114.5 x 6 cm. From the exhibition at Forte Belvedere, Florence.

Figure 19. **Mimmo Paladino**, *Witnesses*
[Testimoni], 1992. Vicenza stone, 170 x 60
x 40 cm. From the exhibition at Forte
Belvedere, Florence.

Very Ancient Memories

Figure 20. **Mimmo Paladino,** *Sculpture dedicated to Giovanni Falcone and Paolo Borsellino,* consisting of one wooden sculpture and seven oils on panel, *Choral I–VII* [Corale I–VII], 1992. 305 x 220 cm each. From the exhibition at Forte Belvedere, Florence.

are several similarly overpainted masks. Or, since they are made to cover not just the face but the entire head all around, one could call them *helmets.*

Indeed, when one enters the exhibition, at the very entrance where one still has to climb a stairway up to the level of the grounds, the very first thing one sees is a huge helmet (130 x 190 x 190 cm) (figure 21).

Figure 21. **Mimmo Paladino**, *Untitled* [Senza titolo], 1993. Terra-cotta, 130 x 190 x 190 cm. From the exhibition at Forte Belvedere, Florence.

Though it consists of terra-cotta, it has the appearance of iron and looks as though it was fashioned by welding together various suitably shaped plates of iron. In the helmet there are eye-holes and an opening for the nose, and the position of these apertures on the helmet as a whole shows that this helmet—like all the others seen at the exhibition—would cover almost the entire face, thus functioning also as a mask. In a sense one could regard the helmet in general as more appropriate to sculpture than

155

the mask, since it conceals from all sides and not only from a limited, frontal perspective. At the same time, by leaving the lower part of the face and head exposed, it incorporates into the appearance a more open reference to what lies concealed, more open than the allusion of a mask to the face concealed behind it. Moreover, a helmet has a function that one would not directly ascribe to a mask, namely, that of sheltering and protecting—whether, actually, in war itself or, otherwise, in the enactment of the conflict of mortal with immortal, the $\pi\acute{o}\lambda\epsilon\mu\sigma\varsigma$ that shines through ancient drama. In its double function of concealing while also sheltering and protecting, the helmet poses an archaic connection that again today both concentrates and discatters thought: it is gathered in *sheltering,* which is to protect by putting under cover, by concealing, and yet in such a way as to preserve, to save, to free, rather than simply to let disappear.

Inside the fort there are many other helmets, not of colossal proportions but more suited to those of the human head. In one room, for instance, there is a rust-covered iron table on which lie a dozen helmets made of similar material (figure 22). Another room features a kind of iron bin or frame in which are piled up several helmets very similar to (perhaps the same as) those displayed on the table. Another helmet is actually being worn by a human figure. This instance confirms that the helmets are such as to cover almost the entire head and face; from the front everything but the lower jaw and the chin of the figure is masked by the helmet.

It is decisive that the helmet one sees first, that one cannot but see first, is not one of human proportions but rather is such as could be put on and worn only by a colossus, a human figure of superhuman size and strength, a human figure that would exceed the human to the point of bordering on monstrosity. Despite the profusion of human-size helmets, indeed despite the numerous humanlike figures that haunt the various precincts of the exhibition (many of the sculpted ones being more or less of human size), there is something undeniably, uncannily, monstrous about the exhibition as a whole. Not only because these figures are so ghostlike, but also because in the exhibition one finds again and again figures or even entire works in which there is presented a mixing, a con-

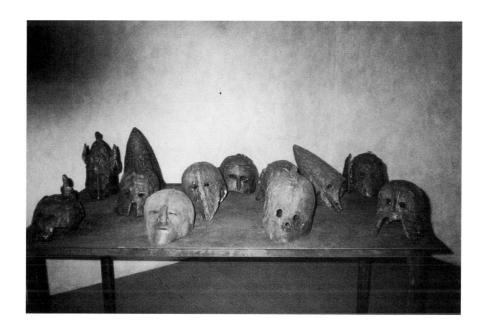

Figure 22. **Mimmo Paladino**, *Untitled* [Senza titolo], 1993. Wooden table, terra-cotta and clay, 100 x 162 x 85 cm. From the exhibition at Forte Belvedere, Florence.

founding, of human, animal, and botanical that is no less monstrous than in the bronze mask discussed above. Indeed that bronze mask is there, its monstrosity augmented by the effect of the other sculptures (another mask, a helmet, flaming hands, etc.) among which it is set. To say nothing of the piece that one sees first as one ascends from the landing where the colossal helmet is placed to the garden area above (figure 23): a sculpture in which one of the two figures doubles as a dwarf and a kind of animal (a

Very Ancient Memories

Figure 23. **Mimmo Paladino**, *Nocturnal Song* [Canto Notturno], 1984. Bronze, 230 x 200 x 105 cm. From the exhibition at Forte Belvedere, Florence.

kind that is not a kind, a kind of cross between a horse and a goat), while the other figure (human, though ghostlike) incorporates the stalk of a plant growing out of a human head at the base of the figure. Not even to mention the various other instances in which the human is intertwined with living things that a long history has taught us to delimit in opposition to the human, as other than human, but that these works now mix with the human, confounding these delimitations, calling back, in place of them, very ancient memories.

Even if one lingers for some time on the grounds before going up to the terrace, even if one bypasses it initially and goes on to visit first the various rooms of the fort, one will still not be fully prepared to behold what is to be seen on the terrace. Not that preparation will have been entirely lacking. Totally white figures, not completely unlike those on the terrace, will have been seen in the garden area—to say nothing of the uncanniness, the strangeness, the foreignness as if coming from another world, that nearly all the works serve to evoke. There is also the room in which almost everything is, like the figures on the terrace, white—the room with the helmet-covered figure in the center and the seven large paintings, everything overpainted in white. All seven paintings have the same title[29] and are differentiated only by the fact that for each individual painting a numeral is added to that common title. The common title is *Corale* (Choral).

As one steps up onto the terrace, it is as if a dramatic performance had been prepared there, indeed as if it were already under way. There are twelve perfectly white stone figures standing on the terrace, spaced on it (see figure 24). They are human figures but not without that ghostlike aura seen in other figures below. Each of the figures is different, though their similarity, their unison, is immeasurably more striking than their individual differences. There is no explicit sexual differentiation either in the bodily representation or by way of the garments that drape some of the figures. Even the molding of the breasts in those cases where the upper body is nude leaves one undecided whether the figure is male, small-busted female, or simply undecidable as such (the breasts left unmolded).

The sense of a dramatic performance under way is confirmed as soon as one glances at the porch joining the terrace to the fort itself. It is from this porch that one would look on at the dramatic spectacle on the terrace

29. According to the catalogue. At the exhibition itself titles, even the title *Untitled,* were lacking. In the catalogue, on the other hand, all the works for which proper titles are not given are listed as "Untitled [*Senza titolo*]."

Figure 24. **Mimmo Paladino**, *Witnesses* [Testimoni], 1992. Vicenza stone, 170 x 60 x 40 cm. From the exhibition at Forte Belvedere, Florence.

where all the figures face toward the porch. On the porch itself one finds, except for some large potted plants, only one thing: a metal sculpture consisting of two sets of double wheels, the two sets of wheels joined by a long bar (figure 25). On top of the bar one sees roughly sculpted human heads, nineteen of them in all. They are lined up along the full length of the bar as if to behold the drama being performed for them by the figures out on the terrace. Images of the spectators. Of the spectators of the images enacting the drama.

Figure 25. **Mimmo Paladino,** *Untitled* [Senza titolo], 1988. Bronze, 122 x 706 x 33.5 cm. From the exhibition at Forte Belvedere, Florence.

Much that one will have seen below and perhaps elsewhere in Paladino's work finds some resonance here on the terrace. One of the figures is almost completely covered in front by an obfuscating panel on which is sculpted another, smaller figure (figure 26). There are two figures that are intertwined with animals, one of them literally bound up with a beast as with a rope wound around much of the length of their bodies (figure 27). On another of the figures there is writing, large indecipherable symbols in a space taking up almost the entire frontal side of the figure.

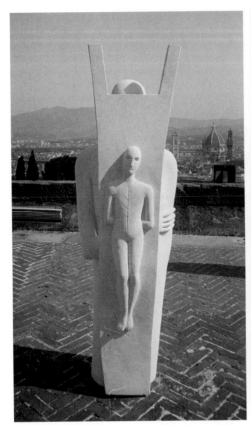
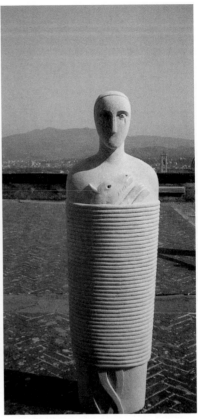

Figure 26. **Mimmo Paladino**, *Witnesses* [Testimoni], 1992. Vicenza stone, 170 x 60 x 40 cm. From the exhibition at Forte Belvedere, Florence.

Figure 27. **Mimmo Paladino**, *Witnesses* [Testimoni], 1992. Vicenza stone, 170 x 60 x 40 cm. From the exhibition at Forte Belvedere, Florence.

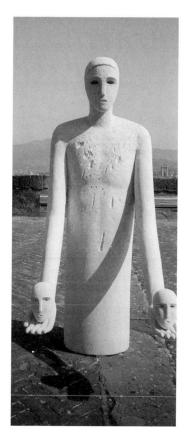

Figure 28. **Mimmo Paladino**, *Witnesses* [Testimoni], 1992. Vicenza stone, 170 x 60 x 40 cm. From the exhibition at Forte Belvedere, Florence.

There are masks—for instance, three of them sculpted on the chest of one of the figures. Another figure with outstretched arms holds in each of its palms a sculpted head (figure 28), as if these solid images were being offered to the beholder, perhaps even in the very performance that is under way. In this case especially one cannot but be struck by the similarity between the sculpted heads being offered and the heads of the figures themselves. One might be tempted, then, to regard the figures themselves as augmented masks, just as in another way helmets constitute augmented masks. There are also signs of music, as in the case of a figure from whose mouth extends what looks both like a musical pipe and like an animal, as if the figure's voice had been assumed by the animal, as if the figure were speaking in the voice of the animal, or conversely.

But all twelve figures are in a sense linked to music, and it is this link that gives one the sense—the moment one steps up onto the terrace—that a dramatic performance is under way. The twelve figures constitute a chorus, as in the chorus of Greek tragedy. One notices from the beginning that their posture and the bearing it implies are quite ceremonial. This is not to say that the figures are expressive. On the contrary, the faces of the

figures either border on utter expressionlessness or, if one can ascribe some slight trace of expressiveness to them, it is of a kind that is not recognizable, of a kind that is not a kind familiar to us, an expression not translatable into a stable meaning of the sort involved when one says that a face expresses anger, fear, or anxiety. If it can be said that some of the figures' faces are not totally without expression, one will still have to admit that it cannot be said what these faces express, perhaps not even whether they express a *what*. If there is expression on some of these utterly strange faces, it is an expression that slips away from language and that interrupts the usual extension of the very word *expression* to cover speech as well as appearance.

Yet, even if their faces are utterly without expression, the choral figures are nonetheless highly gestural, and it is the bearing of their gestures that gives the entire scene an aura of ceremony. But even the concept of gesture—assuming there is one, assuming that something as elusive as gestures can be effectively brought into a concept—will have to be submitted to a certain deformation if it is to be appropriate to what one sees when one takes one's place among the spectators beholding the performance there on the terrace. For the gestures of these figures are not such that one can say what is indicated by the gesture. Even more decisively than in the case of the works seen on the ground below (which can still mostly be seen from the balcony), the choral figures are as if they came from another world, from a region farther beyond or farther below than everything under the sun. It is as if these figures of stone had come up into the light that they might attest to that other world, that they might bear witness to the subterranean darkness. One of the figures (with a fish sculpted on its front) is as if in a casket, one that looks as though it could also double as a boat (figure 29). It is as if these figures were shades come up from Hades, up into the brilliant sunlight, to perform in silence an unheard-of drama that, like the shades themselves, will never be translated and domesticated in this world above.

And yet, one will listen. Sitting silently among the spectators in the shade of the porch, sheltered from the intense sunlight. Or even perhaps,

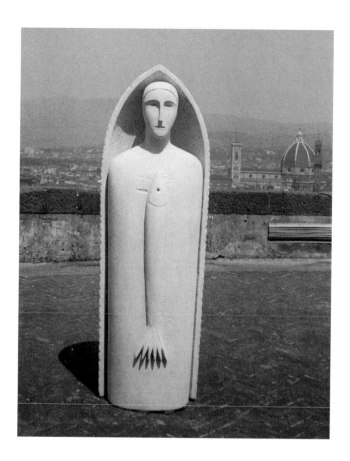

Figure 29. **Mimmo Paladino**, *Witnesses* [Testimoni], 1992. Vicenza stone, 170 x 60 x 40 cm. From the exhibition at Forte Belvedere, Florence.

ever so cautiously, venturing onto the scene itself, moving quietly among the choral figures, always on tiptoe.

Index of Proper Names

Courbet, G., 35
Creuse Valley, France, 24, 26, 35, 36n*30*
Cucchi, 120n*6*
Cumming, H., 70n*12*

Dabrowski, M., 95n*32,* 103n*34,* 104n*36,* 106n*42*
De Maria, 120n*6*
Derrida, J., 6, 8, 13, 31n*22*
Dionysus, 135
Durand-Ruel, P., 22, 25, 27, 29, 35, 36, 46, 49

Empedocles, 5
Étretat, France, 34

Faust, W. M., 129n*21*
Fichte, J. G., 80, 81n*19*
Florence (Forte Belvedere) exhibition of Paladino (1993), 20, 143, 144
Fuller, P., 70n*12*

Gadamer, H.-G., 89
Geffroy, G., 23, 24n*8,* 35, 36n*30,* 43, 44, 46, 50
Giverny, France, 22, 23, 24, 25, 26, 27, 29, 30, 31, 32, 69
Guillemot, M., 34
Guys, C., 51n*52*

Hades, 21, 128, 135, 164
Hahl-Koch, J., 83n*21*
Hartmann, T. v., 58
Hegel, G. W. F., 6, 9, 12-18 passim, 31, 63, 64, 65, 71,
 72, 76, 84, 85, 139, 140, 141, 142
Heidegger, M., 9, 12, 31n*22,* 32, 33, 34, 42n*39,* 55, 64, 87, 88, 89, 96
Homer, 21
Hoschedé, A., 22, 23, 24n*9,* 29n*16,* 35, 45

Index of Proper Names

Hotho, H. G., 64
House, J., 25n*13,* 29n*17,* 49n*51*

Isle of Wight, 35

Kandinsky, W., 20, 57-116 passim
Kant, I., 7, 13, 14, 18, 54, 55

Lankheit, K., 57n*1*
LeRoux, H., 44
Leroy, L., 39
Lindsay, K. C., 57n*1,* 67n*10*
London, England, 24n*11*

Marc, F., 57
Mendelssohn, F., 18
Merleau-Ponty, M., 42
Moffett, C. S., 25n*12,* 25n*13,* 39n*35,* 43n*42,* 49n*49,* 67n*10*
Monet, Camille, 51
Monet, Claude, 18, 20, 22-56 passim, 67, 68, 69
Monet, M., 29n*16*
Montmartre exhibition of Monet (1889), 45
Morisot, B., 35, 39
Moscow, Russia, 67, 68, 69, 81n*20*
Mount Kolsaas, Norway, 23
Munich, Germany, 57, 66, 68, 70
Münter, G., 105

New York (The Museum of Modern Art) exhibition of Kandinsky (1995),
 20, 95
New York (Sperone Westwater Gallery) exhibition of Paladino (1990), 134
Nietzsche, F., 41, 42, 56, 82, 88, 115, 121, 124

Odysseus, 21
Oliva, A. B., 120, 121n7, 126n20
Oslo, Norway, 23, 45

Paduli, Italy, 132
Paladino, M., 20, 117-165 passim
Panni, M., 125n19
Paparoni, D., 117n2, 132, 133n23
Paris exhibition of Monet (1891), 18
Petit Ailly, France, 35
Petit exhibition of Monet-Rodin (1891), 29, 35
Pissarro, C., 39
Plato, 9
Pollock, J., 90n29

Renoir, P. A., 39
Rewald, J., 25n12
Robinson, H., 14n8
Rodin, A., 23

Sandvika, Norway, 23
Schönberg, A., 83, 84n22, 94n31
Schumann, R., 63
Seiberling, G., 27n15, 44n45
Seurat, G., 68
Shakespeare, W., 18
Shapiro, C., 90n29
Shapiro, D., 90n29
Shapiro, M., 31n22
Sisley, A., 39
Socrates, 80
Sollins, S., 120n6
Spate, V., 25n12, 29n19, 34

Starnbergersee, Germany, 84
Stella, F., 70n*12*
Stuckey, C. F., 18n*14*, 35n*28*, 39n*37*, 45n*47*, 51n*53*

Teiresias, 21
Tolstoy, L., 62, 63n*5*
Tucker, P. H., 25n*12*, 25n*13*, 26n*14*, 29n*20*, 30fig*3*, 38n*34*, 43n*42*, 53n*54*

Van Gogh, V., 31n*22*
Vauxcelles, L., 30fig*3*
Venice, Italy, 24n*11*
Vergo, P., 57n*1*, 67n*10*
Vernon, France, 53
Vétheuil, France, 53n*54*
Vettese, A., 117n*1*, 118n*4*, 120n*6*, 140n*26*

Wagner, R., 69, 77, 78, 105
Webern, A. v., 84n*22*
Weimar, Germany, 66
Weitzenhoffer, F., 25n*12*
Wildenstein, D., 22n*1*, 29n*16*, 34n*25*, 38, 39n*36*, 45n*48*, 51n*53*
Wright, W., 90n*29*

JOHN SALLIS is Liberal Arts Professor of Philosophy at Pennsylvania State University. His previous books include *Being and Logos; Crossings; Delimitations; Double Truth; Echoes: After Heidegger; The Gathering of Reason; Phenomenology and the Return to Beginnings; Spacings;* and *Stone.* Sallis has edited several books including *Reading Heidegger* and *Deconstruction and Philosophy.* He has also written catalogues for exhibitions by such contemporary artisits as Mimmo Paladino and Paul Kipps. ▼ ● ◆

Editor: Jane Lyle

Book and Jacket Designer: Sharon L. Sklar

Typeface: Stone Sans / Huxley

Compositor: Sharon L. Sklar

Book and Jacket Printer: Thomson-Shore

Insert Printer: Phoenix Color